The Necessity of Scu

Eric Gibson

The Necessity of Sculpture

Selected Essays and Criticism, 1985–2019

Criterion
Books

First American edition published in 2020 by Criterion Books, an imprint of Encounter Books, an activity of Encounter for Culture and Education, Inc., a nonprofit, tax-exempt corporation.
www.newcriterion.com/books

LIBRARY OF CONGRESS CATALOGING-IN-PUBLICATION DATA

Names: Gibson, Eric
Title: The necessity of sculpture : selected essays and criticism,
 1985–2019 / Eric Gibson.
Description: First American edition. | New York, NY : Criterion Books,
 2020.
Identifiers: LCCN 2019057527 | ISBN 9781641771085 (paperback)
Subjects: LCSH: Sculpture. | Sculptors.
Classification: LCC NB45.G53 2020 | DDC 730—dc23
LC record available at https://lccn.loc.gov/2019057527

Contents

To the memory of my parents.

GROWING UP, I always found our family museum visits difficult. The paintings bored me, but I particularly disliked the sculpture – so many brown and white lumps strategically positioned, or so it seemed at the time, to slow my path to the exit. And modern art was simply a joke. Then, in 1968, my mother took me to the Henry Moore retrospective at the Tate Gallery (as it was then) had organized to commemorate his seventieth birthday. It proved to be the proverbial *coup de foudre.* I entered the museum a fifteen-year-old philistine and left some time later an ardent modernist, moreover one for whom sculpture would become the abiding passion.

So this is a book on sculpture and sculptors. The topics emerged randomly, thrown off by successive exhibition calendars over the years and coming to range in time from ancient Mesopotamia to twenty-first-century Manhattan. As I made the selections, what began to take shape, beyond a conventional anthology, was a synoptic history of the art form. Since, compared to painting, there are so few introductions to the subject, and indeed so little standalone writing on sculpture at all, this seemed the most useful way to present this material. Accordingly, I have organized the topics chronologically, by artist and period. The title is a play on that originally given to the Rodin essay and, more pointedly, a belated, across-the-decades riposte to Ad Reinhardt's famous dismissal, *circa* 1960, of sculpture as "something you bump into when you back up to look at a painting."

No writer is an island, and my largest professional debt is to Hilton Kramer, the co-founder of *The New Criterion,*

who in the early 1980s took on a greener-than-green writer and gave him the opportunity to learn and grow through a rigorous editing process. Managing Editor Erich Eichman did the heavily lifting in those days, and I remain more grateful than he will ever know for all that I learned about both writing and editing from his close attention to my copy. In the years since, Roger Kimball and James Panero have been at the helm of the magazine, and I remain deeply indebted to them not only for continuously making its pages available to me, but also for granting me the space to discuss the assigned topics at the length I felt they needed – a true gift in today's journalistic climate. Others at the magazine now and then to whom I remain grateful are, in alphabetical order, Stefan Beck, Christopher Carduff, Jeffrey Greggs, Rebecca Hecht, Brian P. Kelly, Donna Rifkind, Andrew L. Shea, Emily Esfahani Smith, and Eva Szent-Miklosy.

At *The Wall Street Journal*, I owe a large debt to Editorial Page Editor Paul A. Gigot for his unstinting support of our work in Arts in Review; for making possible, in a time of straitened budgets, the travel some of these pieces required; and for granting permission for their publication in this volume. Editors at the *Journal* from whose care and skill the pieces benefited greatly are the incomparable Barbara Phillips and, in alphabetical order, Phillip Connors, Adrian Ho, Brian P. Kelly, Michael Phillips, and Raymond Sokolov. I'm also grateful to Robert Greskovic, the *Journal*'s dance critic, for guidance on ballet positions when I was writing the essay on Edgar Degas' *Little Dancer of Fourteen Years*.

At *The Washington Times*, I'm grateful to Editor-in-Chief Wesley Pruden and Life! section Editor John Podhoretz – the latter particularly for patiently schooling me in writing on a specialized subject for a general audience – and to Robin Berkowitz.

I'm indebted to my agent, Glen Hartley, for arranging

the marriage to Criterion Books, and at Criterion to Roger Kimball and Rebecca Hecht.

A word of thanks and praise to the curators of the exhibitions reviewed in this volume, even those with whom I take XI issue. They are the too-little-sung heroes of our cultural life, and we are all in their debt.

Beyond minor adjustments for clarity and consistency, these pieces are as they originally appeared. The one exception is the essay on Jeff Koons, to which I have added a short paragraph on his technique that I felt was important but didn't have room for the first time around.

Three women stand behind this effort. Besides my mother, there is my sister Serena Gibson, who the summer I entered college gave me a copy of James Lord's *A Giacometti Portrait*. The book quickly became a touchstone for understanding Giacometti, the creative process, and what good art writing can be. In addition, she has devotedly read, clipped, and pasted into scrapbooks these pieces and others as they have appeared. Third among equals is my wife, Kay, who has been by my side through every fraught deadline, gamely endured the absences mental and physical required to put these pieces to bed, and, when they have appeared, been a close and enthusiastic reader. No writer could ask for a more generous muse.

Mesopotamian Cylinder Seals:
Epics in miniature

WHEN WE THINK of the artistic accomplishments of the Ancient Near East, it's the great monumental structures that come to mind – the ziggurat at Ur, the barrel-vaulted arch at Ctesiphon, or sprawling temple complexes such as those at Persepolis and Khorsabad, of which only fragments remain. Yet there is a body of work that ranks, not just with those, but with the greatest achievements of all art: Mesopotamian cylinder seals, simple utilitarian objects whose inscribed images constitute a narrative art of a power and sophistication out of all proportion to their size. They were produced between about 3500 B.C. and 500 B.C. primarily in the area we now know as Iraq. They are small stone cylinders, rarely measuring more than an inch tall and one-half inch in diameter – sometimes considerably less. An intaglio design has been cut into them, more often than not a scene of combat between men, or some fantastic creature, and animals. When rolled across soft clay, the image would appear in relief, quickly forming a repeat pattern if the seal was rolled over any length, which it usually was. They functioned the way rubber stamps or one's signature does today, authenticating documents and protecting commercial goods from theft. Thus each image was, as it had to be, distinctive and unique.

Despite the fact that some of the greatest museums here and in Europe have extensive collections of seals, they tend to be known only to specialists. This is not only unfortunate, it's surprising, because there is much about them that speaks

to our modern sensibility across the gap of five millennia, however accidental these affinities may be. The repetitive imagery finds resonance in the serial imagery of late-twentieth-century art, particularly that of Donald Judd and other Minimalists. And because of the seal cutters' considerable descriptive gifts, which allowed them to endow their depictions of animals with such vitality, there is a Muybridge-esque, even cinematic, quality to these rolled-out pictures, particularly when the seal design consists of a frieze of coursing antelopes or similar creatures. Indeed it was this suggestion of motion that most attracted the British art critic Herbert Read when he discussed seals in his 1954 Mellon Lectures, "The Art of Sculpture," at the National Gallery in Washington. Of a seal in the Louvre showing a line of running horned animals he wrote (in the lectures' published form), "We must imagine the cylinder moving rapidly across the soft clay and leaving a trail of animals. The animals would actually seem to move as the cylinder left its trace." And lest his point be lost on his readers, Read chose to illustrate his cylinder seal alongside reproductions of Duchamp's *Nude Descending a Staircase* and a Futurist painting by Giacomo Balla.

Fortunately, two recent events have brought cylinder seals to a wider audience. As part of the series of small exhibitions it has mounted to celebrate its reopening, the Morgan Library and Museum has placed an abundant selection of its own large holdings of seals on view through next spring. It gives admirers of these extraordinary objects a chance for some in-depth study and members of the general public an opportunity to discover them – as they are doing with delight, to judge by audience reactions I overheard during my own visits to the exhibition. In addition, the British Museum Press this summer published a revised paperback edition of the British Museum curator Dominique Collon's *First*

Impressions: Cylinder Seals in the Ancient Near East, a book which, within the modest compass of some two hundred pages, manages to be the definitive study of this subject.

Seals have long provided a trove of information to archaeologists about the civilizations that occupied or ruled over the area between the Tigris and Euphrates rivers, chief among them the Sumerian, Akkadian, and Assyrian. We know the details of their religious beliefs and rituals, what their temples looked like, what they wore and how fashions changed. We know details of everyday life, such as the musical instruments they played and the animals they hunted and husbanded. And we know a very great deal about their worldview. They saw themselves locked in a pitched battle for survival against the powerful and capricious forces of nature, and they propitiated their gods in order to win this struggle. Egyptian art is informed by a pervasive serenity derived from its focus on the afterlife. But the images on Mesopotamian cylinder seals are intense and energized, miniature epics depicting a life-and-death struggle.

Yet this focus on archaeology can easily blind us to the seals' other source of interest: they are simply extraordinary works of art, blending closely observed naturalism with decorative patterning in a seamless unity. No detail seems too small for the seal cutter: leaves and branches are readily discernable, musculature is clearly articulated on man and beast, and the cutters take particular delight in differentiating textures – the varied fabrics in a personage's clothing, or the contrast between a lion's taut skin and furry mane.

Not surprisingly, perhaps, since their lives depended on it, nature and, in particular, the animal kingdom are keenly observed. One seal in the Morgan depicts a winged demon pursuing an ostrich. It's a rather humorous scene – the terrified, fleeing ostrich and its young look back at the knife-wielding demon who has grabbed the larger bird by the tail,

its feathers picked out to the last detail. Another of the Morgan's seals simply depicts a deer leaping over a bush next to a tree. Caught on its descent, with rear legs still splayed up to clear the obstacle, with the forelegs readied for the impact of landing, it's a powerfully immediate image that conveys not just the look but the feel of the animal's action.

At the same time, the seal cutters possessed an equally keen sense of the decorative. Figures and animals shown in a clinch of combat are arrayed in a heraldic symmetry that imposes a unity and stability on a given composition. And animals' appendages such as horns and tails form taut arabesques that impart an overall linear energy that plays across the surface of these compositions. And we will often see a hero or demon holding a conquered beast by its rear hooves so it is upside down. A true gesture of triumph, of course, but also a way for the seal cutter to impart a heraldic balance to his composition.

One cannot look at seal impressions for very long, though, without wondering how the seals themselves were made, for they are the product of innumerable and seemingly insuperable challenges.

To begin with, there was the narrative challenge. It's no exaggeration to say that in formulating and depicting their epics, the Mesopotamian artists were addressing – several centuries ahead of time – the same set of problems that artists such as Giotto and Masaccio faced at the dawn of the Renaissance, namely, how to tell complex stories in a nonverbal language within a limited space. The difference, of course, was that Renaissance artists had large walls to work on whereas the seal cutters were confined to surfaces little more than one inch square. Their solution was to limit themselves to very few characters – rarely more than three or four personages and animals to a seal – and rely on their highly sophisticated understanding of the language of pose

and gesture to communicate the story. Humans tend to be stiffer and more stylized than animals, but I suspect this has to do more with the dictates of legibility than any artistic failing. The premium was on letting us see the animal being stabbed, the blessing being given, and so on, in order to be able to grasp the story.

5

More formidable were the technical challenges. Seal cutters had to think in the negative. Printmakers have always had to do this but only in a passive way. They understand that the image they are drawing on, say, an etching plate, will register in the opposite direction once printed – a figure looking to the left on the plate will look to the right in the print. But that only becomes something they really have to think about if some detail of that image – say a man's pocket handkerchief – requires a specific orientation. Seal cutters, however, always had to think in the sculptural negative. What protrudes in nature must, in a seal, recede. To emboss the rounded forms of a haunch or crown on the soft clay, the seal cutter had to excavate depressions into his stone. Moreover, just as a sculptor carving in the round must, as he works on one particular side or face of the block, keep in mind its relation to all other aspects of the sculpture, most of which he cannot see, so did the seal carver have to maintain the proper relation of all parts to the whole, half to three quarters of which would, at any one time, have been invisible to him since, unlike the printmaker, the surface he was working on curved away from him.

The stones themselves did not make the seal cutters' task any easier. As Ms. Collon notes in her book, to withstand repeated use and to ensure the forms stood out with maximum clarity, these seals had to be very hard. They were cut using a bow drill and an abrasive such as emery powder, and the process was a long one. Images we savor for their spontaneity and vivacity were the product of protracted labor. "The

all-important ingredients were the abrasive and patience," she wryly notes.

The color of the stones posed an additional challenge. A draftsman, laying down dark lines on white paper, has conventional figure–ground relationships to guide him. He can clearly measure his progress – determine where he is going right and where wrong – by seeing his evolving image contrasted against the light background. But seal cutters had no such advantage. They were in a sense working blind because the stones they used were often dark (lapis lazuli), mottled (banded agate), translucent (chalcedony), or transparent (rock crystal), which means their incisions read simply as so many indistinct pools of shadow on an already dark ground. There was no contrast. Looking at the seals cut into these materials in the cases at the Morgan, they are completely illegible – we rely on the clay impression (or the photographic enlargement next to it) to know what they represent. One wonders how the seal cutters were able to keep track of what they were doing. The light-colored abrasive dust settling into the recessed nooks and crannies of a seal during drilling might have established a helpful figure-ground relationship. More likely, the cutters kept some soft clay nearby as they worked and would roll out the seal repeatedly during the process of cutting, the only real way they could check their work.

By far the greatest challenge, of course, was the seals' size. Just as we marvel at how these societies created works as monumental as a ziggurat, so it is equally astonishing that they produced such detailed, animated images on such a diminutive scale without magnifying glasses. How are we to account for it? Ms. Collon argues that the seal cutters were all short-sighted and that "the craft would have been passed down from father to son and myopia, transmitted as a dominant, would have been inherited as well." While some, no

doubt, were shortsighted, Ms. Collon's thesis assumes that in each generation at least one child would have inherited both myopia and artistic talent, which seems rather long genetic odds.

Perhaps, as with other masterpieces, the explanation is simply the mystery of artistic talent. Looking at the seals in the Morgan and wondering how they ever could have been made, I was reminded of an incident in a course on early Netherlandish painting I took at Columbia in the early 1980s, taught by the legendary Howard Davis. We were studying Jan van Eyck, and to demonstrate the artist's mastery the professor showed a series of slides of *Virgin and Child with Canon van der Paele* (1434–36) starting with an overall view and steadily closing in, until the last slide was the artist's microscopic self-portrait reflected in the shield of one of the attendant figures, an armor-clad St. George. It was as crisp and clear as every other part of the painting.

At the end of the class one of my fellow students asked Prof. Davis if van Eyck had achieved this with the aid of a magnifying glass.

"No," he replied. "Just a keen eye and a sure hand."

Originally published as "Epics in miniature"
in The New Criterion, *December 2006.*

GOOD EXHIBITIONS PRESENT marvelous things to look at; great ones change your thinking. The J. Paul Getty Museum's "Power and Pathos: Bronze Sculpture of the Hellenistic World" falls squarely into the latter category. Organized by Getty curators Jens Daehner and Kenneth Lapatin, the show consists of some fifty works ranging in size from full-length figures to portrait heads to tabletop sculptures. Included is *Seated Boxer* (*Terme Boxer*) (300–200 B.C.), a life-size sculpture of a scarred and battered athlete at rest, last seen in a solo turn at the Metropolitan Museum of Art two years ago.

To many, the term "Greek art" is synonymous with the Classical Period (480–*ca.* 323 B.C.) and epitomized by the Parthenon Sculptures (aka the Elgin Marbles). It features well-toned, athletic figures, idealized human proportions and faces, and an air of Olympian detachment – hardly surprising, since many of its subjects involved the gods.

The art of the Hellenistic Period (*ca.* 323–31 B.C.), which followed it, could not be more different: its language is down-to-earth, extremely realistic and intensely emotional, with highly energized figures often depicted in complex poses.

There's a sense in which scholars have tended to look down upon Hellenistic art. Some have regarded it as, at best, a coda to a period whose achievements could never be equaled, much less surpassed. At worst it has been considered decadent, its churning action and frank outpouring of emotion standing in unseemly contrast to classicism's studied gravitas. *Statue of a Dancing Satyr* (*The Satyr of Mazara del Vallo*), an

erotically charged image of physical and psychological abandon discovered in 1997 and featured only in the catalogue, is just the kind of thing the naysayers would have had in mind.

It hasn't helped that much has been lost or destroyed. The Louvre's *Winged Victory* (*ca.* 190 B.C.) is perhaps the most visible of Hellenistic creations, but outside of that and one or two other monumental sculptures there are proportionally fewer surviving masterpieces of this period to impress themselves on the collective consciousness than from earlier eras of Greek art.

This is especially true of bronze works. Many were melted down and repurposed – or wound up on the sea bed, to be stumbled upon later. More than a half dozen works in this show fall into the latter category, with two discoveries as recent as 2004.

All this would make "Power and Pathos" an event of the first magnitude. But it is more – a show that demonstrates that far from being Greek art's poor relation, the Hellenistic period was one of revolutionary innovation, with sculpture taken to new levels of technical, formal, and psychological achievement.

The first thing that strikes the visitor is a heightened level of drama, the product of a new and unprecedented relationship of the work of art to its surroundings.

Because in earlier phases of Greek sculpture figures largely looked off into the distance, the object inhabited a zone apart. Here, by contrast, poses and gestures appear calculated to focus the work beyond itself, infusing the immediate environment with a kind of electrical charge and making the viewer part of the implied narrative.

Nowhere is this more apparent than in *The Boxer* (300–200 B.C.), who turns and stares upward and outward, as if

beseeching you, the spectator, for sympathy or, better yet, deliverance from his ordeal.

Bronze has greater tensile strength than stone, meaning the top-heavy human figure can be shown in more naturalistic and dynamic poses without shearing off at the ankles, always the risk with marble. And it can be worked after casting with tooling and patination. Hellenistic sculptors exploited both techniques to create startling effects, such as the colored bruise under the Boxer's right eye. They also used materials such as glass for the eyeballs, and copper for eyelashes. The result was preternatural, near-pictorial levels of illusionism. As the catalogue foreword notes, this kind of technical audacity and skill would not be seen again until the Renaissance.

But material is nothing without a compelling vision to shape it, and what comes through time after time in "Power and Pathos" is the Hellenistic sculptors' determination to capture the world as they saw and experienced it with maximum truth.

Statue of a Young Man, thought to be a depiction of a discus thrower, is a fragment – the head, right arm, and right leg below the knee are all missing. Yet what's left reveals a knowledge of the dynamics of movement so penetrating that whoever made it must have spent long hours observing athletes in the field. The torso tilts in one direction, the left arm begins a swing the opposite way, and the left leg trails behind. In contrast to the smooth series of repeated actions depicted in Eadweard Muybridge's time-lapse photographs, this is human locomotion understood as a sequence of spontaneous, on-the-fly adjustments in which head, torso, and limbs move now in concert, now individually, to keep the shifting mass of the body balanced and upright as it surges through space. A revolutionary insight, yet one that would remain dormant for two millennia, until rediscovered by Auguste Rodin.

Since this is the first-ever show of its kind, it's hard to imagine we'll soon see another. Which makes "Power and Pathos" a rare opportunity to get a close-up view of one of the truly thrilling episodes in the history of art.

Originally published as "A Revolution in Sculpture"
in The Wall Street Journal, *September 3, 2015.*

Netherlandish Boxwood Rosary Beads:

Medieval marvels

FOR A LONG TIME, one of the best kept secrets at the Metropolitan Museum of Art was a display case in Gallery 306 on the museum's first floor. Its contents were small and, from a distance at least, unspectacular – which probably explains why so few visitors stopped before it as they moved between the Medieval Hall and the American Wing. Those who did, however, were rewarded with the sight of some of the most remarkable objects in the entire encyclopedic collection: hinged wooden beads about one inch in diameter which opened to reveal, carved in the round inside each hemisphere, a Cecil B. DeMille Crucifixion scene or similar Biblical narrative. Imagine Michelangelo's 45' x 40' Last Judgment fresco relocated to the inside of half a golf ball and you'll have an idea of the head-spinning combination of epic conception and diminutive execution these works embody.

The objects in question are rosary beads, made in the Netherlands in the sixteenth century and unlike anything in the history of Western or Gothic art. A group has now been brought together in "Small Wonders: Gothic Boxwood Miniatures," an exhibition at the Met Cloisters. The title is typical of the vocabulary of astonishment so often resorted to by writers trying to come to terms with these extraordinary creations. Others, we learn from the show's catalogue, are "ingenious," "enthralling," "magical," and "miraculous." Yet, as the exhibition's introductory wall text advises us, "[N]o adjective has ever been adequate to express the sense

of wonder and amazement that the miniatures elicit." The show itself makes clear just why that is.

Jointly organized by Alexandra Suda, the curator of European Art at the Art Gallery of Ontario (AGO) in Toronto; Barbara Drake Boehm, the senior curator for The Met Cloisters; and Frits Scholten, the senior curator of Sculpture at the Rijksmuseum in Amsterdam, "Small Wonders" consists of nearly fifty objects drawn primarily from the collections of the Met and the Art Gallery of Ontario, the latter's holdings the gift of Canadian publishing magnate Ken Thomson (1923–2006), who began collecting them in the 1950s.

The first discovery on entering the show is that this genre of sculpture was far more complex and ambitious than the objects in the Met's display case would have suggested. Besides Biblical narratives, their subjects included episodes from the lives of saints such as Jerome or Augustine. Then there are the objects themselves. Besides beads, there are miniature altarpieces, tabernacles, and diptychs, all as figurally complex as the contemporaneous monumental retables to be found in churches in Germany and Austria. And the composition of the beads often involved more than simply two hemispheres. One telling the story of King David has two tiny hinged wings carved in relief covering one hemisphere and a single decorated disc covering the other so that, as the label text tells us, "Like curtains at the theater [they] can all be opened so that the drama of the biblical King David's life unfolds act by act."

One of the most memorable objects is a rosary that once belonged to Henry VIII and Catherine of Aragon, each of its small beads carved with the image of an apostle, a figure from Hebrew scripture, a Christian narrative, and an excerpt from the Apostle's Creed. Talk about *multum in parvo*. Nor were the "beads" always round. Some here are carved in the shape of skulls with, inside one, carvings of the Entry into

Jerusalem and Christ Carrying the Cross. Reinforcing the contemporary worldview that, as the label so vividly puts it, "life is short, death inevitable and punishment for sin certain," there are even three miniature coffins, one containing a carved skeleton no more than two inches long.

Before most works of art one's normal experience is to enter into their imaginative life. With these, one finds oneself instead pondering a host of questions: Who were they made for? What purpose did they serve? How have such exquisitely delicate objects, in which Roman centurions wield spears one quarter the thickness of a matchstick, survived the ravages of time? Above all, how were they made? And what preternatural degree of eye–hand coordination would have been required to produce them, there being so little margin for error when working at these tolerances?

Some things we do know: These are works created for private devotion. They would be held in their owners' hands, their scenes contemplated, the religious inscriptions on their carved exteriors read or idly fingered. Some were taken everywhere, carried on the owner's belt in a protective case. And thanks to the research undertaken for this exhibition, we now know how they were made. Each hemisphere was not, as had long been thought, a single piece of wood painstakingly dug out by its maker. Instead it is a composite of multiple layers or slices of wood – anywhere from one to eight per bead – each carved individually, the whole bead then assembled and held together with wooden pegs inserted into drilled holes. The effect, in the curators' apt analogy, is like so many flats creating deep space in a proscenium stage.

One of the exhibits is a disassembled bead, its four-layer Crucifixion scene and two-piece hemispherical housing arrayed in one of the cases like the contents of some just-opened do-it-yourself kit. That should break the spell, like

the explanation of a magician's trick. Instead it enhances it, as we come to understand what was involved in making each work: bas-relief, carving in the round and joinery, all on a miniature scale.

But there's more: In some, microscopic details such as headdresses, finials, and candles were carved separately and inserted, like pegs, into holes. In one Last Judgment scene, a tiny figure is just visible inside the mouth of Hell that had been added separately. And then there is this description of a bead depicting Jesus clearing the Temple in Jerusalem of the money lenders and merchants:

> What makes this prayer bead special is the tiny bird cage held by the woman fleeing right in front of Jesus. Behind the curved cage bars are several tiny doves carved in the full round. When the prayer bead is moved in the hand of its user, the doves shake within their cage creating an astonishing kinetic effect. How did the maker of this prayer bead accomplish the feat of carving the doves behind bars? In an otherwise simple scene, this little detail was almost certainly included to inspire wonder in the original viewers.

Despite what we know and have recently learned, the questions keep coming. In particular, one would like to know more about how these objects fit into the medieval worldview. We know the purpose they served, but what did they represent to those who made and used them? For people in the Middle Ages, the world was saturated in symbolism. Every aspect of the physical world had some larger theological meaning. The choice of boxwood here may have been practical – its dense, fine-grained makeup made it ideal for this kind of intricate carving – but it was also symbolic. Being an evergreen, boxwood was considered emblematic of

eternal life; some medieval writers believed it was used for the Cross; it was thought to ward off the devil. Might there not be some similarly larger meaning to the objects themselves?

For example: the Bible contains instances of spiritual lessons being communicated through glaring disparities of scale – the parable of the mustard seed and the metaphor of a camel passing through the eye of a needle. These rosary beads do much the same thing. As the catalogue states, "Sight and touch join forces to facilitate meditation on the drama of the Christian story, to cradle a virtual walk on Jerusalem's Via Dolorosa in the palm of the hand." Might there be a connection between the two? Could the mysteries of the beads' creation – just how did that artisan carve those doves behind bars? – be an analog to the mysteries of the Christian faith?

While the beads are utilitarian, they are so only in the narrowest sense – to facilitate their owners' devotions. What they really are is acts of faith, their makers going beyond the impossible for the glory of God and in the confident expectation of finding a better world beyond our own. It is an outlook one can only admire. And envy.

Originally published as "Exhibition note:
'Small Wonders: Gothic Boxwood Miniatures'"
in The New Criterion, *April 2017.*

THE MOST DAZZLING SHOW on this year's winter calendar is taking place not in a major metropolitan museum or high-end commercial gallery, but at New York's Asia Society. That organization's exhibitions have often been must-see events, but with "Kamakura: Realism and Spirituality in the Sculpture of Japan" it has outdone itself. Richly plastic, charged with sacred presence, in places grippingly expressive, and marked throughout by technical innovation, this group of forty-odd works, almost all made of wood, is the ideal intro- duction to Asian sculpture for the uninitiated (of whom I count myself one). Naturalism, for centuries the lingua franca of Western art, here affords entrée, by way of the familiar, to an art form whose more common characteristics of psychologi- cal withdrawal and a high degree of stylization and abstrac- tion can often make it seem remote and inaccessible.

The Kamakura period (1185–1333) coincides with the first stirrings of the Renaissance in the West – Giotto died in 1337. Yet at least in the area of sculpture, it constitutes a kind of renaissance of its own. A civil war in the 1180s had destroyed the great Buddhist temples, along with libraries and arti- facts, precipitating an urgent need for rebuilding and popu- lating these structures with images of the deities and other figurative works. And, as such episodes of sweeping destruc- tion often do, it created a climate conducive to fresh thinking.

And so two innovations appeared. First, artists took an idea from an earlier era of Japanese sculpture, composing works from multiple wood blocks instead of, as had been done previously, a single one, permitting more animated,

expressive poses. This made possible a second: the eye sockets were hollowed out and crystal orbs painted to look like eyes were inserted from behind, thus greatly increasing the verisimilitude of figures conceived not as decorations but as objects of religious devotion. They were spiritual presences, embodiments of the divine, or as the catalogue puts it, "enlivened images." (To which end, sacred relics, texts, or miniature images would sometimes be deposited inside the sculptures.)

The first work we encounter in the show is the head of a Guardian King, a type of figure that would have stood near the altar (or outside the temple), and the power of its fiercely grimacing visage is greatly increased by its bright, gleaming eyes. Writing in the catalogue, Hank Glassman, a Haverford College professor, conveys a vivid sense of what it would have been like to experience these works in situ:

> [A] large wooden hall echoes with the rhythmic chanting of monks; the air fills with the heady fragrance of incense pressed from sandalwood, agarwood and camphor; and numerous oil lamps and candles flicker, set in their heavy iron bases. We can envision the *gyokugan* (inset crystal eyes) of the statues glittering in flashes of candlelight and the golden gleam of the ritual implements as the monks move them with practiced solemnity and grace.

At the same time, drawing on Song dynasty art in China, sculptors of the Kamakura period adopted a more realistic approach to the figure: lifelike facial expressions, more naturalistic proportions, and a sense of movement.

The apogee of this naturalistic impulse is to be found in *Standing Shotoku Taishi at Age Two* (*Namubutsu Taishi*), one

of the high points of the show. In this twenty-seven-inch-tall figure of the two-year-old prince Shotoku Taishi, shown naked to the waist and hands clasped in front of him, the sculptor has captured the smoothness of his bare scalp, the hardness of the cranium beneath, the soft pudginess of the flesh of face, arms, and, especially, his belly, and, in a shimmering grace note, the slight swish of the hem of his garment as if moving in response to a breath of wind or the slightest bodily motion.

To the list of defining characteristics of Kamakura sculpture, we must surely add the treatment of drapery. Here realism and stylization commingle. Folds set up a linear rhythm that is self-sufficiently decorative and at the same time convincingly evocative of the way material falls around a body in nature. At the same time, these artists use it to suggest something larger, more abstract. *Seated Monju Bosatsu* (early fourteenth century), a robed figure shown cross-legged and holding a sword upright in his extended right arm, is a symbol of wisdom. The fabric of his tunic is all rhythm. The sleeves lift and billow as if caught in a breeze, and the folds crisscross his legs in an endlessly looping linear rhythm. The overall effect of the sculpture is of continuous fluid motion in a way that calls to mind Leonardo's studies of water.

Perhaps one reason this treatment of drapery is so striking is its contrast with Western sculpture. In a work like the Louvre's *Winged Victory* (*ca.* 190 B.C.), for example, flowing drapery functions as a kind of objective correlative, a sign of physical or emotional perturbation. In *Seated Monju Bosatsu*, however, drapery that gives the impression of movement seems to exist apart from – even in opposition to – the mood of meditative tranquility conveyed by the seated figure, with its stillness, poise, and delicate gestures. The two – the energy of the one and the sobriety of the other – should clash, yet

they don't. Instead, the drapery reinforces rather than interferes with the figure's magnetic spiritual presence. This is a temporary show one wishes could be up forever.

Originally published as "Exhibition note: 'Kamakura: Realism & Spirituality in the Sculpture of Japan'" *in* The New Criterion, *May 2016.*

WANT TO BE DEPRESSED? Read up on Florence in the fifteenth century. It's not just the overabundance of outsized talent. At one time or another, centers like Amsterdam, Rome, Paris, and New York have boasted comparable rosters. It's the unmatched level of ambition, innovation, curiosity, self-discipline, and imagination its denizens brought to bear in remaking their world. Some of their endeavors – Brunelleschi lofting a dome over the cathedral without centering, for example – were the moonshots of their day, efforts that involved not just realizing a vision but inventing, every step of the way, the means of doing so. They revered their classical heritage, seeing the past as a bottomless wellspring of instruction. Early on, Brunelleschi and Donatello moved to Rome to study, respectively, ruins and statuary, then used that knowledge to revolutionize architecture and sculpture upon returning to Florence a couple of years later. But the past was also the standard against which such figures measured their achievements. In his *Lives*, the highest praise Giorgio Vasari can bestow is to say someone or something "surpassed the ancients." (Unless you were Michelangelo, in which case you had gone one better and "vanquished" them.) Finally, they refined and elevated narrative art, purging it of lingering Gothic conventions and stylizations to forge a naturalism of such emotional and psychological immediacy that we sometimes feel the artists are speaking as much about their own experiences as about the scriptures. How small our era feels by comparison.

This fall, the Frick Collection has offered a window into this remarkable world with its exhibition "Bertoldo di

Giovanni: The Renaissance of Sculpture in Medici Florence," a small gem of a show that resuscitates a pivotal yet all-but-unknown figure and at the same time offers an immersion in some of the less familiar byways of the sculpture of the time.

22

Until now Bertoldo (*ca.* 1440–91) has been one of the big question marks of art history. Reputationally, he has come down to us as an essential link in the great chain of Renaissance sculptors. He stands between Donatello in the fifteenth century, whose student and assistant he was, and Michelangelo in the sixteenth, to whom he gave early instruction in his capacity as live-in sculptor to Lorenzo de' Medici (the Magnificent) and curator of his garden of antiquities, where a number of young artists of talent were invited to school themselves in sculpture under Bertoldo's guidance.

Yet in many respects he has been the *missing* link. As artists tend to, Michelangelo portrayed himself as *sui generis*, a talent so supreme and original it owed no debts to others. As a result, early biographers such as Vasari and Ascanio Condivi either substantially downplayed Bertoldo's role in his formation, or wrote him out of the story altogether. An added problem was the lack of a reliable corpus of sculptures. Only four works could reliably be attributed to Bertoldo: two reliefs, a *Crucifixion* from the 1470s and *Battle* (*ca.* 1480–85); a mythological subject, *Bellerophon Taming Pegasus* (*ca.* 1480–82); and a medal commemorating Sultan Mehemed II (*ca.* 1480). It was not until the nineteenth century that he was rediscovered by scholars and a larger body of work identified, and not until the 1990s that the first monograph was published, by the former Metropolitan Museum curator James David Draper, to whom this exhibition is dedicated. Henry Clay Frick purchased the classically inspired Hercules-like *Shield Bearer* (*ca.* 1470–80), the only work of Bertoldo's outside Europe. The occasion for the show, which has been organized by the Frick curators Aimee Ng,

Alexander J. Noelle, and Xavier F. Salomon, as well as the
Frick conservator Julia Day, is the desire to learn more about
this work (it has never been previously exhibited) and,
thereby, Bertoldo himself.

This they have done with resounding success, securely
establishing and clarifying his role. "History comes alive" is
an overused phrase, but it applies here, owing to the pres-
ence of two remarkable works which make the case for Ber-
toldo as someone who, as Noelle writes in the catalogue,
"facilitated an almost hereditary transfer of creative genius
between the great sculptors of the Early and High Renais-
sance." At one end of the aesthetic spectrum is the life-sized,
polychromed, wood-and-gesso *St. Jerome* (*ca.* 1465–66).
This is jointly attributed to Donatello and Bertoldo, though
it is thought to have been a commission originally awarded
to the former but executed by the latter. It shows the emaci-
ated saint naked and mortifying himself with a stone, blood
dripping down his torso. His head, with its matted gray hair
and beard, turns upward and to his left as if he's in a state of
ecstasy, the result of meditating on a now-missing crucifix.
He seems slightly unsteady on his feet, as if made delirious
by his physical privations, religious visions, or both. This is
Bertoldo at his most Donatellesque. He and other Floren-
tine sculptors in the fifteenth century would sometimes
allow a fold of drapery or portion of a figure to protrude
beyond the confines of a sculpture's base or enclosing niche
to connect it more vividly with the viewer's world and expe-
rience. Donatello had one further method. As he did in his
wooden *Mary Magdalene* (1454), he would make some
works so physically stark and psychologically raw that the
viewer was instantly caught in their grip and had no choice
but to participate fully in their implied narrative. This is
what Bertoldo has done with *St. Jerome*. We are mesmerized
by this figure, at once appalled and curiously fascinated by

his physical state and marveling at how such a ruined specimen could wear such an expression of ecstasy and wonder.

At the other end of the spectrum is *Battle*. A relief roughly eighteen inches tall by three feet wide, it is aptly described in the catalogue as a scene "of organized chaos." Nude and semi-nude, with classical proportions and musculature, twenty-five warriors, some on horseback, battle each other without clear lines dividing friend and foe. What is striking here isn't so much the military drama as the figures. In the 1960s Richard Serra compiled his famous "Verb List" of all the actions he associated with art-making. One could create a similar inventory here of positions and postures of the figure in vigorous motion: to crouch, bend, twist, reach, stretch, fling, strike, recoil, lean, swing, lunge, and so on.

Battle is based on an ancient Roman sarcophagus in Pisa. But Bertoldo has gone beyond merely copying, animated, it would seem, by the desire to transcend the details of his subject and make the figure an independently expressive entity. In this sense, *Battle* is Bertoldo's most proto-Michelangelesque work, nothing less than an academy for the study of the human body in action. No surprise that it is credited with influencing one of Michelangelo's earliest efforts, a relief, *The Battle of the Centaurs* (1491–92). (Seeing Bertoldo's *Battle* makes it more impossible than ever to accept the simpering Peter Pan figure, from around the same time on loan to the Metropolitan Museum and now known as *Cupid*, as being by the hand of Michelangelo.) There's a straight and uninterrupted line from Bertoldo's *Battle* to the Sistine ceiling. But let us not sell Bertoldo short by subordinating him to Michelangelo. *Battle* is a masterwork in its own right, a riveting work of art that is hard to quit.

"Bertoldo" is a small show of only around twenty works, almost all his extant œuvre. It is also one likely to come as a surprise to those who think of the Renaissance solely in

terms of monumental art – large fresco cycles and super-sized statuary. *St. Jerome* (*ca.* 1465–66) is the only life-sized sculpture. In the main, Bertoldo was what you might call a cabinet artist, a maker of small-scale objects for individual delectation: commemorative medallions, small-scale reliefs for private devotions, and table-top sculptures. Anyone who thinks large is a prerequisite for monumental, however, need only look at *Bellerophon*, a marvel of competing energies as man and beast battle for supremacy. Such works also offer some of the most exquisite, refined pleasures to be found in the art of the Renaissance or almost any other period. Another equestrian sculpture, the highly articulated and richly embellished *Hercules on Horseback* (1470–75), shows the ancient hero seated atop a prancing horse as he turns to look behind him. It's a pity that visitors can only experience it visually, for, as the catalogue tells us, the tactile dimension was just as important in appreciating such works – they were meant to be picked up and handled. And what a frisson for the fingertips this one would have provided with its myriad surface textures: the smooth musculature of the horse; the knotty business end of Hercules' club; the furry mane of the lion skin that drapes him.

The Frick deserves a lot of credit for organizing this exhibition on such a worthy but undeniably niche subject, especially when, in terms of scholarly research, catalogue production, borrowing, and display arrangements, it was surely a huge investment for an institution of its size. Yet if there is a flaw to what is otherwise a judicious treasure of an exhibition, it is the sense we get that for all the considerable and necessary focus on contextualization – clarifying chronologies, attributions, personal and professional relationships – we are missing out on the details of Bertoldo's artistic evolution, particularly his relationship to Donatello. It's a trajectory that appears to have been both effortful and inspired.

As works such as *St. Jerome* and *Bellerophon* indicate, Bertoldo was an accomplished sculptor in three dimensions. He was equally good at medallions, such as the one he designed, shown here, to commemorate the Medici survival of the Pazzi Conspiracy, the 1478 effort to overthrow Lorenzo and drive the family from Florence. Yet possibly because of his success in this last area, it seems to have taken him a little longer to master the kind of narrative relief of which Donatello became the supreme exemplar in the Renaissance. When he did, however, the results were spectacular.

The difficulties Bertoldo encountered can be seen in the plaque *Virgin and Child with Angels* (*ca.* 1470). In his reliefs, Donatello used barrel vaults and other monumental architectural forms to create a fictive space within which his dramas played out. Bertoldo does the same thing here, the vault being visible at the top of the relief. But Mary and the attendant figures are way over-scaled in relation to the architecture and don't so much inhabit it as stand in front of it, filling the entire field in a way that suggests Bertoldo's source was medieval ivories (such as the "Archangel Michael" ivory in the British Museum) in which there is a similar compositional approach. (These had come to central Italy from France in the late Middle Ages, helping to spark the sculptural revolution of the Pisani, so they could have been known to the artist.) Bertoldo here seems to be caught between two aesthetic realms: on the one hand the medallion, where legibility demanded a clear-cut figure–ground relationship; and on the other the Donatellesque relief, which depended for its effects on dissolving the ground to achieve pictorial illusion.

But it didn't take him long to overcome this problem, because in the slightly later (and, at about two feet square, considerably larger) *Crucifixion* (1470s) we have one of the most remarkable and ambitious reliefs of the Renaissance. In the foreground, Mary and seven other grieving, gesticu-

lating figures form a frieze that runs across the bottom third of the composition. They look up at the dead Christ in the center, flanked by the two thieves set against a cloud-flecked sky that fills the remaining two-thirds of the scene. We see the thieves from the side, their crosses having been placed perpendicular to the picture plane. The overall effect is of an event taking place out-of-doors in an expansive, even atmospheric space. Bertoldo achieves this illusion by the contrast between the foreground frieze and the clouds in the rear, the turned crosses that lead our eye into the space opened up between these two markers, and the gesticulating impenitent thief at the right, who animates it.

There is nothing like this in Donatello, at least not in bronze, and no wonder. He had pioneered the atmospheric relief with his *St. George and the Dragon* (1416) on the exterior of Orsanmichele in Florence, but using marble, a material whose receptivity to light permits a sculptor to achieve a play of optical and luminescent effects. Bronze, which reflects light, often harshly, does not, which, one suspects, is why in his bronze reliefs Donatello attempted no such thing. Instead, the field is filled top-to-bottom, edge-to-edge with visual incident, and space is created with a multiplicity of orthogonals.

What Bertoldo has done in his *Crucifixion*, then, is bold indeed. And since there is no precedent for it in sculpture, one imagines he must have been inspired by the painters of his time, most likely Fra Angelico or Verrocchio, two pioneers of deep, atmospheric space. With works like this, Bertoldo emerges from this show not just as the missing link, but as a Renaissance sculptor of the first rank.

Originally published as "Florence's missing link'"
in The New Criterion, *December 2019.*

"THE 'YOUNG ARCHER,' Attributed to Michelangelo" at the Metropolitan Museum of Art is a single-work show of a sculpture that in 1997 was attributed by New York University scholar Kathleen Weil-Garris Brandt to the adolescent Michelangelo. (Born in 1475, he died in 1564.)

The *Young Archer* (*ca.* 1490) is a standing figure of a young boy in a spiral stance – legs twisting in one direction, and head and upper torso the opposite way. It's severely damaged, with both arms missing and legs extending only to just below the knee.

An artist in formation is like a compass in search of True North: the needle swings this way and that, impelled by an unremitting stream of influences, the struggle to master technique and the pressure of ambition. This makes work at this stage raw, eclectic, unformed. So just because this figure doesn't look like the canonical Michelangelo – the David, for example, or one of the figures on the Sistine Ceiling – doesn't mean it isn't by him.

On the other hand, an artist's earliest works sometimes show traces of a nascent personality, a dominant idea that will come to define their aesthetic. With Michelangelo this is the conception of the figure as a dynamic unity. From the very beginning, in contemporaneous reliefs made around the time he is supposed to have carved the *Archer* such as the *Madonna of the Steps* (*ca.* 1490) and *Battle of the Centaurs* (1492) in the Casa Buonarotti in Florence, Michelangelo's figures twist and squirm, each torqued limb or torso trigger-

ing a related movement elsewhere up or down the body and leading your eye seamlessly to it.

By contrast, whoever carved this figure appears to have conceived of his task as a series of discrete set-pieces – now the head, now the torso, now the buttocks, and so on. They are executed well enough, but our eye isn't led from one to the other, it has to get there by forced march across arid planes of lifeless stone. It's hard, here, to see the hand of a master-to-be.

Of course, I may be wrong. But if I am, the Met has been of very little help in telling me why. Accompanying the *Archer* are wall texts that don't so much explain the museum's reasoning as ask us to accept the attribution at face value with, for example, broad, unsubstantiated claims such as "a growing number [of scholars] have accepted it." Really? One would like to know who, because in 1997 Ms. Brandt's announcement was greeted with something close to stony silence from the profession – artworldspeak for "Thanks, but no thanks." It's been pretty much that way ever since.

Surely a public institution, particularly one that sees education as one of its primary missions, can do better than this. If the Met is going to put its considerable prestige and credibility behind a disputed discovery – not to mention to lure the public with the word "Michelangelo" – it needs to explain its reasons. In October 1997 Ms. Brandt published a scholarly essay in the distinguished professional journal *The Burlington Magazine* explaining her attribution. She was even gracious enough to acknowledge another scholar's dissenting view in one of her footnotes. At minimum the Met might have secured rights to republish her article for this exhibition. Better yet, why not take a cue from the article itself and publish a catalogue offering a mix of scholarly opinions, some pro and some con? With only these

one-sided wall texts as guidance, the public has been shortchanged.

Still, there's hope. The *Archer* is on view until 2019. It's not too late for someone to start writing.

Excerpted from "Are They or Aren't They?"
in The Wall Street Journal, *January 28, 2010.*

Gian Lorenzo Bernini:
Fingers moving at the speed of thought

FOR ADMIRERS OF Gian Lorenzo Bernini (1598–1680), or even of sculpture generally, the collection of fifteen of his terracotta sketches in the Fogg Art Museum has long been a pilgrimage point to glean a deeper insight into his genius, or simply a straightforward Bernini fix. If the essence of his marbles is their jaw-dropping illusionism – their ability to simulate wind-blown hair, soft flesh, even tears – what distinguishes these preparatory works is their immediacy. They convey the quick flash of an idea and even, in their rough tooling or the vestigial impress of a finger, the very presence of the artist. Now the Metropolitan and Kimbell museums have joined forces to present a larger and more representative group of these clay sketches and related drawings. It is a stunning show, and without exaggeration, for the way it enlarges and even transforms our understanding of Bernini, one of the most important accorded any artist in our time.

"Bernini: Sculpting in Clay" was organized by a team of four curators: Ian Wardropper, currently director of the Frick Collection and before that chairman of the European Sculpture and Decorative Arts department at the Met; Anthony Sigel, conservator of objects and sculpture at the Harvard Art Museums; C. D. Dickerson III, curator of European art at the Kimbell; and Paola D'Agostino, senior research associate at the Met. They have assembled thirty-nine *modelli* and *bozzetti* from public and private collections

around the world and installed them with wall photos of the completed projects in Rome for which they were conceived. Considering how delicate they are – some, such as a "St. Longinus" sketch from the Museo di Roma, are in such fragmentary condition they could be mistaken for semi-abstract works by contemporary ceramic artists like Stephen de Staebler or Mary Frank – it is a tribute to the industry and perseverance of the curators, not to mention the generosity of the lenders, that this exhibition came to fruition. It will probably never be done again. It is a once-in-a-lifetime event.

The earliest work in the show is *Charity with Four Children* (*ca.* 1627), an allegorical group planned for the tomb of Pope Urban VIII. The show concludes with studies of angels for Bernini's last commission, the 1672 Altar of the Blessed Sacrament in St. Peter's Basilica. In between, virtually all aspects of his output are represented, among them the Four Rivers and Moor fountains, the Cornaro Chapel, equestrian portraits of Constantine and Louis XIV, and the Cathedra Petri. It amounts to a kind of synoptic retrospective, and as such the byways can be as captivating as the main thoroughfare. One of the most irresistible objects in the entire show is the model for the Lion on the Four Rivers Fountain. The King of Beasts is but a bit player in the completed project; you see only his head reaching down to lap at the pooling water, and his hind parts. Yet Bernini treats the model as if it were the main event, giving us a finely detailed, richly textured representation that is as closely observed and as penetrating a characterization as any of his human portraits.

What did clay do for Bernini? One's first impression, walking through this show, is that it was a kind of playground. Marble's obduracy made form hard-won. By contrast, clay's malleability allowed it to spring from his hands almost at the speed of thought. Indeed, in the catalogue, Mr. Dickerson cites a contemporary who compared Bernini's fingers

working clay to those of a professional harpist making music. Then there is the range of handlings, which run the gamut from the sharply etched realism of the Four Rivers Lion to the Head of St. Jerome, an image so free and fluid it seems to be in a continual state of becoming. Clearly, Bernini reveled in clay as a material for its own sake.

On a more practical level, clay was an indispensable instrument of thought. Bernini was a superb draftsman, but clay let him do what pencil and chalk wouldn't: test out pictorial effects, particularly the way shadow could be used to "sculpt" the stones, imparting definition to forms that might otherwise not "read" in the white-on-white of marble.

Just how indispensable clay was can be seen in the section of the show devoted to the over-life-size statue of St. Longinus that Bernini carved for the crossing of St. Peter's in 1635. An early stab at the subject, the 1630 gilded terracotta-and-gesso study at the Fogg shows the saint's robes draped over one shoulder, bunched belt-like around his waist, then falling in near-vertical folds to the calf. It's a common compositional device, seen in many such saintly depictions. The fractured, "de Staebler" terracotta of four years later from the Museo di Roma shows a more vigorously movemented drapery, folds that are in many ways independent of the body they clothe rather than, as in the earlier work, expressing it. We are well on our way to the final version in stone where drapery takes on an independent plastic and psychological life of its own, and through it, in the words of the German art historian Hans Kauffmann, "[t]he sculptor transforms the figure into an event." Clay, then, let Bernini work his way from convention through to innovation and so realize his full artistic potential.

It did this in another way. In his ambitious and illuminating catalogue essay, Mr. Dickerson argues persuasively for something more radical, namely that Bernini incorporated

some of the "aesthetic virtues" of modeling into his marbles. Specifically, says Mr. Dickerson, working with clay made him more sculpturally adventurous than he would have been otherwise, inclined to "experiment with ways to make his marbles look strong and light, as if they had the same tensile strength as clay, wax, and even bronze." Just what could be done with clay is evident in the 1635 terracotta figure of *Daniel in the Lion's Den*. The half-kneeling, leaning, twisting figure seems precariously balanced, and his arms cantilever forward in prayer – something you could never do in marble lest they snap off. Mr. Dickerson points to the wider stance of Pluto in the marble *Pluto and Proserpina* (1621–22) as an example of the greater sculptural and structural boldness Bernini acquired as a modeler. There's also the more open arrangement of the figures. In the earlier *Aeneas and Anchises* (1618), the figures are stacked, with the younger man carrying the older one on his shoulder, the two making a vertical stone silhouette. Not so in *Pluto and Proserpina*, where the figures connect like two colliding arcs. It was clay that inspired such boldness.

As often happens when you get a large number of works by an artist in one place, themes emerge that might not when seeing them individually. Here, one is struck by how much of Bernini's art was a response of one kind or another to Michelangelo. Earlier artists had fed off, even worshipped him; Bernini did not. As a young man, Bernini had studied him. But then, as his 1623–24 *David* shows, he simply bypassed him. Against Michelangelo's poised, aloof *David*, sizing up his opponent just ahead of the action, the fully muscled figure announcing that here is a force to be reckoned with, Bernini gives us force itself, body and mind tensed and coiled. Action, not anatomy, is the driving interest here. As late as 1665, a sexagenarian writhing amid the intrigues of Louis XIV's court, Bernini still had Michelan-

34

gelo on his mind. In his chronicle of the *cavaliere*'s ill-fated visit to France, where he'd been invited to redesign and complete the Louvre and sculpt the king's portrait, the British art historian Cecil Gould recounts that Bernini told a group that "Michelangelo was greater as an architect than as sculptor or painter, that his figures never seemed of flesh and blood and were only remarkable anatomically."

In the show, this impression of a career conceived in opposition to Michelangelo begins with the very first object, the marble *Bacchanal: A Faun Teased by Children* (1616–17), a work made with his father, Pietro. Like Michelangelo's *David*, it is carved from an unusually, even awkwardly shallow block – the roughly four-foot-by-three-foot sculpture is barely eighteen inches deep. Could the pair have deliberately set out to take on Michelangelo on his own turf?

At the very least, they certainly offer a master class in bravura carving and sculptural engineering. The figure of the faun stands astride a central tree, left hand gripping one projecting stump, left leg braced against another. His head is pushed back by two infants above him, perched amid a large growth of ripe fruit still higher up the tree. On the ground a dog raises its head to feed off some dangling grapes, while another infant tumbles over him. Disposing the elements this way required Bernini *père et fils* to open up the block to the point where, in purely formal terms, it offers an interplay of solids and voids more common to twentieth-century rather than seventeenth-century sculpture. Yet it is all deftly braced and balanced, with elements such as legs and arms doubling as buttresses to support the structure, and with a sufficient weight of stone left at the bottom to keep the piece from toppling over. The work's hefty upper elements – Faun's head, children, and vegetation – anticipate Bernini's later insouciant lofting of great masses of marble in *Aeneas and Anchises* (1618–19), *Pluto and Proserpina* (1621–22), and

Apollo and Daphne (1622–25) – an approach to sculpture that couldn't be more different from Michelangelo's, whose figures are securely grounded, contained within a clearly circumscribed silhouette, and never toy with the laws of physics.

36

But Bernini's swaggering repudiation of all things Michelangelesque is most evident here in the model for the Fountain of the Moor. As with Michelangelo, we have a well-muscled, upright male nude. But all similarities end there. Bernini's Moor strides forward with his left leg, at the same time twisting his torso in the opposite direction and turning his tilting head in a direction counter to that. Everything in the figure that can bend, swivel, tilt, tense, or flex is made to do so, and musculature is used as a means to an end – dynamic motion – not an end in itself. And in what strikes one as an anything-you-can-do gesture, the Moor's back is more heavily muscled and his *contrapposto* pose more extreme than any of the Ignudi on the Sistine Ceiling. Bernini never surpassed Michelangelo – nobody could. But he fought him to a draw of sorts. Alone among artists, Bernini made Michelangelo seem tame, even conventional.

One way of looking at "Bernini: Sculpting in Clay" is as a standard "background" or "preparatory" show, where we get to see, in an assemblage of small, often summarily executed works, the preliminary stages of finished masterpieces. It is certainly that, but much, much more besides. It reveals another dimension of Bernini entirely – the sculptural metaphor is inescapable. It forces us to reconsider the long-held view of clay and marble as two mutually exclusive materials: the one accretive, the other reductive; the one yielding sculptural form through manipulation and modeling, the other by hacking at it with a hammer and chisel. Here the two materials are shown to be co-equal, interdependent, and mutually reinforcing. You leave this exhibition

understanding that Bernini would not have been Bernini without clay. If you only know the sculptor from his marbles, you don't know him at all.

37

Originally published as "Bernini's feats of clay"
in The New Criterion, *December 2012.*

AT THE BEGINNING of the twentieth century, younger sculptors such as Brancusi complained that Rodin loomed so large that they couldn't move forward. "Nothing can grow in the shadow of the great trees," he said upon quitting the master's atelier. Sometimes it seems that Rodin blocks our view of the past, too, keeping sculptors who preceded him just out of reach. No one has suffered more from this neglect than Jean-Antoine Houdon (1741–1828), the greatest sculptor between Bernini and Rodin, the latter having admired Houdon enormously. There has been no monograph for nearly thirty years about Houdon's work and no retrospective in even longer.

This neglect is all the more strange since Houdon is a fixture of our national consciousness, thanks to his canonical likenesses of the country's founders and early patriots – figures such as Washington, Jefferson, Franklin, and John Paul Jones. Indeed, we are daily in more intimate contact with him than with any other artist, for Houdon's likeness of Jefferson adorns the nickel coin.

Happily, this wrong has been righted with "Jean-Antoine Houdon: Sculptor of the Enlightenment," the splendid show that Anne Poulet (the newly appointed director of the Frick Collection) has organized. It opened at the National Gallery this past spring and is now at the Getty through January. Besides including the Americans and his signature portraits of Voltaire, the show runs the gamut of Houdon's career, beginning with student works such as the *Ecorché* (1767), or flayed male nude, through mature works such

as his portraits of Diderot, Gluck, and members of the *ancien régime*'s aristocracy as well as allegorical subjects such as *La Frileuse* (1787), and ending with his post-Revolutionary portraits of Napoleon and Josephine that show him subtly accommodating his prodigious talent to the stifling dictates of Neoclassicism.

Surprising as it may seem, Houdon's stature is not, even now, a matter of settled opinion. Although he did concede that Houdon possessed an "astonishing" ability to capture his sitters, the British art historian Michael Levey, writing on eighteenth-century France in the prestigious (and influential) Pelican History of Art series, opined that history had singled out Houdon "not without some concomitant unfairness to great sculptors [of the time] and with some slight overestimation of Houdon's own abilities." The sculptor, he said, possessed a "highly competent yet essentially uninventive talent."

It is true that Houdon wasn't *sui generis*, much as the unique force and realism of his work may make him seem that way today. In fact, Houdon was part of a tradition, his work the climax of a century of sculpted portraits in France. Like his predecessors, Houdon took as his point of departure Bernini's "speaking likeness" – portraits that attain such a pitch of realism as to suggest a Pygmalion-like transformation from artistic representation to living, breathing human being. Like them, he was a vivid depicter of physiognomy, character, and the inner life of his sitters. And, along with some of his predecessors and contemporaries, he sculpted creative artists and men of letters, not just the aristocracy.

But Houdon's distinctive achievement was to distill and extend the legacy of Bernini's speaking likeness, elevating it to such a level of verisimilitude as to shock his contemporaries – some of whom thought Houdon had crossed the line of propriety – and introducing an unprecedented depth in his readings of man's inner life. The eighteenth century

was not short of great portrait sculptors: Antione Coysevox, Guillaume Coustou, Jean-Baptiste Lemoyne, Jean-Baptiste Pigalle, and Jean-Jacques Caffieri among them. But they are all Algardis to Houdon's Bernini.

40

In pursuit of his aesthetic vision, Houdon stripped the sculpted portrait of its accumulated rhetoric and anything else that obtruded on his primary goal: the revelation of the sitter's character. In earlier portraits of the era, clothing, wigs and other personal adornments often indicated social status at the expense of personality. By contrast, Houdon shows many of his sitters from the neck up and unadorned. When he does show them dressed, Houdon is careful to "weight" his depictions. In his 1792 portrait of Antoine Louis (co-inventor of the guillotine), the clothing and hair are somewhat generalized in treatment but the face is rendered in full detail, so that while we have some idea of where he stands in society, we are in no doubt about who he is as a man. Similarly, where Houdon's predecessors were partial to bravura effects – high wire acts of carving hair, lace filigree, and the like – Houdon only rarely (as in the finely pleated linen cravat on his 1804 bust of the inventor Robert Fulton) indulged in such tours de force of carving for their own sake.

But Houdon's transformation of the eighteenth-century portrait went beyond externals. Bernini and his followers in France had captured the individual at a peak moment, as if in response to a call or some other outside stimulus. Houdon transformed the sculpted portrait by portraying his sitters as if animated by some inner impulse and, more, as if captured in the instant of transition between one psychological state and another. His *Diderot* (1771) appears caught halfway between reaction and action, thought and speech. The face of *Armand-Thomas Hue, Marquis de Miromesnil* (1777) registers emotions ranging from curiosity to empathy to hauteur, depending on what angle you view it from. In Houdon's

work, the outside is a function of the inside – what happens on the sitter's face is determined by what's going on inside his or her mind at that moment. This emphasis on the individual, moreover one animated by an inner psychological impulse, is what speaks to us most forcefully today. His art is a watershed in the history of art. In the portraits by his predecessors and contemporaries, we see figures from the past. In Houdon's work, for the first time, we begin to see ourselves.

Houdon's portrait of Diderot was shown at the Salon of 1771, his first work publicly exhibited after returning to Paris in 1768 after four years studying at the Académie de France in Rome. It created a sensation, recognized at once as representing a revolutionary approach to portraiture. In other words, Houdon's apprenticeship was astonishingly short; he went from student to fully formed artist in about seven years. How? The four years in Rome had formed the building blocks of his art. While there, he studied the antique and Bernini's portraits. From the latter and Roman Republican portraiture he would have learned that the area on the body between crown and thorax could be as capable of expression as a fully articulated sculpted human figure that the ancients had left behind. He also dissected corpses, thereby discovering and then, in the *Ecorché*, showing that he had mastered, the musculature of the head, the subcutaneous array of ropes and pulleys that articulates a person's face, giving it character and expression. For most artists, the *Ecorché* was an academic set piece, merely a footnote to their career. Not Houdon. Seeing this one in the show makes one feel in the presence of the touchstone of his art.

Out of these experiences came a new conception of the portrait. Beginning with Diderot, Houdon's portraits depart from precedent in that every square millimeter of the head and face is marshaled in the revelation of character. Earlier

portraitists had relied on the eyes – "the windows of the soul" – to be the carriers of insight and expression. But Houdon gives equal attention to the lower half of the face, the soft, fleshy area surrounding the mouth, the cheeks, the jowls, and the neck. Cover the eyes of any of Houdon's portraits, and you will still come away with a clear picture of the sitter's personality: Franklin pinched and persnickety; Voltaire emphatic but circumspect; the Revolutionary minister of war Charles-François du Périer remorseless. No one else in art had done anything like this.

In Houdon's Roman years we get our first glimpse of one of Houdon's most singular traits and what was to be one of the most powerful weapons in his creative arsenal: what you might call his prehensile eye. In the catalogue entry to the 1767 *St. John the Baptist*, an early commission, Houdon is quoted in a letter explaining that he had spotted the ideal model outside St. Peter's but had been rebuffed when he had asked him to pose. So instead, "I studied him carefully and stored it in my head as well as I possibly could." This was to be his lifelong practice. Houdon never made sketches or preparatory drawings of his sitters. Instead, through vision alone, he captured the varied, evanescent expressions of his sitters and held them in his mind throughout the long process of transferring them to sculpture. Houdon's art embraces two extremes, the mechanical and the intuitive. To attain absolute fidelity to external appearance, he took measurements and casts of his sitters' heads and faces. But life casting is by nature a static enterprise, good only for recording the face in repose. It could only take him so far in his quest to replicate the truth of his sitters. And Houdon's aim was to capture their inner truth, one revealed incrementally and on the fly by a face animated by consciousness and in near-continuous motion. For that, Houdon had only his eye, his hand, and his memory to guide him.

It's often said that there's no such thing as a perfect exhibition, uncertainties of securing loans being what they are. But it must be said that if there is one, this is it. Ms. Poulet has obtained just about every significant Houdon sculpture extant, winnowing the selection carefully to secure the version closest to the artist's hand and eliminating lesser ones, pirated casts, and outright fakes. The catalogue is a feat of comprehensive and scrupulous research as well as an enthralling exercise in connoisseurship. Taken together, they give us the definitive portrait of Houdon – a speaking likeness, as it were.

Originally published as "Exhibition note:
'Jean-Antoine Houdon: Sculptor of the Enlightenment'"
in The New Criterion, *December 2003.*

Franz Xaver Messerschmidt: About face

ONE OF THE STRANGEST yet most compelling figures in the history of art begins a star turn in Manhattan Thursday as the Neue Galerie opens "Franz Xaver Messerschmidt 1736–1783: From Neoclassicism to Expressionism."

Messerschmidt is best known for the roughly fifty "character heads" he sculpted at the end of his life, busts of men (in some cases himself) whose faces are squeezed into an extreme grimace in response to a psychological or physical state (grief, nausea). These works represent a sustained level of emotional intensity rare in art and unheard of in portraiture. Seeing nineteen together as we do in the Neue Galerie is as psychologically challenging as it is aesthetically pleasing.

Messerschmidt was born in 1736 in Weisensteig, southeast of Stuttgart, and moved to Munich with his family at age ten after the death of his father. There he was apprenticed to his uncle, the court sculptor Johann Baptist Straub. In 1755 he enrolled in Vienna's Academy of Fine Arts, establishing himself after graduation as a successful court portraitist. In 1765 he briefly visited Rome, returning to Vienna at the behest of the Empress Maria Therese to sculpt a commemorative portrait of the late Emperor Francis I.

The next five years saw Messerschmidt reach the top of his profession as a portraitist in Vienna, and his art change direction. It moved away from the late Baroque manner – heroically posed half-length figures swathed in abundant drapery, ribbons, and baubles – to the formal clarity and emotional restraint of the nascent Neoclassical style. Mimicking the ancient Romans, Messerschmidt's portraits depicted

their subjects staring impassively ahead, head-and-shoulders only, without clothing or other adornments.

A small group of these at the beginning of the exhibition shows Messerschmidt's skill and provides us with a bench-mark for what comes later. His marble likeness of the court physician Gerard van Swieten mixes gravitas with closely observed naturalism. The face conveys the sitter's maturity and professional stature, while the artist's mastery of tech-nique is evident in his deft differentiation of forms and textures – for example the soft, jowly flesh of the mouth and cheeks as against the tightly curled yet flowing locks of hair.

Then, in 1771, came catastrophe. Suddenly unable to secure commissions, deprived of a teaching post, and forced to sell his possessions, Messerschmidt left Vienna. His sudden fall is thought to have been the result of a mental breakdown. He suffered paranoid delusions, believing he was besieged by evil spirits. After six peripatetic years he settled in Bratislava, there to see out the remainder of his days in near isolation. Reclusive, but hardly idle. He spent the last thirteen years of his life working on his "character heads" (he had made his first one in 1770).

The word "character" suggests portraiture, but these aren't portraits in the conventional sense. Nor are they cari-catures. Rather, they depict extreme states of being at their moment of maximum intensity. As much as anything else, the artist's animating impulse is a clinician's interest in the topography of a face at a particular instant and under a spe-cific set of conditions.

Whatever Messerschmidt's mental state, it had no impact on his descriptive powers. The same visual acuity and craft skill is on display here as in the bust of van Swieten. In each bust every muscle, fold of skin, and bulging ligament is cap-tured and orchestrated into a whole that can only be described as explosive.

Messerschmidt lived long before modernism's interest in probing man's inner impulses. So it's inappropriate to see them as expressionist works in the sense we understand the term today. They are at root, masks – everything is on the surface. Nonetheless, they speak in powerfully contemporary terms, and their existence suggests Messerschmidt found something wanting in the accepted portrait conventions of the day and turned to his character heads as a way of exploring the farther shores of human personality.

Messerschmidt is thought to have created his character heads to ward off the evil spirits he thought were after him. Seeing them in a group, as one does in this show, makes you think he may have been onto something. Certainly they leave the ordinary mortal taken aback. To be in the presence of a crowd of sneering, scowling, and laughing faces is to become suddenly aware that the normal relationship between art work and viewer has been overturned. You feel that you, rather than the objects on display, are the subject, the focus of attention. It's a sensation reminiscent of the work of the late Spanish contemporary artist Juan Muñoz, and that of the myriad installation artists since the 1960s, whose work has been about inducing a feeling of acute self-consciousness in the viewer. Something of an outsider in his own time, Franz Xaver Messerschmidt fits comfortably into ours.

Originally published as "Before Expressionism, Great Expressions" in The Wall Street Journal, *September 16, 2010.*

Jean-Baptiste Carpeaux:
Pressuring the old order

ANYONE STUDYING art history in the 1960s and 1970s had it made clear to them in books, in articles, and in the classroom that the three hundred years between the death of Michelangelo and the emergence of Rodin constituted a dark age as far as sculpture was concerned. If you were lucky, you would find a writer or professor willing to concede that that Bernini fellow might be worth a brief glance or two, but this was by no means assured. And the closer you got to the advent of modernism the darker the age became, so that the French sculptors of the nineteenth century were portrayed as green-eyed goblins worthy of some Gothic Last Judgment painting.

Fortunately, tastes have changed in the intervening decades, opening our eyes to hitherto maligned or undervalued talents and allowing us to perceive the essential continuity of the French sculptural tradition from the seventeenth century to the twentieth, Rodin's radical innovations notwithstanding. The latest artist to get his due is Jean-Baptiste Carpeaux (1827–75), currently the subject of "The Passions of Jean-Baptiste Carpeaux," a magnificent retrospective at the Metropolitan Museum of Art, the first there in nearly forty years. The show, jointly curated by the Met's James David Draper and Edouard Papet of the Musée d'Orsay (where the show travels after closing at the Met), consists of some one hundred and sixty works – finished and preparatory sculptures, as well as drawings and paintings. A group

of five self-portraits, the last dating from shortly before his death from cancer at the age of forty-eight, forms a poignant coda to the exhibition.

It's commonplace to declare that exhibitions of this kind constitute "a revelation," but in this case the word aptly applies, both as a descriptive term and accolade. To the extent that Carpeaux is known at all, it is primarily, to Met audiences, for the life-size marble *Ugolino and His Sons*, long part of its permanent collection, and, to the wider world, for *The Dance* (1869), the bacchanalian group on the exterior of Charles Garnier's Paris Opera building. But this show reveals that there was far more to Carpeaux than that, so much so that it seems almost unfair to group his many facets together under one roof. One comes away feeling the only way to do justice to the man would be in three separate exhibitions: one devoted to his public commissions, one to his portraits, and one to his terracotta sketches.

Carpeaux was not an artistic innovator, but the virtue of such figures is that they can reveal more about the swirling aesthetic currents in a period of transition than those lightning-in-a-bottle revolutionaries who, almost by definition, stand apart from their time. Such was the case with Carpeaux, whose work reflects both a waning Romanticism and nascent Naturalism. Though he had strong allegiances to the past – in many ways he was the heir of Jean-Antoine Houdon in portraiture – he was enough of an independent spirit to serve as a precursor of Rodin, both in his free approach to sources and influences and in the way he reconceived the public monument. Three decades before the public outcry precipitated by Rodin's *Monument to Balzac*, Carpeaux found himself embroiled in similar scandal over *The Dance*, which was deemed obscene and splashed with ink by an angry protestor two weeks later after its unveiling

Carpeaux's independence manifested itself almost from

the beginning. *Ugolino and His Sons*, a project he began in 1857 and that took him six years to bring to fruition, was created to fulfill one of his requirements as a Prix de Rome student. Carpeaux took a subject from Dante: the tyrant of Pisa, Count Ugolino della Gherardesca, who was deposed by Archbishop Ubaldino, walled up in a dungeon with his two sons and grandsons, and, after their deaths, eventually driven to cannibalism. In choosing Dante, Carpeaux departed from the practice of picking a subject from classical antiquity or the Bible; in executing the group he rejected a strictly classi-cizing approach, his sources instead ranging across the spec-trum from past to present, from the Belvedere Torso and the Laocoön, to Michelangelo and Bernini, to Théodore Géri-cault's *The Raft of the Medusa*.

In what amounts to a show-within-a-show, the Met's sculp-ture is installed at the center of a gallery surrounded by pre-paratory drawings and terracotta sketches that allow us to trace the evolution of Carpeaux's thinking, from the project's first adumbration as a relief through the final, densely com-posed, five-figure grouping. Remarkable in the final sculpture is both Carpeaux's seamless blending of these varied influ-ences, and his creative orchestration of the emotional con-tent of the sculpture. Our eye is led upward from the dead son languishing by Ugolino's feet to the elder son grasping his father's legs and looking in desperation into his face, to Ugolino himself. But here Carpeaux upends our expectation of a Laocoön-like climax. Instead of wide-eyed, open-mouthed despair, Ugolino's expression is that of a man so inwardly absorbed by the realization of what has become of him and those he loves as to be all but oblivious to his surroundings, his anguished interior state contrasting powerfully with the overt emotionalism of the figures around him. Carpeaux even adds a grace note – if you can call it that – and has Ugolino's toes intertwining with each other. It's a gesture that vividly

conveys the all-consuming nature of his torment, yet one which, as far as I know, is impossible in nature.

In the matter of Carpeaux's portraits, which occupy the next two galleries in the show, one wants to say, "Who knew?" – not just that he did so many so well, but that this master of public oratory in sculpture could come to grips with his fellow man in such intimate, revealing ways. Carpeaux's portraits possess the psychological immediacy of Houdon's combined with a depth of insight worthy of Sigmund Freud. He sculpted both the aristocracy and the bourgeoisie, and in his handling of the former we can see the old aesthetic order under pressure from the new. In French portrait busts from the seventeenth century onward, artists had to balance their depiction of their subjects' coiffure, dress, and personal adornments – with all the opportunities these offered for sculptural tours de force – with the work's portrait function, the sense of the individual we get from the treatment of the head and face. With some artists the personality leaps out at you while with others it is all but upstaged by the sculptor's fascination with ribbons, bows, brooches, and brocades. But one way or another, the artists invariably fused these competing elements into a convincing overall unity.

Not so in Carpeaux's *Marquise de La Valette* (1861), which reveals a kind of disjunction: On the one hand we have the lavish, even buoyant rendering of duchess's finery – her elaborate hairdo with its flowers and ribbons, her six strands of pearls, and the lace and other richly textured stuffs of her dress, all possessed of a kind of late-Rococo exuberance and insouciance. On the other we have the marquise's countenance, on which is written, with an unsparing naturalism, not only the toll taken by her advancing years but an expression of melancholy inwardness. Each aspect seems to belong to a different artistic universe. Carpeaux fared better with the members of the bourgeoisie, delicately and humanely getting

across both individual identity and social station, as he does unforgettably in the twin busts of the shop owners-turned-philanthropists Pierre-Alfred and Madame Chardon-Lagache.

Portraits also serve as our point of entry into the section on another of Carpeaux's masterpieces, the *Fountain of the Observatory* (1868–72). Located in Paris's Luxembourg Gardens, it consists of four figures symbolizing Europe, Asia, Africa, and America holding aloft a celestial sphere. They stand on a pedestal in the center of a wide, low basin surrounded by rearing horses and spouting turtles. Like that of *The Dance*, the full-scale plaster model – which is now in the Musée d'Orsay – could not travel, so in the main this portion of the exhibition consists of small-scale sketches in plaster and terracotta. But it also features portrait busts related to the fountain project, the plaster *Chinese Man* (1872), and the marble *Woman of African Descent* (1868). They give us direct access to one of Carpeaux's central achievements in the fountain: his honest and humane treatment of these "exotic" subjects, something more difficult to see in the finished monument owing to its size and the circumstances of its placement. They are naturalistic renderings true to their subjects' nature yet devoid of any trace of "Orientalist" stereotyping or caricature. The face of the *Chinese Man* is softly and sensitively modeled, and he is shown staring intently off to one side as if he is sizing up something that has just caught his attention. Similarly *Woman of African Descent*, bound with ropes and with the inscription "Pourquoi Naître Esclave" ("Why be born a slave") on the socle, turns to look up and back, as if to confront her captor from a kneeling position, the rugged beauty of her wide, open face reflecting a mix of pain, determination, and fearless defiance.

One wonders if this figure's full-scale counterpart on the fountain, Africa, influenced Augustus Saint-Gaudens when he came to depict the black members of the 54th Massachu-

setts regiment in his Robert Gould Shaw Memorial in Boston starting in the 1880s. The Shaw Memorial was one of the first works of American art to break with the Sambo stereotype, instead depicting blacks as flesh-and-blood human beings. Yet there were no precedents in American art for this sort of treatment other than John Singleton Copley's *Watson and the Shark* (1778), which entered the collection of the Museum of Fine Arts in Boston in the late 1880s. Carpeaux's fountain hadn't been completed when Saint-Gaudens was studying in Paris just prior to the outbreak of the Franco-Prussian War. But it was in place when he returned for six months in June 1877, and both his living quarters and, to a lesser extent, his studio were a stone's throw from the fountain. His biographer Burke Wilkinson writes that "Each morning Saint-Gaudens walked the pleasant mile from 3 Rue Herschel to his studio at 49 Rue Notre Dame des Champs.... At the place where the Avenue joins the Boulevard Saint-Michel, he would often pause to admire the Observatory Fountain.... He particularly liked the four sinuous nudes by Jean-Baptiste Carpeaux that form the centerpiece and crown of the fountain." It's hard to imagine Carpeaux was not on his mind a decade later as he undertook the Shaw.

Two constants run through Carpeaux's varied output. The first is that in all his sketches, be they in two dimensions or three, he has an unerring eye for the way bodily pose can by itself embody narrative and express intense emotion. No doubt this is the fruit of his close study of Michelangelo in Rome, Florence, and the Louvre. The animal desperation of the protagonist in *Ugolino Devouring the Skull of the Archbishop* (*ca.* 1861), the contorted central figure in *Scene of Childbirth* (*ca.* 1870), the limp body of the dead Christ in *Pietà* (1864), and the thrown-back head in *Despair* (1869–74): you don't need a label to understand what is going on in these works; the images themselves say it all.

The second constant is Carpeaux's perfect emotional pitch. *Ugolino* could easily have deteriorated into empty melodrama or exploded into bombast. Similarly, starting with *Fisherboy with a Seashell* (1861–62) and *Girl with a Seashell* (1867), there were innumerable opportunities for him to serve up saccharine images in the manner of William-Adolphe Bouguereau and other *pompier* artists. Yet he never does. Nowhere is this perfect pitch more in evidence than in *The Imperial Prince with the Dog Nero* (1865–66). The ten-year-old boy stands with his left hand resting on the neck of their hunting dog, which wraps its body against his legs and raises its head to look up at him. It is a touching portrait of mutual affection – devotion, even – that could easily have turned into one of those mawkish Victorian exercises in sentimentality being turned out by Sir Edwin Landseer and other British artists of the time. But all that is held in check by the boy's distant gaze, his slight air of adolescent self-consciousness mixed with the hieratic detachment appropriate to a member of the imperial household. Carpeaux has caught it all.

Originally published as "Carpeaux, public and private"
online at newcriterion.com, April 22, 2014.

THE IDEA WAS too tempting to resist: see as many of the displays commemorating the one hundredth anniversary of Auguste Rodin's death (born in 1840, he died in 1917) as possible, in an effort to take, once and for all, the measure of this artist and to come to terms with the paradox of his legacy. Though widely recognized as "the father of modern sculpture," Rodin was repudiated by those who came after, most famously by Constantin Brancusi.

No single exhibition has ever seemed equal to the task of capturing the essence of this artist. Perhaps, I thought, an approach as various and discontinuous as Rodin's art itself, one that took in multiple exhibitions, would do the trick. The checklists would overlap, but the individual emphases would vary, producing a kaleidoscopic image of the artist through whose multiple facets and fragments might emerge a clearer picture than that provided by a unitary, more tightly circumscribed effort.

But which exhibitions? There are eight in the United States, one in France, and one in Mexico, as well as six permanent collection installations in America. I eliminated any that didn't focus exclusively on Rodin, and those featuring large numbers of the posthumous bronze casts that have so distorted our perception of the artist. That left four shows: Paris, New York, Philadelphia, and Cleveland. The reaction against Rodin has left the impression that his impact was fleeting. Yet these shows proved the opposite. He is the indispensable man, without whom twentieth century sculpture would not have played out as it did.

In Philadelphia, the Rodin Museum's *The Kiss* makes its 1929 copy of that famous (or infamous) work the centerpiece of an installation of nearly twenty works in bronze and plaster centered on "the theme of the passionate embrace," as the press release informs us. It is a curious show. Though most of the works, such as *Eternal Springtime* (1884), are in line with the erotic subtext of the exhibition, the more maternal, nurturing depictions seem out of place. Yet the emphasis placed on *The Kiss*, along with the stone sculptures elsewhere in the museum such as *Danaid* (*The Source*) (1885–1902) invite us to consider the problem of Rodin's marble sculptures as a whole.

The marbles have long been the fault line in Rodin criticism. In 1972 the art historian Leo Steinberg republished, in his anthology, *Other Criteria*, a 1963 catalogue essay to a Rodin show in a New York gallery that wrote the marbles out of the canon as "dulcified replicas made by hired hands." The real Rodin lay in "the plasters, the work in terra-cotta and wax, and the finest bronze casts. Rodin himself rarely drives his own chisel; he kneads and palps clay, and where a surface has not been roughed and shocked by his own fingering nerves, it tends to remain blind, blunted, or overblown by enlargement; rhetoric given off by false substance." Two years later the British-born modernist sculptor William Tucker dismissed the marbles as "vulgar, facile, unthought-out and pander[ing] to just that Salon taste which he had explicitly challenged in *The Age of Bronze*."

The opposite case was advanced by John L. Tancock in his 1976 catalogue of the Rodin Museum in Philadelphia. He wrote sympathetically and insightfully about the marbles, as did Daniel Rosenfeld five years later in the catalogue to the National Gallery's retrospective, "Rodin Rediscovered." Both men set the artist's stone sculpture within the context of late-nineteenth-century taste and artistic practice, and Rodin's overall œuvre.

So: you could admire Rodin as a modernist or a tradition-alist, but not both. Yet you cannot pick and choose with art-ists; you must take them whole and make what you can of them. Can we, in this centenary year, reconcile the nineteenth-century artist Rodin was with the twentieth-century artist we want him to be?

56

Let's start by recognizing that while it's true that Rodin used an army of *practiciens*, it's also true that this was stan-dard practice at the time and had been so for centuries. Stein-berg's essay first appeared at a rare point in history when this was not the case, the artist's individual touch then being an article of modernist faith. A few years later the pendulum swung back, when Donald Judd and the Minimalists turned to "hired hands." Jeff Koons, Damien Hirst, and others con-tinue this practice today. Are those same critics going to damn Rodin for what they excuse in Jeff Koons? And how can we reject the marbles because Rodin never touched them when the posthumous bronzes – some of which were produced as recently as the 1980s – are accepted despite that fact?

Besides, Rodin *was* involved with his marbles. Some he carved entirely himself. He closely supervised the *practiciens'* work on the rest and finished each of them. Moreover, the iconic status and pedestrian nature of *The Kiss* have blinded us to Rodin's ambitions for his marble sculpture – one as large as that for his work in other media. Rodin adopted Michelangelo's practice of *non-finito*, leaving roughened passages of stone to suggest forms emerging from the block, in part to break with the academic conventions of unifor-mity of surface and handling, but also to convey a feeling for sculptural process. He used the same technique, along with generalizing the details of his finished forms in an effort to make them more evanescent, as if fused with the surround-ing light and atmosphere.

We see this in *Orpheus and Eurydice* (1893) in the "Rodin

at the Met." Two figures are set within and against a con-
cave backdrop, the stone masterfully shaped and roughened
to create a dramatic play of light and shade evoking the ten-
ebrous entrance to Hades from which Orpheus rescues the
shade of his deceased wife. The two protagonists stand
before it in full light, their forms subtly modeled by a play of
lights and darks across their surfaces. And to distinguish
Eurydice's otherworldly incarnation from Orpheus's earthly
self, Rodin has suppressed physical detail in her figure in an
effort, through his handling of material and the play of light,
to create the illusion of a ghostly apparition.

So Rodin's ambitions for his marbles were every bit as –
dare one say it – modernist as in other media. But we don't
always see them that way, partly because of the contradic-
tions inherent in that ambition. Michelangelo's *non-finito*
asserts the materiality of the block; illusionistic, atmospheric
effects deny it. But because the same technique could not do
both things simultaneously, and because stone's obdurate
materiality is insuperable, Rodin's ambition outran the
means available to realize it. It would take Medardo Rosso
in the next generation to reconcile the conflicting aims of
materiality and illusion in modernist sculpture.

Then there is the problem of display. I wrote the above
description of *Orpheus and Eurydice* looking at photographs
of the work in the Spring 1981 Metropolitan Museum of
Art Bulletin, published on the occasion of the museum's
reinstallation of its Rodins. It is similar to the way the sculp-
ture looks in a photograph taken in Rodin's studio that
Rosenfeld included in his National Gallery essay. They read
as they do because the photographers understood that with
Rodin's marbles, as with his work in other media, every
square inch of the surface counts and must be so treated in
lighting them. Now at the Met, by contrast, the sculpture is
lighted in a more conventional manner, in terms of major

and minor masses. Thus the two figures are brilliantly illu-minated, with the background stone a more or less even play of half-tones.

The problem was even more pronounced at "Rodin: 100 Years" in Cleveland. Direct sunlight pours through the floor-to-ceiling glass walls, eliminating virtually all traces of shadow on *The Fall of the Angels* (1890–1900), and with them any articulation of form, leaving us to contemplate little more than a glowing white blob.

I don't know whether, in the end, I share the views of Tancock, Rosenfeld, and other scholars that the marbles rank with the best of Rodin's work. I do know that I would like to find out. It's time for a well-selected, well-installed exhibition that will allow us to ponder them anew.

Rodin's importance for modern sculpture is commonly said to derive from his return to naturalism, his invention of the partial figure, and his rethinking of the public monu-ment. All true of course. But in my view his contribution is more fundamental: he made possible a figural art in sculp-ture in the twentieth century. This was the lesson of the show in Paris.

In its scale and sprawl, "Rodin: The Centennial Exhibi-tion" at the Grand Palais was nothing if not Rodinian. Fea-turing over two hundred works by him and over one hundred and fifty more by artists ranging from Edgar Degas to Rachel Whiteread, it sought to reveal both Rodin's work and his impact on those who followed, and did so in good measure. If there was a flaw, it was that it was at once too broadly and too narrowly focused. Although any artist involved with the figure, in whatever form, seems to have been included, the organizers' definition of "figure" was, generally speaking, that of the closed monolith. This led to some distortions and missed opportunities. For example, Joel Shapiro was absent. Julio González was represented by

Jeune Fille Nostalgique (1934–36), a modeled bronze head. Yet in many ways his welded constructions, such as *Femme au miroir* (1936–37), are closer in spirit to Rodin, despite their sculptural language being so different. None were included.

59

What would twentieth-century sculpture have looked like without Rodin's transformative, galvanizing influence? We cannot know for certain, of course, but the show gave us an idea. Absent Picasso's cubist constructions, I suspect it would have resembled the *juste milieu* tendency in late nineteenth-century French painting, wherein artists broke with tradition but without embracing the most radical tendencies of their time. A similar impulse informed the efforts of Lehmbruck, Maillol, Minne, Dalou, Meunier, Duchamp-Villon, Barlach, Zadkine, early Picasso, and others. Many were there, presented as Rodin's heirs. But their inclusion only highlighted how little they had in common with him and what he represented.

Rodin's revolution was to introduce a wholly new language of the figure, one that evolved in three stages. The first stage was *The Age of Bronze* (1875–76), a life-size male nude and Rodin's first major work of sculpture. So realistic was it that when it was first exhibited Rodin was accused of having taken a plaster mold of his model. Rodin was mortified, but he should have been proud. For he had, at a stroke, cleared the ground and swept away all of academic classicism's accumulated rhetoric and convention, opening the way for something completely new. At the same time, he established the centrality of the single figure, an idiom previously limited to portraiture and public monuments.

There's a refreshing back-to-basics quality to *The Age of Bronze*, as if Rodin had asked himself, "What is sculpture about? It's about the figure. OK, let's start there." What he told someone about an earlier effort, a clay *Bacchante* that

broke apart shortly after completion, applies to this work: he sought "to approach as closely as possible to nature, to the very point of extinction of form, and without adornment from my brain." Each of the four shows featured a cast of this work, and it's extraordinary how fresh and new it felt each time I saw it. Rodin's "extinction of form" produced a work that is open, transparent, and self-revealing in a way few later works are. Perhaps only Picasso's *Bull's Head* (1942) and Anthony Caro's slender, floor-hugging steel constructions of the mid-1960s rival it.

But Rodin still had to invent a new figural rhetoric – a language of bodily pose and gesture – to replace the old one. For this he turned to Michelangelo, traveling to Italy in 1875. The results can be seen in such works as *Adam* (1880), *Eve* (1881), and *The Thinker* (1880), a rare, close-up view of this last having been possible in Paris, where the plaster sat on a low pedestal.

This was stage two, an idea of the human body as carrier of meaning in its own right, in which the pose *is* the gesture. Yet the limits of Michelangelo – or Rodin's reading of him – are also evident here, in the overplayed, hypertrophied musculature. *The Thinker* is surely the only figure ever depicted in an attitude of restful introspection whose every sinew is flexed as if engaged in a life-or-death struggle. And so we get to stage three, the *Gates of Hell*.

The *Gates* began as a commission in 1880 for a pair of entrance doors to the (ultimately never built) Musée des Arts Décoratifs. A cast of it exists at the Rodin Museum in Philadelphia and a plaster of it was shown in Paris. Rodin worked on it for the remainder of his life, leaving it unfinished at his death. It was in the *Gates* that Rodin became his most radically inventive. He pushed the Michelangelesque aesthetic of pose as gesture virtually to the breaking point, twisting, contorting, and compressing the human figure as

it never had been previously – even chopping it up: Rodin, a longtime admirer and collector of antique sculpture, appropriated the idea of the fragment, thus inventing what would become a staple of modernist sculpture, the partial figure. This turned plaster, previously a journeyman material, into an instrument of vanguard experimentation, since unlike clay it can be cut, carved, and painted after it dries. Later, Rosso, Matisse, and Giacometti would pick up on this.

As if all this weren't enough, Rodin used these new figures and figure fragments as collage elements, attaching the plaster forms to each other, combining and recombining them in myriad ways. It's an extension of the back-to-basics approach of *The Age of Bronze*, only more radical: the figure had to be blown up and a new rhetoric formulated from its parts individually and collectively.

Rodin's restless experimentation on the *Gates* and his inability to get the work to a point of tools-down completion transformed the practice of sculpture from making to searching, from the creation of self-contained objects to a continuing quest, a drive to attain the unattainable. This outlook, of course, defined the second half of Giacometti's career.

And so the *Gates* became the laboratory in which modern sculpture was born. Rodin's idea of the figure as an idiom open to limitless reimagining was his gift to the twentieth century. From Matisse and Brancusi through David Smith and beyond, it would become the ground on which much sculpture would take root and grow.

It was but one of five such gifts, the others being contour, volume, surface, and the silhouette. Further study would be required to determine exactly how these ideas passed into the bloodstream of twentieth-century sculpture, but they did. ("I have always considered line contour as being a comment on mass space and more acute than bulk," Smith wrote in a notebook.) But certainly one transmitter was Brancusi.

One of the most illuminating journeys aficionados of modern sculpture can take is to travel the few hundred yards from Rodin's *The Kiss* to Gallery 188 of the Philadelphia Museum of Art, there to contemplate Brancusi's 1913 sculpture of the same name. His repudiation of everything Rodin stood for here and in his other works on display appears sweeping, remorseless, even. Yet there are aspects of Brancusi that are profoundly Rodinian.

Contour and volume are central to Rodin's aesthetic. He told one writer that "translation of the human body in terms of the exactness of its contours gives shapes which are nervous, solid, abundant." To another he recounted a lesson imparted to him by a decorative sculptor when he was just starting out: "never think of forms as planes, but always as volumes. Consider a surface only as a protruding volume – as a tip, however wide, pointing at you."

They are essential to Brancusi's aesthetic, too. To take one example, in Philadelphia's *Torso of a Young Girl* (1923), a small marble that resembles a bottom-heavy lozenge with its top sheared off, contour tautly delineates form, while surface is a continuous, outward-pressing skin suggesting the pulsation of organic life. And, as the gleaming, polished *Bird in Space* (1923) attests, surfaces were as aesthetically significant to Brancusi as they were to Rodin.

From Brancusi to Henry Moore: in a series of sculptures from the 1930s, such as "*Four-Piece Composition: Reclining Figure,*" the handling of form and surface is identical. This can hardly have been a coincidence. Brancusi's aesthetic of direct carving was a formative influence on Moore; the Englishman closely studied all the art that he saw; and he had visited the artist's studio in Paris around this time.

The silhouette derives from *Balzac* (1898). In her 1993 biography, Ruth Butler quotes Rodin saying that he had placed it "in the courtyard so that I could see it against the

sky." Around the same time he explained to the poet and critic Camille Mauclair – in words that could have been uttered by Giacometti – that in making sculpture for the open air, artists should consider contour and "value":

> ... think about what one sees of a person stood up against the light of the twilight sky; a very precise silhouette, filled by a dark coloration, with indistinct details. The rapport between this dark coloration and the tone of the sky is the value, that is to say, that which gives the notion of material substance to the body.... All that we see essentially of a statue standing high in place, and all that carries, is its movement, its contour, and its value.

Edward Steichen's photos of *Balzac* set against a moonlit sky, included in the Met's show, give a vivid sense of the effect Rodin was after. He had been traumatized by the negative reaction to *Balzac* when it was first exhibited, and he was ecstatic over Steichen's photos. One of the wall texts quotes from a letter to the photographer: "You will make the world understand my 'Balzac' through your pictures."

I'm not saying Rodin is the only source for sculptors' concerns with contour, volume, surface, and the silhouette. But they are such recurrent features of twentieth-century sculpture, and as a group so unique to him, that we must count Rodin a major progenitor.

As one would expect for a native son, the Paris show did Rodin proud. The American exhibitions, however, are in many ways perfunctory, disappointing affairs. There are no publications, just wall texts and pamphlets. In Philadelphia there is confusion and lack of focus. And while the Met's installation of *Adam* allows visitors a rare opportunity to study it from all sides, one has to contend with the marbles' flawed lighting scheme and the strange decision to show

small bronzes in cabinets painted battleship-gray inside, the dark-against-dark display swallowing them up and robbing them of all sense of form and dimension.

Most disappointing is Cleveland. Their display has its high points, such as the three-foot-tall plaster enlargement of the head of Pierre de Wissant from the *Burghers of Calais* (1886). A large, top-heavy mass rising up and twisting in space, it is compelling in purely abstract terms and thus an example of the "pure sculpture" – plastic expression independent of representation or narrative – that Rodin held as his highest aspiration. As such it points into the future, as we saw most recently in William Tucker's stunning show of new work at the Danese Corey Gallery in Chelsea earlier this fall, particularly *Chinese Horse* (2003). An eight-foot-tall, vigorously modeled semi-abstract bronze, it rises from a narrow support, swells mightily, tilts back, cantilevers out, and then, as you walk around it, seems to heave and twist, evoking nothing so much as the strain of the human body moving against its own mass and the pull of gravity.

Otherwise, there is no theme to the installation, no logic to the selection of works nor explanation of why out of the museum's thirty Rodin sculptures – one of the best collections in the country – these ten are chosen. Worst of all is the location, in a gallery that forces visitors to shield their eyes from the glare of the sun while viewing the sculptures. Still, there's time to get it right. Rodin's bicentennial is just around the corner.

Originally published as "The necessity of Rodin"
in The New Criterion, *December 2017.*

ON OCT. 25, the John F. Kennedy Center for the Performing Arts will open *Little Dancer*, a musical inspired by Edgar Degas' sculpture *Little Dancer Aged Fourteen* (1878–81). Directed and choreographed by Susan Stroman and starring Boyd Gaines as the artist, it is based on the life of Marie van Goethem, the young ballerina who was the model for the sculpture.

To coincide with the production, the National Gallery of Art has just opened "Degas's 'Little Dancer,'" a small exhibition centered on the original wax-and-clay version of the sculpture, the only one Degas actually worked on. The show, which runs through Jan. 11, 2015, includes fourteen other works, among them prints and paintings, both from its collection and the Corcoran Gallery of Art.

Little Dancer is a two-thirds life-size figure of an adolescent ballerina standing erect, her head tilted back, eyes half closed, arms hanging down, and hands clasped behind her back. She is posed in an approximation of ballet's fourth position, and attired in a cotton-and-silk tutu and linen slippers, with a silk-and-linen ribbon tied around the braided portion of her human-hair coiffure. She stands on a wooden base suggestive of a ballet studio floor.

Little Dancer is one of the most bewitching and mysterious works in the entire canon of modern art. In part this is due to the contrast between the in-your-face realism of the dancer's attire and the mood of psychological withdrawal created by her facial expression, with its half-closed eyes.

But it also has to do with the work's history and the circumstances of its creation.

Degas had announced that *Little Dancer* would be included in the fifth Impressionist exhibition of 1880, yet the show opened without it. Anticipation increased when, well into the run, a glass case was placed in the exhibition, as if the sculpture's arrival were imminent. Yet the show closed with the case still empty.

Degas showed the sculpture in the Impressionist exhibition the next year, where it caused a sensation. The work's unprecedented realism – no work of art had ever included non-art materials before – was the main focus of attention. Some praised the subject and treatment as a brilliant expression of the new modern aesthetic that called for drawing subjects from everyday life rather than, as had been standard practice, from history, mythology, or religion. Others found the sculpture shocking, denouncing it as ugly, even decadent. "Can art descend lower?" wrote one critic. When the show closed, Degas brought the *Little Dancer* back to his studio and never again exhibited it in his lifetime.

In many respects, *Little Dancer* is an outlier in Degas' œuvre. His painted and drawn images of ballerinas mostly show them in motion, often performing with others. They address the audience, each other, or an instructor. Unlike them, this dancer is stationary and withdrawn into herself. Degas' other ballet-themed sculptures are small studies; this one is a near-life-size, finished work of art. Those others are studies of movement; this one isn't. Yet far from being an anomaly, *Little Dancer* represents a synthesis, combining the illusionism of painting with the physicality of sculpture to take his art to a new level of immediacy and power.

In struggling to come to terms with this strange new work when it was shown in 1881, critics and members of the public looked for precedents beyond contemporary styles or

inherited traditions. Some likened it to a child's doll, or an automaton, while others looked to older periods of art. Perhaps responding to the figure's near-symmetry and mood of stillness, still others cited Egyptian art. The collector Louisine Havemeyer later recalled it as being "as ancient as an Egyptian statue and as modern as Degas!" She was more accurate than she knew.

In photographs, *Little Dancer* is almost always shown in a three-quarter view. That may be the best angle for someone not in the room with it to get a sense of the whole sculpture, but it is not the one that allows the work to reveal its meaning.

In many of Degas' smaller sculptural studies of dance positions (one is included in this show), the limbs point in different directions, inviting you to circumnavigate them, experiencing them in the full round. Not *Little Dancer*. Everything about her seems designed to lock us into a face-to-face encounter: her near-symmetry, her mysterious expression, and above all her hieratic frontality, so evocative of those ancient statues of the Pharaohs.

This might be of little consequence except for the fact that Degas' painted and graphic work is all about point of view. From the beginning, what set his mature work apart from that of the other Impressionists and, indeed, all previous art, were his radical compositions. In place of balanced, one-point-perspective views, Degas adopted sharply angled, fragmented views with figures and other elements often cut off by the canvas edge. They were spatially compressed or the opposite, showing broad areas of open floor or wall where nothing seemed to be happening.

Take *Dance at the Old Opera House* (*ca.* 1877), a pastel in the exhibition. It shows a view out onto the stage from the wings during a performance. A line of dancers is partially visible at the left, while at the right we can glimpse the orchestra pit. But the majority of the image is taken up by

the empty stage between them, its surface washed by the illumination from the footlights at the stage's forward edge.

This approach gave the viewer a new and more intimate relationship to the painted subject by making it seem as if he were actually involved in the unfolding drama. Indeed, at times Degas seems to be assigning a specific role to the viewer. Here we might be a ballerina waiting to enter or the choreographer keeping an eye on the performance. A series of monotypes from the late 1870s of naked prostitutes taking their ease inside a brothel turns us into voyeurs. (Degas said of them, "It's as though one were peeping through the keyhole.")

In *Little Dancer*, too, Degas has assigned us a role. In his painted and drawn images, two types of individual establish the kind of face-to-face relationship with the ballerinas that we have with this figure. One is the so-called *abonné*, the wealthy patron whose support allowed him contact with the dancers by granting him privileged access to rehearsals and nonpublic areas of the theater. The other is the dance instructor – most famously in the Musée d'Orsay's *Dance Class* (*ca.* 1873–76), in which we see an elderly man, arms extended in front of him and resting on a long cane, surveying a group of ballerinas arrayed in front of him.

The compelling frontality of *Little Dancer* positions us as surrogates for these people, a feat of illusionism Degas achieves through that most physical of art forms, sculpture. For in our shared space, we engage with her much as, in the paintings, the depicted individuals do their ballerinas. In the process, we are elevated from mere witnesses to active participants in the unfolding drama of the dancer's world.

Originally published as "Masterpiece: An Impression Indelible in Wax" in The Wall Street Journal, *October 10, 2014.*

IN OUR CULTURE of easy celebrity it's hard to imagine such a thing as an undersized reputation. Yet that has been the fate of the Italian sculptor Medardo Rosso (1858–1928), currently the subject of an enthralling and exceptionally well thought out exhibition at the Pulitzer Arts Foundation.

Sculpture is traditionally the art of solidity and tangible form, painting the art of illusion. Irreconcilable opposites? Not to Rosso, whose ambition it was to fuse the two by modeling figures and forms that appear wrapped in an envelope of light and atmosphere.

A contemporary of Auguste Rodin and, like him, a pioneering figure of the modern movement, Rosso has never been the household name that Rodin is. But among those who know his work Rosso enjoys something like cult status. Visit this exhibition and you'll understand why.

"Medardo Rosso: Experiments in Light and Form" was organized by the independent curator and Rosso authority Sharon Hecker and the Pulitzer's Tamara H. Schenkenberg. On view through May 13, 2017, it is the most comprehensive Rosso show in the United States in over fifty years. It features about thirty sculptures, in some cases versions of the same subject in different media – wax, plaster or bronze. In addition, there are about seventy rarely seen drawings and photographs. If any show should travel, it's this one. As of now, St. Louis is the only venue. But with five months' lead time, miracles can still happen.

Rosso seems to have received little formal training. His first mature works date from the early 1880s of which

Portinaia (Concierge) (1883–84) opens the show. It is a richly material yet evanescent head-and-shoulders image of a woman caught in a reflective mood. The sculpture is broadly and loosely modeled so that, in what one writer has described as Rosso's "double game," its washes of light and pools of shadow don't just articulate the form but present the figure as if seen in a half-light or through a steamed-up window.

In 1889 Rosso moved from Milan to Paris, where over the next decade he was the most radically innovative sculptor at work anywhere – more so even than Rodin. Walking through this show you see much of twentieth-century sculpture predicted. *Madame X* (1896), a head so simplified as to be little more than a large lozenge, gives us a foretaste of Constantin Brancusi's similarly reductive approach to form and anatomy. The vigorously, almost expressionistically worked surfaces of the clothing in his portrait of the Impressionist art patron Henri Rouart (late 1889–90) scream "Alberto Giacometti." And Rosso's overall aesthetic of sculpture as something addressing itself to the eye rather than the hand looks ahead to the work of James Turrell, Robert Irwin, and the other artists of the Light & Space movement that originated in Los Angeles in the 1960s.

At times, Rosso pushes form to the limits of visibility, employing a freedom of handling so extreme that the image seems almost accidental, like those shapes we perceive in clouds or the veining of a rock. Close up, *Madame Noblet* (*ca.* 1897–98) reads as nothing more than a pile of gouged and scraped plaster. Only from several feet away does one begin to discern a face.

Many of the details of Rosso's life are shrouded in mystery so, unusually for an artist, we know little about his influences. One hovering presence here is the Post-Impressionist painter Georges Seurat. Works like the bronze head *Ecce Puer (Behold the Child)* (1906) read as sculptural equivalents

of Seurat's haunting black crayon drawings from the 1880s, where forms emerge from an enveloping gloom. Some of Rosso's drawings here, too, show strong affinities with Seurat's. But how, where, when, or even whether he saw those works is impossible to know.

It would be a mistake to conclude from all this that Rosso was merely a kind of sculptural prestidigitator. His works are deeply human. *Aetas Aurea* (*Golden Age*) (late 1885–86) is a tender yet unsentimental portrayal of maternal love and childlike innocence. And a crackling psychological energy courses among the three sketchy figures in *Une Conversation (A Conversation)* (1892–99). One marvels at Rosso's ability to express so much with so little.

There are no labels or wall texts at the Pulitzer – a printed handout provides the necessary information about each work. But the museum has gone one better when it comes to explaining Rosso's aesthetic. A portable control pad allows visitors to try three separate lighting options on *Ecce Puer*, with each revealing the work in a different way. One handheld is worth a thousand words.

Plan to allow plenty of time for a visit. Once you enter Rosso's world, you won't want to leave.

Originally published as "Fugitive Figures"
in The Wall Street Journal, *December 20, 2016.*

Augustus Saint-Gaudens:
Reinventing the American monument

THE GREAT DRAMA of American culture has been its ongoing dialogue with Europe. Lacking a native fine-art tradition, early American artists were keenly aware that one measure of the new country's legitimacy would be to match the creative accomplishments of civilizations past. They and their successors looked to the forms and idioms of Europe as an armature upon which to erect their own modes of expression. At the same time, they were determined to match artistic with political independence with the creation of a uniquely, distinctively American art. There is, surely, no more prototypical actor upon this stage than the Gilded Age sculptor Augustus Saint-Gaudens, currently the subject of a rich and spellbinding show at the Metropolitan Museum of Art.

Saint-Gaudens (1848–1907) was born in Dublin to an Irish mother and a French father. The family emigrated to the United States when he was six months old, settling in Manhattan, where he got his start as a sculptor working for two cameo cutters – portraitists who carved miniature, low-relief likenesses in bone or shell. His primary apprenticeship, however, was in Europe. In 1867, he arrived in Paris, where he took academic instruction and was profoundly influenced by the work of artists such as François Rude (1784–1855), Emanuel Frémiet (1824–1910), Paul Dubois (1829–1905), Jean-Baptiste Carpeaux (1827–75), and Jean-Alexandre-Joseph Falguière (1831–1900). Their newly complex compositions and animated surfaces signaled the

waning of the icily remote Neoclassical tradition and the rise of more naturalistic representation and emotional expansiveness. In 1870, Saint-Gaudens decamped to Rome, where he began earning his living as a sculptor by carving cameos and modeling portrait busts. He made his first large-scale sculpture, a statue of the seated Hiawatha. He also looked at the art of the Old Masters, later telling friends that he had been particularly struck by the work of Verrocchio, Perugino, and Donatello.

In 1875 Saint-Gaudens returned to America to lobby for and secure the commission for a monument in Manhattan to the Civil War hero Admiral David Farragut, famous for his cry, "Damn the torpedoes! Full speed ahead!" at the Battle of Mobile Bay. Because American bronze founding was still in its infancy, he traveled back to Paris in 1877 to work on his new commission. Thus began a nearly twenty-five year circuit during which Saint-Gaudens alternated between New York, Paris, and Rome. Thus also began a career that saw the creation of several public sculptures that have since become American icons: *David Glasgow Farragut* (1881) and *William Tecumseh Sherman* (1892–1903) in New York; *The Puritan* (1883–86) in Springfield, Massachusetts; *Standing Lincoln* (1884–87) in Chicago; the Adams Memorial (1886–91) in Washington, D.C.; and the Shaw Memorial (1884–97) in Boston, an equestrian portrait of the Civil War colonel Robert Gould Shaw accompanying his all-black regiment, the first to count any black soldiers in its ranks.

American artists in great numbers had previously journeyed to Europe; some had even taken up residence there. But for the most part they had limited themselves to one location. What gave Saint-Gaudens's art its distinctive character was his cosmopolitanism, his assimilation of multiple and very different strains of influence. The antique and Renaissance art of Italy endowed his art with gravitas:

behind the resolute pose of Admiral Farragut stands Donatello's *Saint George* (1415), and, in the solemn march of Shaw's regiment, we can detect the stately rhythms of an Augustan procession on the Ara Pacis in Rome. The modern art of Carpeaux and others that he saw in France gave him a plastic language unlike that of any current or previous American artist. In particular, the continuously animated surfaces that keep the eye in restless motion over the form brought a new and unprecedented vitality to American sculpture. All this was put to the service of a new and very American subject matter: ordinary individuals who, like Saint-Gaudens himself, had risen to their present eminence solely by dint of their own drive and natural talent, and to whom his public could relate through broadly shared experience.

Saint-Gaudens's public sculptures redirected the course of American art and revolutionized the public monument in this country. They also made the sculptor an international celebrity. In 1900, he showed a plaster cast of the Shaw Memorial at the Paris Exposition where, his biographer Burke Wilkinson tells us, "[Auguste] Rodin, in one of his extravagant gestures, doffed his hat before it and stood bareheaded in tribute." It represented the triumph of the New World before the Old.

Organized by Associate Curator Thayer Tolles, "Augustus Saint-Gaudens in The Metropolitan Museum of Art" is the first show of the artist the Met has mounted since its 1985 retrospective. It consists of nearly fifty works by Saint-Gaudens (some acquired since 1985) ranging across his entire œuvre: cameos, portrait reliefs, studies for the monuments, commemorative medallions, and currency. Highlights include busts of Farragut, Sherman, the Victory figure from the Sherman memorial, and Davida Clark, his model and mistress; relief portraits of Robert Louis Stevenson, William Merritt Chase; and three exceptional relief portraits

of children: his seventeen-month-old son Homer Saint-Gaudens; the two-year-old Rodman de Kay Gilder, executed with a freedom of handling more characteristic of a mono-type print than a sculpted relief; and *The Children of Jacob H. Schiff* (1884–85), where the thick, curly mane of the family dog is lovingly fingered by young Frieda Fanny Schiff, vividly captured by the artist.

The exhibition is a revelation for what it tells us about the essential unity of Saint-Gaudens's art. At first glance, his work seems to evoke a paradox: How could an artist who spent so many of his formative years as a portraitist in shallow relief, his subjects shown in strict silhouette and by means of a quasi-pictorial illusionism achieved through the free handling of form and the deft manipulation of light and shade across the surface, demonstrate such a mastery of three-dimensional form? But, far from being incompatible with his monumental sculptures, many of these characteristics were indispensable to their realization and success. To be sure, Saint-Gaudens's monuments are less freely handled and more meticulously realistic than his reliefs. Indeed, he introduced an unprecedented degree of verism into sculpture, striving to get the details of clothing right. He even asked young black men to pose for the faces of the soldiers in the Shaw Memorial, an effort that resulted in one of the few sympathetic depictions of blacks in early American art.

Like his reliefs, Saint-Gaudens's monuments rely on the play of light and shade to articulate their forms. And while they read well from more than one angle, the silhouette profile remained the primary organizing principle of his art. In relief, it demanded a clarity of composition and careful orchestration of major and minor elements. Even without knowing who William Merritt Chase was, the viewer has no doubt what the statue's subject does for a living because of the image's essential attributes – the artist's palette, the

loaded brush poised in the delicate hand – are each given appropriate visual weight and emphasis. The same applies to works such as the Shaw and General Sherman monuments. It is hard to imagine Saint-Gaudens surmounting their manifold compositional challenges without his experience as a relief sculptor to guide him.

Perhaps the most significant similarity between the two sculptural modes, however, lies in Saint-Gaudens's approach to his subjects. His memorials aren't "monuments" in the sense of simple likenesses of a revered individual. They are direct extensions of his reliefs into three-dimensions, portraits that reveal as much of the inner life as of the external appearance of the individuals they commemorate. Despite the challenge of accomplishing this with deceased subjects, Saint-Gaudens went to considerable lengths to establish the same kind of "rapport" with these subjects as he had with living ones. He borrowed Admiral Farragut's coat to drape over his model, and he supplemented his youthful recollections of Lincoln by reading Lincoln's writings and speeches.

The results are not only highly individualized images of great power, they are works that transcend their particular subject to give Americans a national self-image. Nowhere is this truer than in the Shaw Memorial, which stands as the quintessential expression of the democratic ideal in sculpture – and possibly in all of American art up until that time. Saint-Gaudens gives us a leader among, rather than apart from, those he leads; he celebrates the individual within the group; he grants the country's lowliest citizens full partnership in the business of the nation. Small wonder that Rodin, whose career was, in many respects, an ongoing struggle with the idea of the public monument, was moved to doff his hat.

In approaching these commissions as conventional portraits, Saint-Gaudens introduced an unprecedented inwardness to the public monument. At first, this seems to be

incompatible with the heroic mode of commemorative art. But it not only deepens such artworks emotionally, it also ensures they will continue to speak to the viewer across the passage of years by placing him in the presence of an indi- vidual rather than a type. This inwardness also reflects the spirit of the time, which was marked by a new awareness of the human cost of war. For all the reckless abandon contained in Admiral Farragut's legendary cry, Saint-Gaudens depicts him with his mouth firmly closed, resolutely staring into the distance. And unlike the fired-up, clamoring figure of Rude's 1853 *Monument To Marshal Ney* – a work Saint-Gaudens admired – in which Napoleon's general charges into battle, the figures in the Shaw Memorial march quietly off to war, as if aware of their ultimate, grisly fate.

Another Saint-Gaudens innovation was his ability to create dramatic and psychological unity with the viewer. Thus, the Shaw Memorial is placed at or near the spot on Beacon Street along which the regiment actually marched as it departed for war. The hem of Farragut's coat is shown blown back, as if by the same wind that buffets us. The angel and victory figures in the Shaw and Sherman monuments are both calling to some unseen crowd in the distance. In the Adams Memorial, it is the figure's powerful inwardness and sense of mystery and the pervasive atmosphere of silence surrounding her that draws us in and makes us one with the sculpture's theme of grief and mourning.

Nowhere is this effect more powerfully achieved than in Saint-Gaudens's statue of Lincoln. The challenge here was, perhaps, greater than most, since Lincoln's assassination had transformed him from a man into a demigod. By the time Saint-Gaudens received the commission in 1884, there was already an abundance of representations of the sixteenth president. His task, therefore, was to cut through the carapace of myth, familiarity, and veneration and reconnect

the viewer with Lincoln the man. His solution was to show Lincoln in a pose of, as Ms. Tolles puts it in her fine catalogue essay, "a transitional moment of action and imminence." Lincoln is shown standing, in front of the presidential chair from which he has just risen to deliver an address. His left hand grasps the lapel of his frock coat as if to steady himself internally, his head is bowed, as if collecting his thoughts one final time before speaking, and the left knee is cocked, projecting through the perimeter of the frock coat, as if midway through taking one last step before beginning his address. The atmosphere is pregnant with anticipation.

The statue's world and ours are further joined by the left toe of his shoe, which projects just slightly forward from the perimeter of the base so that it shares our space. One wonders if, as an avowed admirer of Verrocchio, Saint-Gaudens didn't acquire this device from seeing the artist's 1483 *Christ and St. Thomas* on the exterior of the Church of Orsanmichele in Florence. Completing the effect of being in the presence of the real Lincoln is the broad, stepped exedra designed by Stanford White, a setting seemingly designed to accommodate the audience Lincoln is about to address.

There's something both timely and bittersweet about a Saint-Gaudens celebration at this moment in our cultural life, when the idea of the public monument is so contentious and the offerings so dispiriting. Saint-Gaudens worked in an era when it was taken for granted that an artist could – and should – confidently celebrate great acts and individuals and conceive of a work of public art as a thing to uplift and inspire. His art represents the twilight not just of the heroic mode but also of the idea that public art should serve as an instrument of civic engagement, even when, as in the case of the Civil War, the subject was one that had divided the nation.

Nowadays, so much of what passes for commemorative

art is unaffecting and hobbled by the need to play it safe. Today's monument makers seem to be groping for the right language in which to express themselves and the proper "voice" in which to speak to their public – that is, when they are not settling for the facile satisfactions of bathos or irony. To understand this, one need only compare two monuments born of national crisis.

Saint-Gaudens's Shaw Memorial commemorates one of the most poignant and tragic moments of the Civil War in a way that elevates its subject, making it vividly present to us. Michael Arad's "Reflecting Absence," his design for the September 11 World Trade Center memorial, likewise commemorates a tragic event that brought the nation together. But one looks in vain to find that concept expressed in the design, which consists of a grove of trees punctuated by two square, below-grade pools marking the footprints of the twin towers, each one bordered by a cascade of water. It is a bland, committee-driven affair that fails to fulfill the basic, most fundamental function of a monument: to prompt the viewer to think about the event it commemorates and to reflect on its larger meaning.

It's probably too much to hope for, but one would like to think that architects, urban planners, elected officials, and other midwives of the nation's monuments would take advantage of the opportunity afforded by the Met to visit the exhibition – and then fan out to study Saint-Gaudens's public monuments *in situ*. Having taken it all in they might then ask themselves, "How can I do something that good?"

Originally published as "Augustus Saint-Gaudens and the American monument" in The New Criterion, *October 2009.*

Frederic Remington et al.:

A cast of the American character

ONE OF THE PLEASURES of the reopening of the Metropolitan Museum of Art's American Wing in 2012 was the reappearance of some of its cowboy-themed sculptures. The museum has now gone all-out on this subject with its exhilarating exhibition "The American West in Bronze, 1850–1925," the first ever such survey of this genre.

The show comprises sixty-five works depicting cowboys, Indians, and a whole menagerie of frontier animals. Nearly thirty artists are represented. Frederic Remington and Charles M. Russell are here. But the list also includes Solon Hannibal Borglum, the younger brother of Mount Rushmore's Gutzon Borglum, and Henry Merwin Shrady, who would later do the Ulysses S. Grant Memorial in Washington.

If names like Alexander Phimister Proctor are unfamiliar, it may be because this is not an aesthetic that finds much favor with elite opinion. Denver (the exhibition's next stop) and cities beyond the Rockies abound in Western art, but not the East Coast, where it tends to be scarce. In New York, work of this kind was last shown in quantity a quarter-century ago when the Met mounted a Remington retrospective. And that was a dozen years after its last appearance, when a smattering of Remingtons and Russells was featured in the Whitney Museum's Bicentennial survey of American sculpture.

So it's no surprise that the critic for *The New York Times* dismissed this exhibition as so much "kitsch," going on to

attack it for failing to criticize "what white, Euro-American civilization did and was doing to the native people, animals and plants of North America. It's as if the devastation of the West were an inevitable natural disaster rather than the product of vicious programs and policies of business and government." Pity the curators, Thayer Tolles of the Met's American department and Thomas Brent Smith of the Denver Art Museum. They can scarcely have imagined that organizing an art exhibition would make them complicit in long-ago crimes against Indians and the buffalo.

Nobody pretends that our treatment of the indigenous peoples isn't a blot on this country's history. Nor is it exactly news. The catalogue quotes the nineteenth-century historian Francis Parkman's mournful observation that "Civilization has a destroying as well as a creating power. It is exterminating the buffalo and the Indian." As for the environment, Yellowstone National Park was founded in 1872 out of a recognition that something unique and precious was in danger of being eradicated completely by the march of progress. It marked the beginning of the conservation movement.

This is not to say the show isn't shrouded in cultural contradictions. As the curators acknowledge, the works' genesis was nostalgia – a desire to recapture and memorialize the vanished "West," with all that word meant in terms of limitless horizons, abundant natural resources, and the cowboy, whose grit and self-reliance made him a symbol of the American character.

Then there is these works' strange dissociation from history. The years covered by this show coincide with the modernist revolution – the invention of Impressionism and all that followed, through abstraction and Surrealism. Yet you will find nary a trace of such tendencies in this meticulously realistic aesthetic, save in the more fluid forms and animated surfaces in the work of artists like Arthur Putnam

and Edward Kemeys that betray the influence of Auguste Rodin. Nor does this change after 1913, when the Armory Show introduced America to modern art.

Nonetheless, taken on its own terms, "The American West in Bronze" offers a rich selection. Russell's *Meat for Wild Men* (1924) is a starkly Darwinian vision of Indians rounding up a herd of terrified and confused buffalo for the kill; Borglum's *Lassoing Wild Horses* (1898) is a brilliantly orchestrated depiction of the dynamic interplay between two cowboys and three horses in motion; and it's almost impossible to resist touching the rich textures of the animal's shaggy, tousled mane in Shrady's *Buffalo* (1899).

Moreover, the show captures a moment when American art further emancipated itself from European influence. An inherited classicism gives way to a gritty, native realism, and for the first time artists didn't have to send their work to Paris or Munich to be cast in bronze. Foundry men who previously could turn out only cannons and other weapons acquired the skills to cast sculptures. This opened up greater technical possibilities for the artists, encouraging them to a greater boldness. In Remington's *Coming through the Rye* (1902, and regrettably only to be seen in Denver), the great mass of four galloping, hootin' and hollerin' cowboys on horseback is supported by almost nothing – only four of the sixteen hooves anchor the sculpture to its base.

Surprisingly, the sculptures of the Indians are the least interesting part of this exhibition. They are mostly the Western equivalent of the boardroom portrait: faithful likenesses, yet utterly bloodless. Perhaps mindful of the sorry historical record, the artists seem to be going out of their way to do justice to their subjects, depicting them with dignity and respect. Just as likely, the artists' real interest lay elsewhere: in the interaction of man, animal, and natural environment. Remington's *The Mountain Man* (1903) ver-

tiginously conveys the perils of a steep descent on horse-back; his *The Norther* (1900), an equally vivid image of rider and mount suffering through extreme cold.

One of the most unforgettable works in this show is among the smallest: Russell's *The Range Father* (1926), a fifteen-inch-long sculpture of a wild horse chasing a wolf. They are caught going flat out, leaning precariously into a turn, legs akimbo, bodies heaving and straining, mouths agape, each creature wholly absorbed in the deadly business of flight and pursuit. Some fifty years after Eadweard Muybridge's revolutionary photographs of a horse galloping, Russell shows us that when it comes to depicting animal locomotion, there is no substitute for the hand and eye of the artist.

Originally published as "A Cast of the American Character"
in The Wall Street Journal, *January 30, 2014.*

Constantin Brancusi I: Rethinking the figure

THIS FALL the Gagosian Gallery on upper Madison Avenue departed from its usual pattern of theme exhibitions by post-war American artists to offer something entirely unexpected, a handful of early sculptures by Constantin Brancusi (1876–1957).

This show was originally planned as a touring exhibition, its second stop to have been the Detroit Institute of Art, but, as *The New York Times* reported shortly before Christmas, the loan of the sculptures had caused such a political scandal in Brancusi's native Romania that they had to be returned immediately after the exhibition closed at Gagosian. Given the exceptional nature of the loan, and the ensuing commotion, it is unlikely that they will ever be allowed out of the country again.

That fact alone made "Brancusi: Masterpieces from Romanian Museums" a noteworthy event. Yet it was one of those exhibitions that create very little stir. It may be that the sculptor is so familiar to New Yorkers from the extensive holdings of his work in the Museum of Modern Art, the Guggenheim, and the Metropolitan that there seemed to be little more to learn about him.

Or it might have been the work itself. The Brancusi on view at Gagosian was, in certain respects, a completely different artist from the one familiar to us. Instead of the modern sculptor of pure forms and dreamy peacefulness, here was someone working his way out of the nineteenth-century tradition of modeled figures. And instead of elemental carved quasi-abstractions, here were naturalistic human forms,

half of them cast in bronze. To anyone not familiar with this phase of Brancusi's career, these sculptures must have appeared to be little more than inconsequential juvenilia, pieces executed when Brancusi was still searching for an artistic identity, and thus of only marginal interest.

In fact, they weren't. Although among the earliest sculptures Brancusi ever made, they constituted a kind of stop-action re-creation of the crucial period in the sculptor's evolution. By revealing a new dimension of an artist we otherwise know well, the exhibition showed us Brancusi becoming Brancusi. His thought processes seemed not only manifest, but palpable. This is, of course, exactly what one most wants from this kind of single-artist exhibition. But how often do we really get it?

There were six sculptures in "Masterpieces from Romanian Museums," all done between 1905 and 1909. Three were bronzes: *Pride* (1905), a bust of a girl; *Head of a Boy* (1906), another bust; and *The Prayer* (1907), a meditative, kneeling female figure. The rest were stones: *The Kiss* (1907), Brancusi's first attempt at his signature motif; *Sleep* (1908), a naturalistic head set within a cloud of roughed-in marble; and *Trunk* (1909) – also known as *Torso*. A nearly ten-inch-tall marble of a woman's midsection bending forward slightly, *Trunk* was the most Brancusiesque work in the show.

Sidney Geist, in his monograph-catalogue *Brancusi: A Study of the Sculpture* (1968), lists some fourteen early Brancusis in Romanian museums. One could have wished that two others were included in this otherwise well-selected exhibition: the 1906 Portrait of *Nicolae Darascu*, which strongly recalls Rodin, and the 1901–02 *Ecorché*, or flayed figure, its skin removed to reveal the body's musculature. The latter is an academic set-piece, of interest mainly because it is so accomplished that, again according to Geist, it is still used by students in Romania. The *Ecorché* would

have provided a kind of aesthetic benchmark against which to measure Brancusi's subsequent departures from academic art.

The six sculptures at Gagosian encompassed the major milestones in the course of this early formative phase of Brancusi's career. They showed him gradually turning his back on academic art, with its canon of truth to nature. After an interlude under Rodin's influence – Brancusi was briefly the older artist's assistant – a reaction sets in. Rodin's rhetoric, expressed in the melodramatic gestures of his figures, was an obstacle. So was narrative. Finally there was the problem of what Modigliani is said to have called the "mud," Rodin's profusion of bronze figures modeled in clay, as stiflingly academic to advanced artists of the day as were the marbles of official art.

In this connection, *The Prayer* and *The Kiss* are particularly important. It is in *The Prayer* that Brancusi really breaks with Rodin. Although traditional in subject, and still modeled, the handling is more restrained and attentive to an overall, shallow surface uniformity. Also, the simplification of the body, especially the thighs, head, and arms, was entirely his invention. Finally, for all the generalized realism of the figure, the pose – kneeling, leaning forward, head bowed – is profoundly anti-naturalistic. (Try holding it for a while and you'll see.) All this means that in *The Prayer* a new form-language is coalescing under the skin of tradition.

And this version of *The Kiss* represents Brancusi's third, but most important, foray into the realm of direct carving. Sculptors had always carved, but typically had used a pointing machine to translate the form of the preliminary model into the final, scaled-up version. Brancusi's approach was to attack the stone without models or pointing machines – directly. Besides emancipating him from academic (and Rodinian) practice, this amounted to a kind of liberation of

the creative spirit, since it dramatically reduced the distance separating the initial idea and the finished work of art, fusing creative expression and manual labor into a single continuum. Finally, the roughened surface of the stone which remained after the artist's tools were laid aside introduced an expressive element to the work which further distanced it from the polished surfaces of academic art. Brancusi's pioneering use of direct carving established an alternative and decidedly modern approach to making sculpture, which made him, for a time, the leader of the sculptural avant-garde.

The main theme of this exhibition, however, was Brancusi's concentrated rethinking of the human figure as the primary subject and vehicle of artistic ideas in sculpture. In this effort, Rodin and the academy are Brancusi's foils. And while nature remains a constant reference, there is in Brancusi's work a growing attempt to depart from it but not to abandon it altogether.

Thus, no doubt taking a cue from Rodin, Brancusi rejects the idea of physical wholeness as a prerequisite for the figure. Going beyond the accepted convention of stopping the body at the chest for a bust, he chops off an arm in *Head of a Boy*, but leaves the other. It's a seemingly nonsensical, arbitrary action, one that violates our reflexive acceptance of this figure as an analogue for ourselves. But for Brancusi, it is an important action. It helps move the figure, ever so slightly, onto another aesthetic plane.

In the same sculpture, he turns the head awkwardly, to the side and down, and gives the face a curious expression. These decisions don't really contribute much to the emotional impact of the sculpture. The pose was a common one in the sculpture of the time, but this version of it has an intensity that tells us more about the sculptor, I think, than about the little boy who is his subject. One feels Brancusi is wrestling with the question of gesture in sculpture, trying

here to find an animating pose for the body that is not a cliché – and not Rodin. The effort seems forced and the result is not particularly successful.

88 At this time, Brancusi was also deeply immersed in exploring the structure of the human figure as expressed in sculpture. The figure's internal relations, how it holds itself up, and how it relates to the space around it all become matters for his attention. Symmetry, and by extension balance, are the primary avenues through which he approached these matters.

Pride is conventionally symmetrical, while *Head of a Boy*, with its missing arm and rotated head, is dramatically not. Being a kneeling figure, *The Prayer* has to be symmetrical, such is the nature of the act of kneeling. But, possibly for the practical reason of ensuring the figure's stability, Brancusi places one of the figure's knees slightly in front of the other. More important, he tilts the figure precariously forward, leaning it so far off its center of gravity as to create an almost cantilever effect. This adds a measure of vitality to the sculpture, counteracting its mood of sentimentality. In addition, the probing of gravity in *The Prayer* points to later work, such as the *Bird in Space* series (1920s–40s), in which freedom from the earth's pull becomes a central part of his subject.

The Kiss marks a decisive return to symmetry, and Brancusi's acceptance of it as a kind of governing principle for the remainder of his career. Brancusi's wrestling with symmetry was not, it seems to me, an idle formal problem, but one intimately connected to his assessment of what was wrong with figurative sculpture and to his personal ambitions for it. Symmetry is a fundamental condition of our physical composition as humans, and therefore of academic sculpture. Everything is ordered around the spine. All artistic influences aside, Brancusi must have felt that an essential precondition for making the sculpted figure anew – or at

least for breathing new life into it – was somehow to over-
come the tyranny of left-side/right-side.

That he returned to symmetrical compositions quickly –
within the space of a year – suggests either that symmetry
wasn't a problem after all, or that he did indeed find a way
out of his problem with it. The former is unlikely, since
nearly every sculpture of this interval involves a twisting
figure – visible most notably in two pieces called *Torment*
(1906–07). It seems more likely that Brancusi did find a way
out of his problem with symmetry, though a way out that
represented a paradox of sorts. For Brancusi overcame the
problem of symmetry simply by accepting it, or rather
recasting it. The symmetry of *The Kiss* is one of design in
competition with nature. The joining of two figures, and the
stylized manner in which they are rendered, introduces an
element of abstraction which nullifies the academic associa-
tions of the single human figure. And in Brancusi's mature
work, the elemental forms (those based on the egg, for
example) provide a way of representing the human figure
without implying a spine. They thus distance themselves
from academic naturalism.

Trunk is the culmination of these efforts. Although
retaining some vestigial appearance of naturalistic fleshi-
ness, it is the artist's first self-contained fragment-object.
The Brancusi we know begins here. Though it was the small-
est sculpture in the exhibition, it stood apart from the rest, a
work of sublime, quivering beauty.

The sculpture is, as I have already stated, a nude female
figure seen from lower abdomen to upper thigh, and bent
slightly at the waist. It is, in fact, the midsection of *The
Prayer* duplicated exactly but now on its own, like a single
brick removed from a wall. It thus shows Brancusi operat-
ing, for the last time, within the orbit of Rodin. Not only
is he making use of a partial figure, a Rodin staple, he is

cannibalizing his own work, something the older artist did constantly.

Yet the connection to Rodin hardly matters here. Rodin may be present in the idea of the partial figure, but what is important is that Brancusi does something entirely individual and new with it. His use of but part of a figure is the first step in his eventual transformation of the figure as a sculptural idiom.

We're so familiar with Brancusi, and so conditioned in the wake of much post-war art to the idea of formal simplicity, that it's easy to see him as an artist who merely reduced the figure in order to arrive at his characteristic sculptures, as though they had been turned on a lathe. *Trunk* shows that there is more to it than that. It stands apart because it conveys a greater feeling of physical density than any of the previous sculptures. This is partly a function of its material, stone, but only marginally so. The real reason is that Brancusi here subjects the figure to a powerful compression so that everything the body has to express – its function, its organic vulnerability, its capacity to speak through gesture – is contained in a single, integral mass. Simplification is part of what Brancusi does here, of course, but concentration is an equally important part.

Beyond the use of the partial figure, Brancusi achieves this feeling of compression and containment by two formal means. One is an unbroken contour, as hard and clear as a drawn line by Ingres, which simultaneously defines the outer limits of a shape and firmly contains it. Brancusi's line is like a lasso; as much as anything, its purpose is to restrain. We hear little about Brancusi's "drawing," yet it is vitally important to his art.

The other thing that contributes to the feeling of compression and containment that Brancusi's sculpture communicates is its evenly swelling mass. On planes facing the

eye, this translates the firmly enclosing line of the edge into a surface membrane containing the mass pushing against it from within. It was this feeling of organic mass contained behind a taut surface that allowed Brancusi to polish his marbles Salon-sculpture smooth without having to worry about their being infected with any of the saccharine preciousness of official art. He was expressing something entirely different.

Nowhere is this sensation of compression felt more acutely than in the realm of physical gesture. *Head of a Boy* shows Brancusi searching for a new way to incorporate gesture into his work, to articulate the figure in an expressive fashion, but without any of Rodin's overheated rhetoric. *Trunk* announces his solution to the problem, which is, quite simply, to internalize gesture, to make it subordinate to the physical mass of the sculpture. Here, the body bends – in a deliberately ambiguous action – yet without violating the sculpture's center of gravity or our sense of it as a thing. It is a discreet motion, one that announces the primacy of pure sculpture over narrative.

Brancusi's mature works follow the pattern established in *Trunk*. In the *Bird in Space* sculptures, the merest backward tilt is the only hint we get of physical motion. The effect is powerful, though; it suggests exultation. And in the Museum of Modern Art's *Fish* of 1930, Brancusi is even more extreme in asserting the primacy of the sculptural mass, but correspondingly more poetic in his suggestion of motion, which is what gesture turns into when your subject is the animal kingdom. There is no specific fish described here. Brancusi doesn't give us a wiggling form. Nor does he, as he might have done had he tackled this subject at the time he carved *Sleep*, leave a roughened marble surround to suggest water. Instead, it is all in the material. He gives us a slender, tapered slab of gray marble. Its generalized form

suggests something glimpsed in transit, while the flecks of white within the gray stone suggest light dappling the creature's skin as it moves beneath the surface of the water.

92 Upon quitting Rodin, Brancusi famously remarked, "Nothing can grow in the shadow of the great trees." "Masterpieces from Romanian Museums" showed that stepping out of that shadow entailed more for Brancusi than simply crossing the studio threshold. But is also showed him beginning to cast a sizable shadow of his own.

Originally published as "Becoming Brancusi"
in The New Criterion, *February 1991.*

THE POINT, though commonplace, cannot be made too often: for works of art to reveal themselves to the fullest, installation matters above all. Placement, lighting, the size and shape of the room, even the character of the floor and color of the walls – all these affect the way we perceive a painting, sculpture, drawing, or photograph. Nowhere is the truth of this principle more evident than at the Museum of Modern Art's new temporary installation of its sculptures by Constantin Brancusi.

Going back at least to the 1970s, when I began visiting MOMA on a regular basis, successive curators have always displayed Brancusi the same way: a half-dozen or so sculptures would be grouped together on a platform, one of whose edges was pushed against a wall. The idea, presumably, was to evoke the atmosphere of Brancusi's studio, which the artist curated as a kind of idealized sculptural environment – really, a work of art in itself – for the display of the large numbers of works that populated it. (At his death in 1957 at age eighty-one, Brancusi, who though Romanian lived and worked in Paris his entire professional life, left his studio and its contents to the French state. Today it can be visited in a Renzo Piano–designed outbuilding at the Centre Pompidou.)

Now Paulina Pobocha, an associate curator, aided by Mia Matthias, a curatorial fellow, have dramatically broken with the past, installing eleven sculptures in a second-floor gallery in a freestanding arrangement directly on the floor. (The show also includes drawings, Brancusi's own photo-

graphs, films, and archival material.) This may seem like a modest change, but the effect is nothing less than transformative, so much so in fact that in some cases I felt as if I were seeing certain long-familiar works for the first time. When seen in the studio-like groupings, Brancusi's sculptures tend to be read *as* a group, that is, each one seen in relation to the others – in terms of similarities and differences of form, size, subject, material, and so on. The other problem with the platform arrangement was that you could only view the sculptures from three sides. By contrast, set out as they are here, on their own and in a way that allows the visitor to circumnavigate them and thus experience them fully in the round, their individuality stands out – we are made more aware than ever of the unique character of each piece. The two sleek, gleaming versions of *Bird in Space* (1928 and *ca.* 1941) seem to shuttle back and forth between a state of pure form and one of pure energy, a more successful expression of the Futurist aesthetics of speed and motion than anything Umberto Boccioni achieved in his *Unique Forms of Continuity in Space* (1913). And *Fish* (1930) is stunning for the way it similarly holds form and illusion in perfect equipoise – Brancusi deftly exploiting the veining and color of the semi-abstract blue marble slab to suggest the watery world his subject inhabits.

Farther uptown, at the Solomon R. Guggenheim Museum, Tracey Bashkoff, the director of collections and senior curator, with David Horowitz, a curatorial assistant, has placed eight of that museum's Brancusis on long-term view.

Here, too, there are photographs (though not all by the artist), and in both cases their presence greatly amplifies our understanding of Brancusi and his art. At MOMA, for example, we can see a 1923 shot juxtaposing the naturalistic *Head of a Sleeping Child* (*ca.* 1908) and the semi-abstract *The Newborn II* (1916–20), a pairing that succinctly traces his

remarkable aesthetic journey. At the Guggenheim, one of a series of images by the Magnum photographer Wayne F. Miller shows a blurred Brancusi at work in his studio with, in the background, such a welter of metal rods and tools that without the presence of the artist the site might easily be confused for David Smith's studio. As with the other, the story it tells is of a journey, but now it is one involving materials. The heavy equipment is a testament to what it took in terms of both time and physical labor to transform the massive blocks of wood and stone that littered his studio into the scaled-down, smoothed, and polished forms that surround us in the galleries.

For its sculptures, the Guggenheim has chosen a hybrid display. Most of the works are freestanding, though *Muse* (1912) is backed against a wall whose blue color is designed to set off the white of the marble figure and brown of its wooden base. Three works, *Adam and Eve* (1921), *The Sorceress* (1916–24), and *King of Kings* (*ca.* 1938) are grouped together on a platform, MOMA-like, but in the middle of the gallery, making it possible to view these works from all sides. (An object lesson in how not to display Brancusi could be seen at the Pompidou this summer, where *Seal II* (1943), a later version of the same subject on view at the Guggenheim, was installed at a spot that functions both as display space and public area for visitors making their way between the escalators and the main exhibition galleries. As a result it existed more as an afterthought than something that invited scrutiny.) All in all, then, there are more Brancusis on view in New York at the moment than there have been for some time.

The MOMA press release states that the aim of its installation is to "demonstrate the artist's singular approach to materials." Does it ever. Brancusi is usually credited with pioneering the doctrine of "truth to materials" that was to

prove so influential on later modernists such as Henry
Moore and Barbara Hepworth, in which the sculptor strove
to bring out the "stoniness" of stone, the organic nature of
96 wood, and so on. That's true as far as it goes. But Brancusi
often combined materials within a given sculpture, and
what becomes clear in these installations is that for him
"truth to materials" really meant working each material in
such a way as to bring out the sharpest possible contrast
with every other material with which it is combined. Thus
in *Blond Negress II* (1933), the wooden base is rough-hewn,
with a formal complexity that speaks to the material's rela-
tive softness and malleability, and with no attempt to dis-
guise or repair the splits in its sides since these, too, are
marks of its uniqueness, a stone block being unable to hold
together in such a state. The marble-and-limestone support
resting on it is dressed and smoothed, but its surface is left
matte and unpolished so we are aware it is stone. The bronze
negress herself is polished to a high reflective sheen, as only
bronze can be. When Brancusi uses only two materials, as in
Muse, the extreme contrast between the dark, rough wood
and the pristine purity of the marble can be startling. The
impossibly insubstantial supports on MOMA's *The Cock*
(1924) and the Guggenheim's *The Sorceress*, in relation to
the masses they must hold up, call attention to the struc-
tures as something only possible in wood. At the same time,
as we've seen in the two *Bird in Space* sculptures and *Fish*,
when he chooses to be, Brancusi can be singularly "untruth-
ful" in his handling of his materials, and nowhere more so
than in MOMA's *Mlle Pogany, Version I* (1913). Here, while
most of the bronze sculpture – face, hands, and neck – is
polished to a rich golden hue, the top and back of the head
are patinated to suggest the model's dark hair color.

It's impossible to look at or think about Brancusi with-
out getting caught up in the matter of his bases. Every

account we have tells us that there was no fixity, no final "right" arrangement, that Brancusi was constantly chopping and changing, combining and recombining, not just individual sculptures and bases but entire categories of object, so that the words "furniture," "sculpture," and "base" became interchangeable terms from one arrangement to the next. Thus the rectangular form perforated on four sides that functions as the bottom element in the Guggenheim's *King of Kings* appears in a 1917 photo of the studio as part of the base for *Prometheus* (1911) – now in the Philadelphia Museum of Art – and again in a 1923 self-portrait photo as an ottoman on which Brancusi rests his feet while sitting in a cushion-lined easy chair fashioned from the trunk of a tree. No arrangement was ever considered permanent, and sometimes they were indeed intended to be temporary, put together only long enough to be photographed, then broken down.

Who does this sound like? Marcel Duchamp, who in his Readymades similarly blurred – or violated – the boundaries between artwork and utilitarian object, and whom the Romanian knew and became friends with, is widely credited as the source of this impulse in Brancusi's art. But in terms of the way it played out for Brancusi – the lack of fixity, with every work or ensemble open to continuous revision and rearrangement as opposed to achieving a definitive resolution – I feel there is a prior example: Rodin and the *Gates of Hell*. Brancusi spent a month in 1907 working as one of Rodin's studio assistants (later famously explaining his swift departure with the words "Nothing can grow in the shadow of the great trees"). There he would have seen the *maître* at work on the commission for doors to the entrance of a (never ultimately built) museum of decorative arts. Rodin worked on it continuously from 1880 to his death in 1917, never bringing it to a satisfactory resolution. Indeed its salient

characteristics became creative flux – figures and figure-fragments combined and recombined, moved from one position on the doors to another, to be repurposed yet again as independent artworks. In this way, Rodin transformed the practice of sculpture from the creation of works begun at one moment and considered finished at another, to an open-ended, continuous process in which there was no definable "end." It is this approach which underpins Brancusi's actions in the studio.

So it would appear to be impossible to speak of any "logic of the bases." But in one area, I believe we can. There are about a dozen works consisting of multiple parts: a two-part base – one of wood and one of stone – topped by a sculpture. The group includes MOMA's *Blond Negress II* and *Young Bird* (1928) and the Guggenheim's *The Sorceress*. In all, the wooden element is on the bottom. This defies structural logic, since, to ensure maximum stability of any vertical configuration, the stone element, being the heavier of the two, should be on the bottom. Why did Brancusi do this? One reason might be symbolic. As the *Bird in Space* and *Endless Column* sculptures attest, vertical thrust is a recurring theme in Brancusi's art, and I've always seen a similar vertical rhythm in many of these pieces, such as MOMA's two, starting from the wooden element at the bottom. There seems to be an upward trajectory of refinement and transfiguration, from raw, rough-hewn wood, to dressed stone to reflective, dematerialized bronze. This would seem to be intentional. In one of her books, the Brancusi scholar Edith Balas quotes the artist speaking of "The theory of the luminous, living pedestal as a starting point of the sculpture – sculpture which is conceived from the floor or earth upward." Wood, of course, originates in the earth in the form of the tree. And here again we have Brancusi's own testimony from Sanda Miller, another Brancusi scholar. She quotes the art-

ist's early biographer Carola Giedion-Welcker recalling that around 1916 Brancusi had been "overwhelmed by emotion in watching 'the development and growth in space of trees.'" So the wooden bottom element in these sculptures would seem to be a conscious reference to rootedness to the ground and a concomitant upward, organic evolution.

But I think there was also a practical reason. With stone on the bottom, there was always the risk that that element would be read as the traditional plinth, something separate from, rather than integral to, the work as a whole. This is not to say Brancusi didn't use stone bases. But in this group of works, he seems to have felt that the imperatives of creating a new, modernist sculpture demanded a wood base.

Brancusi's use of wood as the bottom element in these sculptures sheds light on the larger challenge he faced in his art. What makes a Duchamp Readymade register as it does is that even as the bicycle wheel, bottle rack, or whatever it is, acquires a new identity as an art object upon its transfer to the gallery, it retains its identity as a utilitarian object from the everyday world we inhabit. For Brancusi, the opposite was true. To succeed, his sculptures had to be both part of the everyday world, sharing our space, and as real and tangible as ourselves and the things around us, yet at the same time existing at a remove, as things apart.

The nature of this challenge – and the stakes involved – is dramatically evident in MOMA's *Young Bird*. A polished bronze "bird" – a sort of teardrop form with part of its front sheared off to leave a smooth plane – sits atop a cubic limestone block. They, in turn, rest on a modular wooden base carved into a central, solid cylinder framed top and bottom by half cylinders. The sculpture comes perilously close to reading as a decorative object set out for display on a stylized support. In other words, Brancusi's formal unity and our understanding of this thing as a work of art break down

completely. Why? It is too clean, too trued and faired, too plumb. The wooden bottom unit isn't rough-hewn but as smoothed and sanded as the stone block above it, and its form is about as regular. Everything is perfectly aligned and centered, and there is a uniformity of form, surface, and texture that speaks of the rationalizing impulses of industrial design, where new objects must fit easily into the world of everyday things without any surprises or disruptions. It's possible to imagine this work sitting in a shop window or department-store display in a way that isn't possible with *Blond Negress II* or any of his other works. And that is why, I think, Brancusi puts wooden elements, not stone ones, on the bottom. By deliberately defying the structural logic that – of necessity – defines the assemblage of everyday things, he moves his work into the realm of art.

But, as we can see from *Young Bird*, that by itself isn't enough. So he does something else: engages with issues of weight and balance not so much to defy gravity as to move his work into a zone where gravity – the defining feature of our earthly life – is not a factor. Thus Brancusi's reflective supports in Paris and Philadelphia create a space in which the form upon it appears to float. The later of MOMA's two *Bird in Space* sculptures tilts well off the vertical. As previously noted, MOMA's *The Cock* and *The Sorceress* are strikingly top heavy, as is MOMA's *Socrates* (1922), essentially a double cylinder perched atop a thin stalk. The nearly six-foot-long marble slab that is *Fish* is, literally, poised on a knife edge, its sense of precariousness intensified by the minuscule support directly under it – a marble cylinder just a few inches in diameter. Then of course there is *Blond Negress II.* Much of its appeal, surely, stems from the frisson instilled by Brancusi's perilous dalliance with its center of gravity: the front of the bottom oak support has been deeply cut into and reduced, while the egg shaped bronze head is

poised on the forward edge of its small cylindrical support. We are a long way, here, from *Young Bird*. Brancusi's introduction of weight, balance, and gravity into his object sculptures ensures that we read them as being in the world, but not of it.

In these respects and many others, MOMA's Brancusi display is a revelation. The wonder is that the museum took so long to recognize the benefits of installing the work in this way. Let us hope that it will become the new institutional model, and thus the way we will see Brancusi when MOMA reopens next year at the conclusion of its latest expansion and renovation.

Originally published as "Displaying Brancusi"
in The New Criterion, *December 2018.*

Jacob Epstein et al.:

Bright-eyed British moderns

EVERY NOW AND AGAIN an exhibition comes along that not only puts great works of art on view and deepens one's understanding of the subject under review but also upends or substantially revises the received wisdom surrounding that subject. "Wild Thing: Epstein, Gaudier-Brzeska, Gill" at the Royal Academy in London is just such an exhibition. Organized by the British art historian and critic Richard Cork, an authority on early British modernism, "Wild Thing" brings together some ninety sculptures and works-on-paper by the three artists who between them initiated Britain's sculptural revolution in the first decades of the twentieth century: the Englishman Eric Gill (1882–1940); Jacob Epstein (1880–1959), an expatriate American; and Henri Gaudier (1891–1915), an expatriate Frenchman and self-taught sculptor who added the surname of his Polish common-law wife, Sophie Brzeska, to his own.

The show recreates a pivotal moment in the history of both British and modern art and is of immense value for other reasons as well. It serves as a virtual retrospective of Gaudier-Brzeska, offering the opportunity to take the measure of an artist whose work one rarely sees outside of individual museum collections but is widely regarded as the catalytic force in British sculpture of the period. Even more important is the presence of a reconstruction of Epstein's *Rock Drill* (1913–15), a work with a complicated history that has been known for most of its life only in a truncated form

that has distorted, even obscured, its meaning and importance.

The show's title is derived from a description of Gaudier-Brzeska written by the American poet Ezra Pound – yet another expatriate living in London – after their first meeting as "a well-made young wolf or some soft-moving, bright-eyed wild thing." It can also be read as a metaphor for the impact of all three on the art and society of their time. They espoused direct carving, rejected the imitation of nature in favor of subjective modes of representation that frequently drew on the forms and images of non-Western art, and their work was often frankly sexual. It was thus deeply shocking, even repellent, to a nation still firmly tied to the Edwardian social and aesthetic values that had been slow to embrace Impressionism, much less the innovations of Matisse, Picasso, and Brancusi. As a result, Epstein, Gaudier-Brzeska, and Gill were denounced as barbarians by the arbiters of taste even as they paved the way for sculptors of the next generation such as Henry Moore and Barbara Hepworth.

"Wild Thing" is organized sequentially by artist: Gill occupies the first gallery, Gaudier- Brzeska the second, and Epstein the final one, presumably to convey a clear sense of each as a distinct artistic personality. Gill comes across as the most formally conservative of the three. His simplified figures, which he began making around 1910, are so tame they hardly register as "modern," until one remembers how radical they would have seemed to an audience that only two years before had reacted with outrage to Epstein's carvings for the British Medical Association in the Strand, eight frankly nude figures, unadorned and unidealized. There was nothing conservative about Gill's subjects, however: A typical work, *Ecstasy* (1910–11), is a relief showing a couple achieving sexual climax. Gaudier-Brzeska confirms his reputation as a sculptural dynamo, experimenting willingly,

almost recklessly, with every new work a new departure displaying ambition and mastery in equal proportion. And Epstein is as in love with carving and sex as Gill, though visibly involved with a wider array of sources and influences, mainly non-Western art but also the sculpture of Brancusi.

The reality that emerges is that their modernist odyssey was a group effort. Braque famously described his relationship with Picasso in the years of pioneering Cubism as being like two climbers roped together. The relationship between these three wasn't that close – after an initial friendship, Gill and Epstein fell out – but it's clear that there was much contact and mutual influence between the three. It seems unlikely that any one artist could have invented a fully modernist sculpture on his own. Gill reinforced Epstein's commitment to direct carving; Epstein, in turn, introduced Gaudier-Brzeska to it. Gaudier-Brzeska's radical innovations sparked the older Epstein's competitive edge, pushing him to more radical endeavors. They took up similar subjects – both Gill and Gaudier-Brzeska sculpted athletes (Gill his *Boxers* in 1913, Gaudier-Brzeska his *Wrestlers* a year later). In the installation this relationship is deftly communicated, for example, by the close proximity of Gill's *The Virgin* (1911–12) to Gaudier-Brzeska's *Singer* (1913), which share strong verticality and an almost Cycladic simplification of form.

It's understandable, even correct, to portray this as a heroic moment, when the visionaries, by force of talent and perseverance, dragged the philistines kicking and screaming into the modern era. Yet, if we are to do justice to the achievement of these artists, we have to tell the whole story, and that means saying that they – Gaudier-Brzeska and Epstein in particular – in many ways succeed in spite of themselves. Seen today, much of their work looks dated, jejune, or both, hobbled by inadequately digested sources,

an overweening desire to épater les bourgeois, even a poor comprehension of what modernism represented.

It's only a slight exaggeration to say that their aesthetic recipe might be described as two parts sex, one part "primitive" art, one part Brancusi, and a pinch of Cubism, all served in large dollops to an uncomprehending public. This is particularly true of Epstein: he favors us with not one but three sculptures of copulating birds, none of them small; his *Mother and Child* (1913), a side-by-side double bust of a mother and her offspring that consists of little more than a sphere and an oval, suggests that he believed the lesson of Brancusi was *reductio ad absurdum*; and his *Figure in Flenite* (1913), a sinuous, curving sculpture of a pregnant woman, is overwhelmed by its visible debt to African art. The besetting weakness of these sculptures and others like them is that they never transcend their sources, using them as stylistic borrowings rather than as tools in the invention of a wholly new artistic language.

For this reason the breakthrough pieces – the fully realized, wholly original works – are all the more arresting. This is evident in three sculptures by Gaudier-Brzeska. His powerfully rhythmic *Red Stone Dancer* (*ca.* 1913) goes way beyond Gill's simplified naturalism to move the depiction of the human form into hitherto uncharted territory far removed from the Greco-Roman tradition. At the same time, it was the most plastically alive piece by any of the three so far, as much an exploration of balance and mass as the figure in motion. Gaudier-Brzeska has cut deeply into the block, so the large mass of the torso is cantilevered over the legs and supported only by a narrow, nipped-in waist. His *Bird Swallowing a Fish* (1914) updates themes of a violent and unsentimental natural world explored by such nineteenth-century sculptors as Barye and Frémiet into a fully modernist idiom by means of a stylization that pushes the entire work to the

brink of abstraction. His *Hieratic Head of Ezra Pound* (1914, represented here by a 1973 replica because the original, in the Nasher Collection, is too delicate to travel) may be as frankly sexual as anything in the show, a portrait expressed as a giant phallus. But, for once, a work's erotic content is not an end in itself but a metaphor. Like Rodin in his monument to Balzac, Gaudier-Brzeska here reinvents the sculpted portrait to give us an image of the artist as a procreative force.

Yet for all his talent and innovation, Gaudier-Brzeska's work was predicated on a failure to grasp the essence of modernism. For all his eclecticism, the common denominator in Gaudier-Brzeska's work was that his approach to form was based on a progressive stylization, not transformation. It first appears in the treatment of the face, hands, and breasts of *Red Stone Dancer*, gathers force in the handling of the facial features in *Hieratic Head of Ezra Pound*, and reaches its fullest realization in *Bird Swallowing a Fish* and *Torpedo Fish* (1914). This last is a work so stylized that the image in nature has been completely subsumed to the decorative handling of form. The result is a work that bears a closer resemblance to an everyday appliance – a bottle opener, say – than a work of art.

It can be no accident that one of the modernist sculptors Gaudier-Brzeska professed to admire was Alexander Archipenko. It's never very useful to play "What if?," yet it's hard to survey the run of Gaudier-Brzeska's work and not conclude that, had he lived (he was killed in action on the Western Front in June 1915), it seems likely that this tendency would have provoked, at the very least, a crisis in his art and perhaps ultimately relegated him to the second rank. *Torpedo Fish* shows him approaching a dead end. He would have had to change course radically or spend the rest of his career marking time.

The greatest revelation of the show is Epstein's *Rock Drill* (1913–15). It is a masterpiece and a work without precedent in his œuvre. The reconstruction shows a strange, white humanoid figure perched atop and operating an actual pneumatic drill of the kind used in quarries, hence its description as a "rock drill." He sits astride the black instrument, long legs splayed into an arch while the long, chisellike drill bit and its mechanical housing seem to protrude from his loins. The torso variously suggests a skeleton or an *écorché* or flayed figure, while the sinister, hooded visage looks out sullenly and distractedly into the distance, a cross between an industrial object such as a helmet and a duck's bill. It is an immensely powerful and, even now, deeply unsettling work, an image of man and machine, man as machine, frankly sexual yet, as with Gaudier-Brzeska's Pound, metaphorically so: the machine as creator and destroyer.

Epstein created "Rock Drill" as a celebration of the machine age. But with the onset of World War I, the artist came to rue his glorification of an ethos that was destroying so much of humanity, all the more so when he lost his friend and artistic comrade-in-arms Gaudier-Brzeska. He dismantled the work, saving only the torso, which he exhibited in cast bronze with the figure's right arm cut off at the elbow. (One such cast is on display here alongside the reconstruction.) Thereafter, Epstein turned his back on modernism, became dismissive of abstraction, and turned from direct carving to modeling some very fine portraits and some not so fine religious and allegorical subjects.

One can easily understand Epstein's motivation given that, in the aftermath of the war, the drill reads equally as an artillery piece. Still, seeing the cast in place of the full sculpture is like trying to understand the full import of Bernini's *David* seeing only the head. For *Rock Drill* is a work of radical invention and formal innovation of comparable force. It

combines traditional modeling and assemblage (in the catalogue, Mr. Cork notes the irony of an apostle of direct carving producing his greatest work as a modeler); the found object and invented form; and a reinvention of the human figure at last *sui generis* and wholly independent of all precedents. More than that, however, Epstein's mutilation of his own work has denied us one of the most powerful commentaries on our time made by any twentieth-century artist. Far from being diminished by changing historical circumstances, the meaning of *Rock Drill* has been enlarged and deepened, surely a unique fate for a work of art. What started out as an ode to a glorious utopian present reads today as a remarkably prescient, darkly Freudian allegory of the underside of the machine age.

In the lore surrounding the origins of British modernist sculpture, it is Gaudier-Brzeska who is seen as the great innovator, an artist whose promise was sadly cut short by his premature death. Epstein has been something of an also-ran, although he has been recognized for his pioneering early work and for his mentorship of Gaudier-Brzeska. He has also been credited, as Henry Moore said at his death, as the English artist who "took the brickbats ... took the insults ... and faced the howls of derision" such that later modernists, like Moore himself, "were spared a great deal, simply because his sturdy personality and determination had taken so much."

The state of Epstein's reputation has something to do with Gaudier-Brzeska's incandescent talent and the reaction to his tragic loss – the posthumous mythmaking by Pound and H. S. Ede in books they wrote on Gaudier-Brzeska, bearing such titles as *Savage Messiah* (itself turned into a characteristically over-the-top film by Ken Russell in the 1970s). It also has to do with Epstein's perceived apostasy in returning to representational art. But surely a good measure of the

blame rests with Epstein himself for effectively destroying *Rock Drill.*

Epstein emerges from "Wild Thing" triumphant: it's clear from the reconstruction of *Rock Drill* that it was he, and no one else, who brought the early twentieth-century revolution in British sculpture to its fullest fruition, the only one to produce a work of art capable of holding its own next to anything that had been produced in Paris in the preceding two decades. It would not be going too far to describe it as the *Demoiselles d'Avignon* of British modernist sculpture. He had learned that modernism involved not merely transformation but transfiguration of the subject in nature, and that beyond its anti-classical formal language the deeper lesson of "primitive" art was evocation of primal, even irrational forces through totemic presences. *Figure in Flenite* elicits nary a frisson. *Rock Drill*, on the other hand, is a haunting, almost harrowing image, even now, just a few years shy of its one-hundredth birthday. *Rock Drill* may have been a one-shot – Epstein never equaled, much less surpassed this work ever again. But sometimes that's all you need to achieve immortality.

Originally published as "Bright-eyed British modern"
in The New Criterion, *December 2009.*

Charles Sargeant Jagger:
An unblinking view of war

NOVEMBER 14 is Remembrance Sunday in Britain this year. While it is has by now become an occasion to honor service-men and servicewomen killed in all wars, its origins as a World War I commemoration remain very much present. This is apparent in the tradition of wearing paper poppies, a reference to the flowers growing in the fields of Flanders at the time, and in the day's culminating ritual – when Queen Elizabeth lays a wreath at the foot of the Cenotaph in White-hall. A tall stone monolith inscribed "The Glorious Dead," the Cenotaph was designed by Sir Edwin Lutyens and erected in 1920 to honor those killed in the Great War.

The Cenotaph's restrained, simplified form and ennobling inscription (the words were supplied by Rudyard Kipling) make it a dignified focal point for remembrance. But memo-rials need to communicate as well as commemorate, and for that reason I have always been more drawn to a World War I monument just a few miles away: Charles Sargeant Jagger's 1925 Royal Artillery Memorial at Hyde Park Corner, which both honors the dead and vividly evokes the conflict.

In his 1991 book *A War Imagined*, the historian Samuel L. Hynes wrote that World War I opened "a gap in history." It "changed reality," he argues, by adding "a new scale of vio-lence and destruction" to what had previously been known. "That change was so vast and so abrupt as to make the years after the war seem discontinuous from the years before.... Men and women after the war looked back at their own

pasts as one might look across a great chasm to a remote, peaceable place on the other side."

One area in which this discontinuity was most immediately and keenly felt was in memorials to the war. After the carnage on the Western Front, where tens of thousands of soldiers were killed with no ground gained, the old modes of commemoration – heroic figures extolling martial virtues – ceased to be credible. Different approaches had to be invented, ones that accommodated themselves to the new truth of war without seeming to diminish the cause and the soldiers' sacrifice, or shocking the public by focusing too frankly on the war's barbarity and waste. In this work, Mr. Jagger navigated those treacherous aesthetic shoals to produce a moving memorial that is also a timeless work of art.

Unlike the Lutyens memorial, which speaks for all, Mr. Jagger's pays tribute to a single regiment, the Royal Artillery, which, an inscription tells us, lost "FORTY-NINE THOU-SAND & SEVENTY SIX" of their number in the war – the precise accounting of the dead evoking a poignant sense of loss.

And where the Cenotaph is generalized and abstract, the Royal Artillery Memorial is representational and specific. The centerpiece is an enlarged Portland stone replica of a Howitzer. It may seem incongruous that the memorial depicts in the most ancient material of the sculptor's craft an emblem of the mechanized mass killing the war had introduced, but the material serves as a distancing mechanism. In metal it might have been too explicit a symbol. Around the rectangular base, reliefs depict the regiment in action. Placed in front of each of the four sides, as if against a wall, is a life-size bronze figure: "Artillery Officer," "Driver," "Shell Carrier," and "Recumbent Artilleryman," this last an image of a dead serviceman shrouded in his greatcoat with his helmet resting atop his body.

In these figures, Mr. Jagger adopts a naturalistic style no doubt informed by his own war experiences in the Gallipoli debacle. Rather than being icons or generic types, his figures read as flesh-and-blood individuals who have just come off the battlefield. Even so, the frankness of "Recumbent Artilleryman" comes as a shock. Mr. Jagger has rejected common euphemisms, such as the figure borne by angels, opting instead for the most baldly and boldly factual depiction of death seen in a public monument up to that time.

In doing so Mr. Jagger ran smack up against the cultural sensitivities of the day: The sculptor had to get permission from the memorial committee to site the figure so close to the ground, lest doing so upset widows and other survivors. Equally problematic was the inscription he chose to wrap its base – "HERE WAS A ROYAL FELLOWSHIP OF DEATH" – its pessimism far removed from Kipling's elevated language on the Cenotaph. This, too, required the committee's approval and received it only because its pedigree – Shakespeare's *Henry V* – served as another distancing mechanism.

The art historian Ann Compton, in her 2004 study of Mr. Jagger, singles out two distinguishing characteristics of his art: "the link between combat and dress," and the "intimation of the accidental or passing moment." Both are central to "Recumbent Artilleryman." In contrast to the starched uniforms depicted in traditional commemorative monuments, the clothing on this and Mr. Jagger's other figures looks well-worn, as if they had been long on the front lines without fresh equipment.

Indeed, "Recumbent Artilleryman" is almost all about the clothing. We barely see a figure, only the exposed calves and feet, a hand and the glimpse of a head through the folds of the greatcoat.

The coat itself falls loosely, even casually around the figure, as if tossed rather than draped over it. And in an

inspired narrative device, Mr. Jagger has inverted it, positioning it with the collar at the figure's knees and the rear vent at his head. (It is this that exposes what little we can see of his face.) Its overall disposition suggests a tragic haste, as if the dead man's battle-harried comrades had time to pay only the briefest of respects before plunging back into the fray. Despite having zeroed in so concretely on a specific moment in a particular war, Mr. Jagger has nonetheless attained the universal, creating an unforgettable memorial to the pathos of all war.

Originally published as "Masterpiece: The Royal Artillery Memorial (1925): 'Here Was a Royal Fellowship of Death'" in The Wall Street Journal, *November 13, 2010.*

Naum Gabo: Utopian visions

THE TERM "CONSTRUCTIVISM" is one of the most unstable in the modernist lexicon. Broadly speaking, it describes sculpture that is made by joining discrete masses into open-form, usually abstract compositions. It differs from traditional sculptural methods which require the artist to cut away (as in carving) or build up (as in modeling) his materials so that they form a self-contained, monolithic mass. The Constructivist method was invented by Picasso in the sculptures he produced using cardboard, sheet metal, and other materials to represent a particular object – the most famous is his *Guitar* of 1914 – by reconstituting its elements into a series of open, overlapping planes. As a result, a new role was assigned to space in defining our perception of sculptural volume. Picasso's innovations in this field were taken up by scores of later sculptors, the most distinguished among them being Julio González, David Smith, Anthony Caro, and Mark di Suvero.

There is another Constructivist tradition, however, which tracks a different artistic course. It, too, grew out of Picasso's sculpture, but evolved in Russia in the Revolutionary period largely under the leadership of Vladimir Tatlin. On a trip to Paris in 1913, Tatlin saw some of Picasso's constructed reliefs in the artist's studio ("Don't talk to the driver," an exasperated Picasso is supposed to have snapped in response to the Russian's insistent questioning about methods and materials), and on returning home immediately set to work in developing his own version of this new sculptural genre. He thus laid the groundwork for what was to become the Russian form of Constructivism.

Despite the debt which this new sculptural genre owed to Cubism, and, incidentally, to Futurism as well – examples of which were readily accessible in Russia at the time – the Russian avant-garde made something very different out of it. In the Constructivist vision as it evolved in pre- and post-Revolutionary Russia, the artist came to be regarded as an indispensable agent in the creation – or rather, the *construction* – of a new and better (by which was meant a socialist) society. And while these new Constructivists made use of Cubism's vocabulary of open forms and its syntax of interlocking planes, they did so in an entirely nonobjective style. The materials used by the Constructivists were hailed for their superior "reality" – their congruence with the world of everyday things – and were employed in compositions which rejected whatever had remained of Cubism's illusionism. The new Constructivism attempted to remove the barriers separating the actual space of the viewer from the virtual space of the work of art. Out of this approach Tatlin evolved his doctrine of the "culture of materials," which enjoined the artist to exploit the characteristic properties of his materials (one of these being space itself). Thus, while cubist construction was exclusively an aesthetic matter, with no concern beyond its artistic realization, its Russian counterpart, fired by a Utopian vision, embodied an entire social ethos.

It is to this Russian branch of Constructivism that Naum Gabo, whose retrospective, "Naum Gabo: Sixty Years of Constructivism" was lately seen at the Guggenheim, belongs. Gabo's place in the Russian avant-garde was rather an equivocal one, however. He was abroad from 1911 to 1917, so his artistic outlook was formed on his own, outside the Russian avant-garde movements which flourished at the time. Shortly after his return to Russia in 1917, moreover, he led the split away from Tatlin's group, which advocated a purely

utilitarian, propagandistic role for art. In his *Realistic Manifesto* of 1920, Gabo advocated an art that addressed itself exclusively to the spirit, maintaining that such an art need not be incompatible with the aims of social and political reform. The publication of the manifesto – it was posted in places formerly reserved for decrees from the Czar – coincided with the only public exhibition Gabo ever had in Russia, one organized by himself. One might expect that, having seized the initiative in this way, Gabo would have moved into a position of leadership within the avant-garde. But this was not the case. He remained aloof, as he always had been, participating in discussions and debates at the V KhUTEMAS – State Free Art Studios – in Moscow but accepting no official position there. His open break with the utilitarian Constructivists notwithstanding, Gabo never disavowed the Constructivist movement's emphasis on modern materials, its view of the Constructivist idea as emblematic of the modern age – nor, for that matter, its Utopian vision.

Despite Gabo's equivocal relationship to the Russian avant-garde, it is against the backdrop of its personalities and events that his work needs to be understood. His sculpture constitutes a kind of dialogue between the opposing attractions of orthodox Constructivism's public voice and the private, very different dictates of an inward sensibility. For Gabo brought something personal and extra-artistic to the avant-garde circles of Russia at this time – an interest in the new discoveries concerning space and time in physics, and an ardent desire to give them artistic expression. In Gabo's mind, these discoveries represented the defining issues of the modern era, and no contemporary art claiming to represent the spirit of the time, he felt, could afford to ignore them.

Gabo is one of the few members of the Russian avant-garde to have made anything enduring from Constructiv-

ism once outside the white heat of the Revolutionary environment. Yet in spite of his importance, past retrospectives of his work – the last one was nearly twenty years ago – have been hampered by serious difficulties because much of his work was lost, partially disassembled, poorly restored, or withheld from exhibition. More than is usually the case, therefore, this retrospective represents a concerted effort to unlock the many mysteries surrounding Gabo and to present as nearly as possible a definitive account of the artist. Works have been retrieved from obscurity and restored. (*Constructed Head No. 1*, Gabo's first constructed sculpture, is exhibited for the first time in half a century.) Elaborate research and documentation have also been undertaken to put the Gabo œuvre in order.

There is one omission worth commenting upon, however. That is the important *Construction* of 1951 in the Baltimore Museum of Art. Suspended in a stairwell, this sculpture is the realization of longstanding ideas concerning the use of a staircase to afford continuous, changing perspectives of a single work. At fifteen feet in height, it would have looked superb in the well of the Guggenheim's rotunda, and would have offered viewers making their way down the ramp their one opportunity to experience of a critical element in Gabo's aesthetic: dynamic motion in space experienced through time. As the show was mounted – with many of Gabo's works backed into the bays that form the museum's temporary exhibition space – the viewer could glimpse this aspect of Gabo only sporadically and imperfectly.

Gabo's artistic career is one of very definite highs and lows. During the decade 1915–25 – the time of his debut as a mature artist – he produced work in which there is scarcely a false note. This phase coincides with his wartime residence in Norway, his return to Russia and involvement with the avant-garde, and his later sojourns in Berlin and Paris.

If one knew nothing of the artist who made the work of this period, one would easily conclude that he had spent all those years in a basement studio, so steady and assured is his achievement.

118

During the following two decades, however, this consistency diminishes, until by 1950 it becomes clear that Gabo's career as an innovative artist is effectively over – a fact tacitly acknowledged by Steven A. Nash in his catalogue essay, where scant consideration is given to this concluding phase of Gabo's career. The art of these years turned lifeless as the artist began thinking more and more in terms of monumental public sculpture. As a result of this dramatic falling off, the Guggenheim exhibition ends – inevitably – in anticlimax.

Gabo's first sculptures, composed of interlocking planes and entitled *Constructed Heads*, are often thought to constitute critiques of comparable cubist sculptures by Picasso, work of the sort Tatlin had seen in 1913. In fact, they are critiques of sculpture in general – of the traditional closed monolith – as well as manifestos for the new, more modern form of three-dimensional expression Gabo envisioned. In 1913 he had gone on a walking tour through Italy but had been unable to respond enthusiastically to what he had seen, feeling it was "dead" and that consequently, "something ha[d] to be done in sculpture." The *Constructed Heads* are Gabo's answer to this quandary.

Although derived to some degree from the contemporary geometric abstraction Gabo would have seen in Munich and Paris, these early sculptures reflect more directly his studies of engineering, one of many subjects he turned to after studying medicine for a while in Munich. In particular they draw on principles of structural engineering, using thin planes to create volume with the minimum of mass, just as steel-girder construction does. At the same time they show Gabo's new attitude toward the role of space in sculp-

ture. Like Tatlin, Gabo considered Cubism to be inherently "false" – an illusion – and believed that space in sculpture had to become more "real." But unlike Tatlin, Gabo was not aiming at a metaphor for a new social reality. Rather, he wished to express the spirit of the age by taking as his "subject" newly formulated concepts concerning the nature of space and time (e.g., Einstein's theory of relativity).

In *Constructed Head No. 1* and *Constructed Head No. 2*, both from 1915, mass is expressed entirely in terms of interior structure, where volume is suggested by the linear contours of the plane edges. With the figure opened up so thoroughly, interior space – articulated by planes – is revealed in order to fuse with the surrounding, literal space of the viewer.

In spite of this bold approach to problems of sculptural language, and their considerable degree of success, these Heads remain tied to the past in important respects. Because the plane edges defining the volume of the figure imply a skin around it, Gabo reveals only an *interior* space, a space permanently separated from ambient space. The *Constructed Heads* thus fall short of that direct relationship between actual and aesthetic space which Tatlin achieved at about this time in his own reliefs, where metal rods project directly off the background plane and out into the space of the room. Ironically, Gabo's sculptures engage with ambient space in a way that is very much akin to the Renaissance sculpture he had felt such antipathy toward on his trip to Italy.

A further respect in which the *Constructed Heads* belong to the past is in the play of light and shadow that animates them. This play endows them with a pictorial quality which goes against the greater sculptural purity Gabo was seeking. Finally, *Constructed Head No. 2*, with its folded hands and tilted head, projects a deeply contemplative mood. Dr. Nash accounts for this by alluding to Gabo's affinity for Russian

icons – an affinity he shared, as Dr. Nash also points out, with Tatlin, Malevich, and other members of the avant-garde.

Gabo's idea that sculpture should express the new dynamics of space found its earliest successful realization ten years later in *Construction in Space with Balance on Two Points* in the collection of the Harvard Art Museums, one of the pre-eminent works of modern sculpture. Gabo uses celluloid here, a contemporary antecedent of Plexiglas. Its transparency makes it appear immaterial and weightless, and helps to reduce sculptural mass. The main portion of the work is a complex of two interlocking cubic volumes placed at forty-five-degree angles. Both are reduced to the barest form. One volume, perpendicular to the sculpture's base, is formed by a vertical, transparent plane bisecting a negative horizontal plane formed only by four black edges. The second volume is made up of four narrow white strips, two attached to one side of the vertical transparent plane of the first volume and two attached to the other side. This structure is then suspended above a semicircular strip resting on its outer, curved edge.

Throughout *Points* there is the barest indication of volume, or even material presence. By opening up the sculpture, and by underscoring the immateriality of the transparent planes, Gabo achieves that free interaction with space that eluded him earlier. So successful is he in this respect, that *Points* engages with space in a manner quite different from any sculpture before it. It goes beyond a simple physical involvement with space in the manner of Picasso and Tatlin and enters a realm in which it is no longer clear where matter ends and space begins. *Points* seems at once to contain space and to be constructed from it, even to move through it while remaining at rest.

Gabo achieves these extraordinary results with a series of deft oppositions. Movement, for example, is suggested by

the syncopated rotary motion of the white planes, the zig-zag horizontal trajectory of two black edges, the luminescent white edges of the transparent planes, and, finally, by the rotation of the cube structure and balancing support around a central vertical axis. Against this is set an almost classic stasis, achieved by the seemingly weightless suspension of the vertical clear plane and by the position of the entire structure on a single plane edge. The opaque black and white planes seem to affirm the work's material presence; the transparent sheet calls materiality into question.

Points highlights an important aspect of Gabo's art: his commitment to an aesthetic realization of his experience of the new scientific reality he perceived around him, one based on line, texture, volume, and, of course, space. This is why one need not be familiar with the science that was so often Gabo's starting point in order to appreciate the work that came out of it. And it remains the key to his enduring importance in an era in which nonaesthetic elements – mechanics and technology among them – have come to play an ever-larger role in art.

During the years between his *Heads* and the making of *Points*, many of Gabo's sculptures and drawings were designed for fountains and other types of monuments. Architecture and monumental sculpture had increasingly made their way to the center of the Constructivist aesthetic. For example, Tatlin's *Monument to the Third International*, never finally built, was to have been an enormous structure of rotating conference and assembly halls. The appeal of the monument lay partly, of course, in the means it offered of symbolizing and publicly proclaiming the new gospel of Utopia. Further, it reflected the Constructivists' changing view of art and of themselves. During the Twenties, they gravitated to architecture, believing it to be the logical extension of the Constructivist method in sculpture. It also

fulfilled their image of themselves as builders, common laborers in the forming of a new society – this in contrast to the self-absorbed, bourgeois aesthetes of capitalist society.

122 Gabo, of course, never shared this utilitarian view of the artist's place in society. But he did subscribe to the Utopian ethos, and it is this that explains his commitment to the idea of the monument as a standard part of the repertory of sculpture. The fact is, however, that Gabo was never able to translate his private vision into public sculpture. *Monument for an Airport*, for example, was executed shortly after *Points*, and out of identical materials – black, white, and transparent planes. But how different it is! Wanting to express the concept of dynamic aerial motion, Gabo "floats" the planes above the base and angles them forward, even shaping the transparent forms into parallelograms to suggest forward impulsion. After the quicksilver energy of *Points*, the *Monument for an Airport* communicates all too literally the nature of flight – the lofting of inert, heavy masses with great effort. The transparent planes have none of the weightlessness or immateriality of their counterparts in the earlier sculpture. Nor are we inclined to read the planes as fields of energy, as we do in *Points*. They are simply hard, flat surfaces that happen to be transparent.

It seems Gabo alone was unable to recognize this limitation in his work. As late as 1952, when his international reputation was firmly established, Gabo's entry into the English competition to construct a monument to an unknown political prisoner was turned down by the jury. While they felt the model worked moderately well, they said that "… on a monumental scale … it would register much less effectively, making us all too aware of its lack of pity and terror." Success eluded the artist in a similar proposal carried out in Rotterdam five years later – and for the same reason. Its large size notwithstanding (it is eighty-five-feet

tall), it never bridges the gap between its self-referential abstract idiom and the ideal of physical and spiritual regeneration it is intended to symbolize. Gabo's pursuit of monumental expression is part of the reason the exhibition at the Guggenheim ends on such a dull note. The last major project he executed – and the penultimate piece in the show – was a rotating brass fountain designed to shoot jets of water from its edges. In such a situation the suggested dynamism of Gabo's personal aesthetic is sacrificed to the superficial literalness of public display.

Gabo was always a small-scale sculptor, almost an intimist. His preparatory "sketches" are minuscule, never more than five inches in height and often smaller. They feel just right at that size, too. Even the sculptures worked up from them are not much bigger. Every photograph of Gabo at work – and the catalogue contains several – shows him at a table holding something small in his hand, looking more like an architect than a sculptor. All this suggests an ease with a mode of sculptural operation that is the antithesis of the heroic or monumental.

Looking at *Construction in Space with Balance on Two Points*, one finds it hard to imagine how Gabo could possibly equal it. He does, of course, although one has to traverse some pretty rough terrain to get there, through the stone carvings, for example, which strive for the dynamism and weightlessness of the plastic sculptures but which – needless to say – fail to achieve them.

By the Thirties, Gabo had come to feel that the planar language no longer communicated the spatial reality he sought. He began exploring ways of articulating his perception that space is curved. He did this first in a series entitled *Spheric Theme*, in which he cuts two Plexiglas discs and joins them around an axial armature to create a single, spheric structure. Once again, these pieces articulate inte-

rior structure with almost no mass. They also dematerialize, irradiated by the light that is caught in the incisions along their surfaces. The *Translucent Version on Spheric Theme* (1937), owned by the Guggenheim, is particularly fine, extending, in its absence of any vestige of solid matter, the weightlessness and immateriality of "Points." It appears to be poised on the brink between the physical and the optical.

The *Linear Construction* series of the early Forties – one of Gabo's masterpieces – crosses that brink. In the variations that constitute *Linear Construction No. 1* (ca. 1945–46), a square Plexiglas armature is densely strung with a network of nylon monofilament in such a way as to leave a void at the center resembling a twisted almond. Its two ends are off-axis and point in opposite directions.

In this series, Gabo overturns the longstanding definition of sculpture as tangible form in space. For the almond opening at the center of these pieces is not a "void" in the traditional sense. The nylon monofilament constitutes mass reduced to the bare minimum. When it picks up the light, each thread glows, just as in earlier pieces the edges of the Plexiglas planes glowed. Only here the accumulated fibers – which have a loose, in-between sort of form – dissolve into a haze of light and atmosphere. This transformation acts on the central opening, endowing it with an unexpected quiddity and turning it before our eyes into solid form moving through space. Gabo here seems almost to have created sculptural form out of nothing. But in *Linear Construction No. 1* he gives free rein to the strong pictorial element that has been present in his art from the beginning. It is a visual and sculptural tour de force.

Just how important this is to the success of Gabo's work becomes apparent when he moves to the variations in *Linear Construction No. 2* (1958). In these, two plastic planes shaped like the near-void of the previous series interlock at

right angles. Again, nylon monofilament is used, stretched between the interlocking planes to create gently curving surfaces. These sculptures either hang vertically or lie on their side, and they have all the luminescence of the con- 125 structions in the first series. The one lying on its side has a talismanic quality. We want to pick it up and hold it.

The *Linear Constructions* can survive this new graspability because, being translucent, they are able to maintain a balance between form and pure light. However, the story is very different in the work of the next twenty-five years. Wanting to see as many sculptures as possible installed in public locations, Gabo shifted from plastic and nylon to sheet metal and wire. Although the sculptural language remains the same, the new opaque materials drastically alter the character and feel of the work. In contrast to the vibrancy of most of the previous pieces, this sculpture is curiously inert and flat. At the Guggenheim this sensation was particularly acute, since almost half of the four allotted ramps were given over to displaying it. As one moved along them, one realized that Gabo's career as an innovative artist was long over, having ended with the second *Linear Construction* series, the apogee of his sculptural dialogue with space. For the change in materials effected a dramatic reshuffling of the aesthetic equation. Where sculptural line, expressed as edge or plane, had previously functioned as a carrier of energy, it now served as the outer limit of a static physical form. And whereas multiple nylon threads, aided by light, exerted a transfiguring effect upon the sculptural object, their wire counterparts served only to activate a stilled interior space.

Once this happens, Gabo's œuvre comes full circle, and we find ourselves back where we were at the beginning with the *Constructed Heads* – in a realm where sculpture and space are separate entities. In the sculptures of Gabo's last

twenty-five years, one feels the artist going to great lengths
to infuse his work with the energy and vision of some of the
earlier pieces. Alas, the flood tide of inventiveness has receded,
leaving us to contemplate the empty shell of an idea.

*Originally published as "Naum Gabo at the Guggenheim"
in* The New Criterion, *June 1986.*

Pablo Picasso I: "Bull's Head" (1942) –
A magical metamorphosis of the ordinary

THERE'S A REMARKABLE MOMENT about three-quarters of the way through "Picasso: Masterpieces From the Musée Nationale Picasso, Paris," now at the Virginia Museum of Fine Arts. The revelation comes in a gallery with work Picasso did during World War II. Long gone is the *joie de vivre* of earlier decades – the colorful paintings of sunlit beach scenes with frolicking bathers, and ever-available women. This is Picasso's bleakest period. His palette is restricted to browns, grays, and blacks, pictorial space is sharply constricted, with figures and objects often literally boxed in, forms are painfully contorted, and themes of mortality preoccupy him, most powerfully in *Death's Head* (1943), a bronze sculpture of a pitted, scabrous skull.

Then, out of the blue, comes a moment of wit and whimsy: *Bull's Head* (1942), a sculpture made from a bicycle saddle and handlebars. At once both childlike and highly sophisticated in its simplicity, it stands as an assertion of the transforming power of the human imagination at a time when human values were under siege.

Consisting as it does of only two elements, *Bull's Head* is Picasso's sparest sculpture. And it is unique among his assemblages for its transparency. In most of them, the identity of the found objects, though not disguised, isn't emphasized. The toy car that forms the monkey's face in *Baboon and Young* (1951) is recognizable for what it is, yet at the same time is subsumed under the larger image of which it forms a part.

In *Bull's Head*, by contrast, there is no attempt to play down the real-world identity of the constituent parts. Indeed, the sculpture's reductiveness and simplicity draw attention to them.

Picasso's frank acknowledgment of these elements has prompted scholars to see affinities between this work and Marcel Duchamp's Readymades, where the Dada artist took commercially made, utilitarian objects and, with little or no modification, exhibited them under his name as works of art. The first of these, *Bicycle Wheel* (1913), can be seen in replica at the Museum of Modern Art. Yet there would seem to be more going on with *Bull's Head* than affinity. It is such an uncharacteristic work for Picasso that it is hard not to see it as, on some level, a direct response to Duchamp.

What would make Picasso spare a thought for the clown prince of modern art at the very moment when there were far more important issues at stake, such as the fact that everything he held dear – the values of Western civilization that formed the wellsprings of his art – was going up in flames? Perhaps the fact that Duchamp himself represented a similarly sweeping threat.

Readymades are antiart objects. Their purpose was nothing less than to overturn the entire tradition of art making as it had existed since ancient times, a tradition of which Picasso was both heir and beneficiary. If art was to be redefined as simply a question of shifting a pre-existing object from one context to another, then that meant an end to the idea of the art object as a product of the artist's hand, craft skill, culture, eye, and imagination. Above all, that meant the end of the idea of the artist as shaman, a person able to transform and transfigure, who could conjure one thing, a work of art, out of another, its raw materials and constituent parts.

Picasso, who worked at all hours, was single-minded in his pursuit of his art. Yet he also made it his business to stay

abreast of what was going on around him. He was notorious for keeping tabs on other artists, dropping by their studios, visiting their exhibitions to check up on what they were doing – all to ensure that his position as leader of the avant-garde remained unchallenged. In the same spirit, he would borrow and adapt their ideas and attempt to one-up them in other ways.

He certainly knew about Duchamp, and indeed there had been an earlier point of contact between them. In the third volume of his biography of Picasso, John Richardson notes similarities between another Picasso sculpture, *Head* (1928), and Duchamp's *Rotary Demisphere (Precision Optics)* (1925), the two works having in common a circular form supported on tripod legs.

In a 1912 collage, Picasso had pasted a portion of a news-paper headline that reads "La Bataille S'est Engagé" ("the battle is joined"). And in *Bull's Head* the artist – for whom so much of life was about gaining the upper hand, be it with his mistresses, portrait subjects, or artists living and dead – seems to be operating on the same principle. For he's taking on Duchamp on the Dadaist's own turf.

Picasso's explicit acknowledgment of the saddle and handlebars makes *Bull's Head* a kind of Readymade-by-Picasso, a fact reinforced by the artist's description of the work's genesis: He "often described how he had found the bicycle parts by chance and 'seen' them immediately as a bull's head, adding that, ideally, one day a cyclist would find his assemblage in a tip and 'see' it as a saddle and handle-bars; in that way there would be a 'double metamorphosis,'" writes Elizabeth Cowling in *Picasso: Sculptor/Painter*.

Yet his purpose in annexing Duchamp's aesthetic of the Readymade is not to embrace it but to neutralize it and thus trump it. Duchamp's combinations are deliberately disjunc-tive. His bicycle wheel and stool are joined together precisely

because they have nothing in common and, together, suggest nothing beyond themselves. Not so Picasso's. He goes all the way to the Duchampian brink, allowing the individual elements to stand for themselves to such a degree that he almost reaches the point at which illusion collapses, leaving us with just a bicycle saddle and some handlebars. But only almost, for despite that we are never in doubt that we are at all times looking at an image of a bull's head. Therein lies the bewitching power of *Bull's Head*, and Picasso's triumph.

Originally published as "Masterpiece: Pablo Picasso's 'Bull's Head' (1942): A Magical Metamorphosis of the Ordinary" in The Wall Street Journal, *April 16, 2011.*

IT'S A LONG-ESTABLISHED FACT of art history that Pablo Picasso, trained only as a painter, revolutionized sculpture in the twentieth century. He introduced new subjects, such as still life; new materials, using sheet metal in the 1914 *Guitar* and everyday objects like a bicycle seat and handlebars for the 1942 *Bull's Head*; new processes such as assemblage, used to make the cubist works of the teens; new vocabularies, such as the "drawing in space," openwork constructions of welded iron rods, in the project for a monument to the poet and critic Guillaume Apollinaire in the late 1920s.

He made space an equal partner to mass and form. And he even managed to nudge two ancient and venerable modes, the wheel-turned pot and modeled monolith, into new and unexpected directions. In the latter case, this was a hybrid form, the monolith-assemblage, that resulted when Picasso pushed his exploration of his paramour Marie-Thérèse Walter's head so far in one of the Boisgeloup portraits of the 1930s that it devolved into four separate components.

Prior to "Picasso Sculpture," the sweeping survey the Museum of Modern Art has now mounted, there hadn't been a Picasso sculpture retrospective since 1966, seven years before the artist's death. Until then little had been known about Picasso's activity as a sculptor. He kept almost all of his work to himself and rarely showed it. Not until the opening of the Musée Picasso in Paris in 1985, its collections composed of works formerly in the artist's possession,

did the full scope of Picasso's activity as a sculptor emerge.

Yet organizing such a show is not the kind of simple matter it would be in the case of painter-sculptors like Degas, Matisse, or Giacometti. For one thing, the line between painting and sculpture in Picasso's œuvre is famously ambiguous. Much of Picasso's work in two dimensions, such as the paintings and collages of Analytic Cubism, is profoundly sculptural. Conversely, most of his sculpture, from the 1914 sheet-metal *Guitar* to the *Bathers* of the 1950s, is pictorial, appealing more to the eye and mind than the hand. Even a drawing could be a kind of sculpture, as is the case with a series of sketchbook entries made in Dinard in 1928 and a later suite of drawings, "An Anatomy" (1933). In both, abstract figures are fully realized in the round as three-dimensional illusions. "Surrogate sculptures" was the Picasso scholar John Golding's term for such works. Which raises the question: Where do we draw the line between painting and sculpture in Picasso's work – or are we even supposed to?

Then there is "The Sculptor's Studio," forty-six etchings that form part of the Vollard Suite and are contemporaneous with the sculpted Boisgeloup heads. The dramatis personae are a bearded sculptor – a Picasso surrogate – his nude female model, and the finished sculpture, most often a portrait bust in the style of the Boisgeloup heads. From time to time the artist himself seems as taken aback by what he has wrought as the model, making "The Sculptor's Studio" a kind of window into Picasso's thinking about what it was like to be a sculptor.

Finally, there are Brassaï's studio photographs from the 1930s and 1940s. In one, for example, the 1943 sculpture *Woman in a Long Dress* is shown draped in a painter's smock, fitted out with palette and brushes and posed facing the painting *L'Aubade* (1942), the whole adding up to a kind of

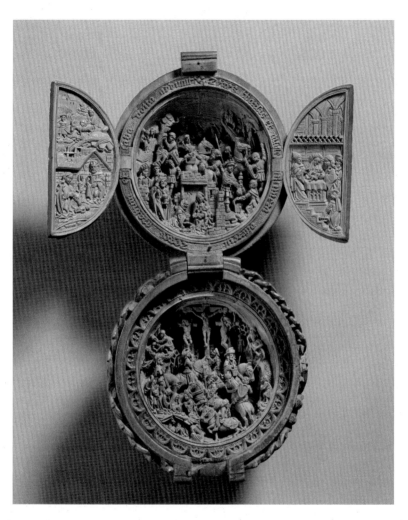

Prayer Bead with the Adoration of the Magi and the Crucifixion (early 16th century), Netherlandish.

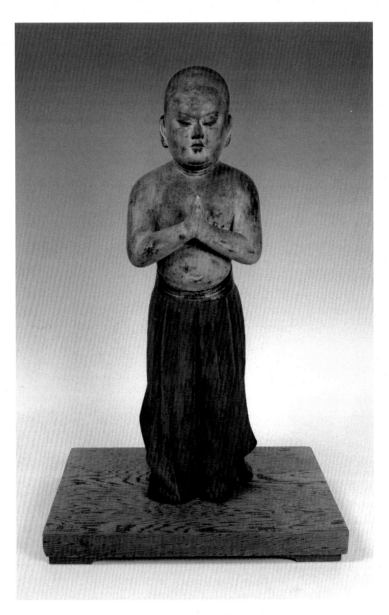

Standing Shōtoku Taishi at Age Two (Namubutsu Taishi) (late 13th–14th century),
Kamakura period.

Larry Ellison Collection.

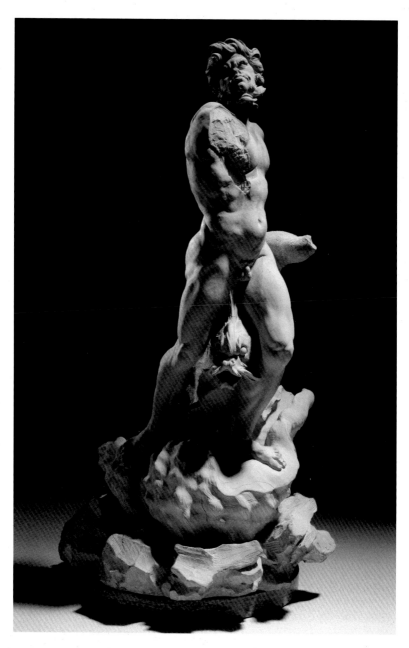

Gian Lorenzo Bernini, *Modello for the Fountain of the Moor* (1653).
Kimbell Art Museum, Fort Worth, Texas.

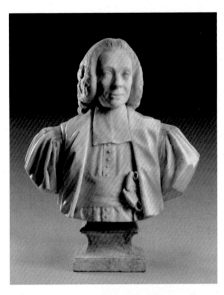

LEFT: Jean-Antoine Houdon, *Armand-Thomas Hue, Marquis de Miromesnil* (1777).

Copyright The Frick Collection.

BELOW: Jean-Baptiste Carpeaux, *Ugolino and His Sons* (1865–67).

The Metropolitan Museum of Art, New York. Purchase, Josephine Bay Paul and C. Michael Paul Foundation Inc. Gift, Charles Ulrick and Josephine Bay Foundation Inc. Gift, and Fletcher Fund, 1967.

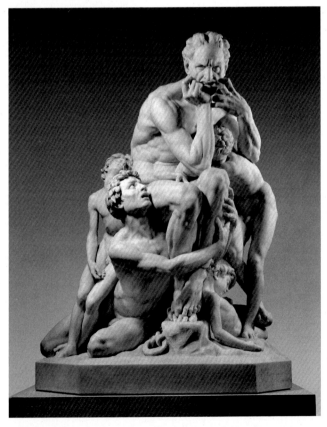

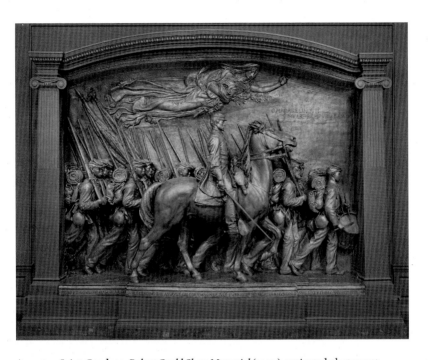

Augustus Saint-Gaudens, *Robert Gould Shaw Memorial* (1900), patinated plaster cast.
U.S. Department of the Interior, National Park Service, Saint-Gaudens National Historic Site,
Cornish, New Hampshire, on long-term loan to the National Gallery of Art, Washington.
Photo courtesy of the National Gallery of Art, Washington.

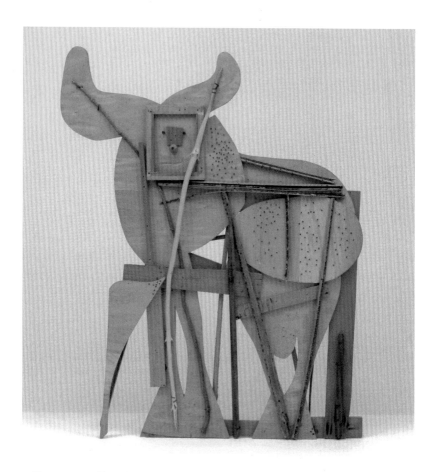

Pablo Picasso, *Bull* (*ca.* 1958). ©ARS, NY.

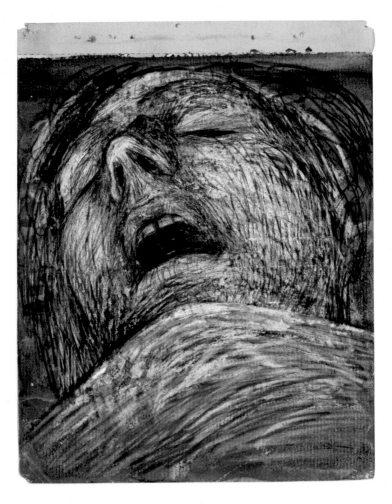

Henry Moore, *Sleeping Shelterer* (1941).

(HMF 1694) Photo: Michel Muller. Reproduced by permission of the Henry Moore Foundation.

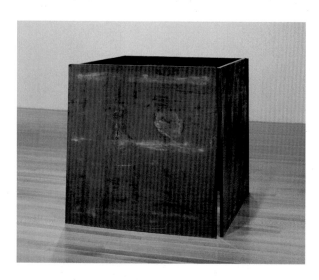

ABOVE: Richard Serra, *One Ton Prop* (*House of Cards*) (1969, refabricated 1986).
© ARS, NY.

BELOW: Rachel Whiteread, *Untitled* (*Domestic*) (2002).

theatrical tableau. This photo and others tell us that, far from regarding them as mere objects, Picasso saw his sculptures as personages, presences, as alive to him as the tribal heads and figures which he had described as "intercessors" after seeing them in the Musée d'Ethnographie du Trocadéro in 1907.

133

So an exhibition capturing Picasso's relationship to the third dimension in all its aspects is no small undertaking. Yet the curators, MOMA's Ann Temkin and Anne Umland, and the Musée Picasso's Virginie Perdrisot, have produced a show that opens up the subject of Picasso and sculpture as never before, and which takes its place in the long line of definitive Picasso shows in MOMA's past. "Picasso Sculpture" is a curatorial and institutional triumph.

The curators have chosen some 140 sculptures out of roughly 700, displaying them in the museum's fourth floor permanent collection galleries for maximum effect. Organized chronologically, the show begins with the first work Picasso ever made in three dimensions, the small clay *Seated Woman* (1902), and ends with the folded sheet-metal works and outdoor Chicago commission of the 1960s. All phases, moods, and categories of effort are included, from the most deeply pondered to the most casually tossed-off, such as the paper cut-outs of skulls and animals of the 1940s. *The Anatomy* is here, as is a selection of six etchings from "The Sculptor's Studio." And while Brassai's images are also present, regrettably the photographs are only of the individual works shot for the 1949 monograph by Daniel-Henry Kahnweiler, Picasso's long-time dealer, not the images of anthropomorphized sculptures. Exhibition highlights include all six versions of the 1914 *Glass of Absinthe* displayed together for the first time, and the Boisgeloup heads of Marie-Thérèse in the original plaster.

It is a rich, sometimes overwhelming bounty, from which

one comes away aware as never before of the scale of Picasso's ambition. The unceasing invention, the use of new materials, and the devising of new techniques – these aren't ends in themselves but instruments in a larger agenda. This was nothing less than to rewrite the laws of nature by making sculpture do things its ineluctable physicality had barred it from throughout its long history: making the immaterial material (transparency in the *Glass of Absinthe* and other cubist works; candlelight in the *Goat Skull and Bottle* of 1951–53); and the determination to make space as plastic and malleable as clay or plaster. We see this especially in the 1931 *Bather*, whose radical anatomical distortions – tiny head and enormous hips and legs – are an attempt to compress perceptions of distance (head) and proximity (hips and legs) into a single plane, as Picasso does to the foreshortened, running figure in the 1923 painting *Three Bathers*. Picasso even sought to extend sculpture's reach to landscape. As the curators note, the configuration of the carved plaster *Apple* (fall 1909) bears a striking resemblance to the hill town of Horta de Ebro as photographed by Picasso during a visit that summer.

For all the attention that has been paid to Picasso's use of unorthodox materials, his use of traditional ones merits attention, too. Bronze, for example, was not for him. Whatever its utility in preserving fragile works for posterity, in aesthetic terms its ties to the heroic tradition of commemorative sculpture made it a liability, setting up a collision between Picasso's revolutionary formal language, which broke with the past, and a material and process that affirmed it. (This in contrast to Picasso's ceramics, whose power derives precisely from their deliberate evocation of past traditions, the swelling forms of Picasso's animal and human bodies both mimicking and playing on those of the utilitarian vessels made by potters since antiquity.)

Picasso himself seems to have been aware of this problem with bronze, because he only agreed to have the Boisgeloup heads cast after repeated importunings by his friend and secretary Jaime Sabartés, who worried they would eventually disintegrate. Hence the importance of including the original plasters in this exhibition. For the same reason it is a pity that MOMA was unable to secure the original *Bull's Head* from the Musée Picasso. The bronze cast shown here, from a private collection, muffles if not vitiates altogether the opposition between the animal image and the real-world objects that make it up, around which the sculpture's meaning turns.

The one exception to the rule about bronze is *Death's Head* (*ca.* 1941), where Picasso borrows Constantin Brancusi's aesthetic of the modernist object-sculpture to achieve the most unsparingly bleak and direct evocation of mortality. This battered, gouged, and pitted head seems to have the weight and density of a cannonball or bomb, and, in so conflating the image and method of death, Picasso endows this ancient material with a meaning unique to the twentieth century – that of mass killing.

Picasso was a prolific self-portraitist in two dimensions throughout his career, but this association with military ordnance invites us to read *Death's Head* as one in three. So do its unusually large eyes, Picasso's powerful gaze, the famous *mirada fuerte*, being a hallmark of the artist's likenesses of himself. We know Picasso was deeply afraid of death. But thanks to Lydia Csato Gasman's essay in the catalogue to the 1999 exhibition, "Picasso and the War Years, 1937–1945," we now know that he was particularly afraid of being killed by aerial bombardment – "death falling from the sky." Thus *Death's Head* stands as a morbid self-projection in time of war, anticipating by some three decades the famous crayon-on-paper self-portrait the artist executed in 1972, nine months before he died.

We see something similar in Picasso's response to another traditional material, wood. In 1906, inspired by Paul Gauguin's work in the same medium and his own exposure to tribal art, Picasso took up wood carving. Most of these sculptures are small, but one, a 1908 *Figure*, is almost three feet tall and is, tellingly, unfinished. Picasso's quicksilver sensibility meant that there needed to be the shortest possible time span between conceiving an idea and executing it, a fact epitomized by the 1945 *Venus of Gas*. This was "created" by doing nothing more than moving the burner from a kitchen stove from horizontal to vertical orientation. Barring one or two exceptions such as the Boisgeloup heads, Picasso simply didn't have the patience for lengthy artistic campaigns, and the hacked, unfinished, and unresolved forms and surfaces of *Figure* suggest the frustrations of someone who knows he's gotten in too deep. Hence Picasso's even briefer dalliance with stone-carving at around the same time. It's significant that, when he next turned to wood, in the 1930s, the technique of choice was whittling – far simpler, faster, and less labor-intensive.

In this sense, assemblage wasn't just an artistic innovation; it was a temperamental necessity. Without it, Picasso might never have had a career in sculpture. And it offered him the chance to work in wood outside the emerging modernist tradition of "direct carving" and "truth to materials," whose chief exponent at the time was Brancusi. As the rudimentary – even in places, crude – joinery of the wooden cubist constructions attests, the roots of Picasso's *bricolage* lay not in art but in industry, in carpentry and cabinetmaking, freeing him from any perceived allegiance to an aesthetic tradition other than his own.

In what is otherwise an exemplary exhibition, one regrets the absence of one work, the 1906 *Head of a Woman (Alice Derain)*, a critical way station in Picasso's development as a sculptor.

In the standard narrative, Picasso was first influenced by Auguste Rodin and Medardo Rosso, leaving them behind when Iberian sculpture caught his eye, then moving on to Gauguin and tribal art, this last the transformative and enduring influence. This is, of course, indisputable in its broad outlines. But artistic influence isn't necessarily tidy, nor does it always manifest itself in obvious ways. For these reasons, we need to look again at Picasso's early formation. When we do we will see that, far from being of fleeting consequence, the influence of Rosso is powerful and long-lasting.

Rosso (1858–1928) occupies a unique position in the annals of early modern sculpture. Often described as an "Impressionist sculptor," Rosso sought to create the illusion of his subjects' being situated in an environment of light and air. In works such as *Man in the Hospital* (1889), *Madame X* (1896), and *Ecce Puer* (1906–07), Rosso achieved his effects by minimizing naturalistic details, radically simplifying volumes and modeling his surfaces in such a way that, as Margaret Scolari Barr wrote in her catalogue to MOMA's 1963 Rosso retrospective, the "protrusions and hollows in sculpture can be made to play a double game" – simultaneously defining form and conjuring the illusion of an enveloping atmosphere.

There is no documentary evidence to indicate Picasso ever saw Rosso's work, but the circumstantial evidence is compelling – the more so given that in a footnote in her Rosso catalogue, Mrs. Barr writes that "Mr. John Richardson informs me that Picasso remembers Rosso's work admiringly." In 1904 Rosso, who was living in Paris, had a one-man show at the Salon d'Automne; the Alice Derain portrait dates from two years later. Its head is radically simplified in the manner of Rosso, lacking virtually all traces of the kind of naturalistic detail and surface articulation visible in *Picador with a Broken Nose* (1904) and *The Jester*

(1905). (Were the order reversed, it could be interpreted as a beginner's hesitation followed by growing mastery. As it is, the simplification in "Alice Derain" appears deliberate, a response to some outside stimulus, the only plausible source being Rosso.) And the surface has been modeled in a way that suggests Picasso wanted entree into Rosso's "double game." A similar handling of form characterizes *Head of a Woman (Fernande)* of the following year. Still, these works are little more than a gloss on Rosso. With *Kneeling Woman Combing Her Hair* of later the same year and the move into wood carving and Cubism soon after, Picasso would seem to have moved swiftly out of Rosso's orbit.

In a literal sense he did. Yet with his magpie sensibility, Picasso seems to have taken away the insight that light could have a role to play in sculpture, becoming a kind of "found object" *avant la lettre.* For it becomes an important element in the work of the cubist years.

In bronze, the 1909 *Head of a Woman* can be difficult to "read," the overall reflectivity of the metal surface conflicting with the articulation of faceted forms in terms of contrasts of light and dark. Things are clearer in the plaster version at the Nasher Sculpture Center (not included in the show). Yet here the pendulum swings too far the other way, with the play of light and dark dissolving form to yield a sculpture that is cubist in its artistic language but Impressionist in its effect. It was Kahnweiler who first noticed this, writing in his monograph that "*Head of a Woman* takes to its extreme consequences the impressionist sculpture of Rodin and Medardo Rosso. The surface is no longer simply rough; deep hollows furrow it and protuberances project from it as if Picasso had wished to endow his bronze with created light, like that in a picture."

The constructed sheet-metal *Guitar* of 1914 is in every respect worlds apart from Rosso. Yet it, too, is Rosso-esque

138

in the way it seems to gather light and shade into itself, its form articulated as much from within as from an external light source – Kahnweiler's "created light," again.

Whatever reasons prompted Picasso to paint the "Absinthe" sculptures, control was surely one of them – control over bronze's surface effects and over light effects, too. Here and in the contemporaneous wood constructions, he shifts from "created" to depicted light, with Georges Seurat's pointillism becoming the means of creating atmosphere, as well as of indicating the presence of light on, and its passage through, form. Hence the strange vertical flange that projects from one side of the absinthe glass. Painted, it stands for the vestigial fragment of "atmosphere" in which the glass "sits" and is thus strongly reminiscent of Rosso's practice of leaving in place the "halo" of bronze that had seeped out and set during casting as a means of joining the figure to a fictive environment. The crosshatching around *Violin* (*ca.* 1915) and the horizontal striations accompanying *Guitar* (1924) can be read similarly.

Light continued to make intermittent appearances in Picasso's work thereafter. In contrast to most modeled sculpture of the twentieth century (think Alberto Giacometti and Henry Moore) the surfaces of the plaster Boisgeloup heads are surprisingly smooth, as if Picasso were concerned to minimize the presence of shadows. As a result, one is struck by their almost preternatural whiteness, almost a glow, as if the artist's aim with his material had been to incarnate light. (Indeed, in the catalogue – certain to be the definitive reference work on Picasso's sculpture for some time to come – the curators use terms like "luminous" and "luminosity" in connection with these sculptures.) Could this indicate some symbolic intent? Is Picasso, in the whiteness of the plaster, telling us of the innocence of Marie-Thérèse, or the purity of his love for her?

Light turns up again in *Goat Skull and Bottle* (1951–53), as candlelight, represented by the halo of nails atop the cubist bottle, and in paint, as cast light and shadow. Only in a typically Picasso-esque twist, the artist reverses the natural order of things, shading the side of the skull closest to the flame, and lighting the side farthest away. Light makes a final appearance in *Woman with Outstretched Arms* (1962), where the black surround symbolizes the atmospheric envelope it inhabits.

Light is more commonly the painter's medium, but it was not the only time Picasso used purely pictorial means to achieve his sculptural ends. In *Glass and Dice* (1914), the single die is a parallelogram, as if seen in perspectival recession – or rather, in another typically Picasso-esque twist, reverse perspective, since it appears to get bigger not smaller as it moves back into space. Dice receive similar treatment in other relief assemblages of the time, highlighting another leitmotif in Picasso's sculpture, the play on the idea of two versus three dimensions. We see this first in the 1907 *Mask* (not in the show) where the right side of the nose is broader and shallower than the left, possibly an attempt to depict in sculpture the simultaneous front and profile views that would be a hallmark of his painting. We see it again in the doll-like *Figure* (1938), whose head is a flat piece of wood cut and painted to give the illusion of a cube seen in foreshortening. And we see it again in *The Bathers* (1956), six sharply flattened wooden assemblages, whose association with two-dimensional representation is made explicit in the artist's use of a picture frame for the arms in two of the figures.

Line, too, figures here, not just the sculptor's in the metal rods making up the monument to Apollinaire, but the draftsman's line, literally so in *Violin and Bottle on a Table* (1915), wherein a sinuous pencil mark defines the right contour of the bottle. Then, at the same time as the Boisgeloup heads,

Picasso sculpted a series of reliefs of Marie-Thérèse of which two (not in the show) are composed of snakes of clay attached to the flat ground – drawing-as-sculpture-as-drawing. A few years later he sculpted a running *Woman* (also not in the show), whose face, spine, and limbs are gouged into the form. The dark lines on the white ground read both graphically and sculpturally, the former by delineating a rudimentary stick figure of the kind a child would draw, the latter because they evoke the interior armature that gives the figure its structure and support.

Yet despite the blurring of categories of painting and sculpture that so characterizes Picasso's work, there is one bright line that separates the two, and that is in the area of allegory. His only two failures in his sculpting career were *Woman with a Vase* (1933) and *Man with a Lamb* (1943), in both of which he strove for some larger metaphorical meaning. *Woman with a Vase* is almost comically lame, one of those works of art so bad that it prompts thoughts of wicked captions. *Man with a Lamb* is simply cigar-store-Indian inert.

The woman-with-lamp motif would, of course, reappear in *Guernica* four years later, and in this contrast we have an explanation for these failures. As Gauguin and Matisse had shown earlier, and Picasso would in *Guernica*, allegory had not been a casualty of the modernist revolution in painting. That tradition, from the painters of the Renaissance through Poussin and beyond, was still viable, and available as source and subject. But modern sculpture had been born in reaction against the windy, high-minded statues that had for so long dominated the official Salons. So in sculpture, Picasso was going against the tide of history. And against the tide of his own work, whose strength derived from being rooted in the concrete, the personal, and the everyday.

Those weak spots aside, Picasso's use of pictorial means was no doubt prompted by the desire to maximize the

expressive range of sculpture and to create works that occupied a zone different from that of the modernist object-sculpture, one that was neither sculpture, nor painting, but a hybrid of both. Where the early cubist collages became known as "tableaux objets," these might be thought of the opposite way, as "objets tableaux."

At the same time, for all his ambition to remake the art of sculpture, there's a sense in which Picasso's work in three dimensions is an extended musing on the idea of the *paragone*, the Renaissance-era debate about which was the superior art form, painting or sculpture. Nowhere is this more evident than in *Bull* (1958), a brilliant late work. *Bull* is composed primarily of superimposed sheets of blockboard, the image itself delineated with the kind of contour drawing familiar from Picasso's Neoclassical period twenty years earlier. As such the work suggests that at heart Picasso's ultimate loyalty was to painting, for *Bull* reads as a painter's witty rebuke of the whole idea of sculpture. Its physical form is flattened almost to nothing and our entire notion of mass and volume is conveyed graphically, through outline alone. *Paragone*, indeed.

Originally published as "Picasso & the third dimension"
in The New Criterion, *December 2015.*

Julio González: Modern art's bright flame

THE BEST-KEPT SECRET of the current art calendar is the Julio González retrospective at the Institut Valencia d'Art Modern (IVAM). One of a continuing series of long-term installations devoted to the pioneer of welded iron sculpture, the show is drawn entirely from IVAM's own holdings of over two hundred González works in all media. Most of them were donated by two of the artist's heirs in the 1980s.

Other museums have large González holdings. But the breadth and depth of IVAM's puts the museum's collection in a class by itself. Included here, besides the signature welded metal works of his maturity, are early modeled works such as *Melancholy Standing Nude* (1910–14) – a small plaster figure of a woman whose face is hidden but whose body language tells us everything we need to know about her emotional state – and subsequent reliefs and cut-outs in metal. There are even some surprises, such as the late-in-life return to carving and modeling. All this means that IVAM can mount a career overview like this one that gives us the fullest and most nuanced view of the artist we are likely to see anywhere. The wonder is that it has received almost no attention from the media.

Unusually for a modern artist, González (1876–1942) straddled the worlds of the fine and decorative arts. Born in Barcelona, he earned his living until the 1920s making jewelry and precious-metal objects, all the while pursuing his interest in painting and sculpture. In 1900 he moved to

Paris, where he would absorb the lessons of Cubism and, during World War I, learn welding when he worked at a Renault plant. In the late 1920s he taught his friend Pablo Picasso the technique and collaborated with him on some of his most important sculptures. It was around this time that he developed a distinct sculptural language of his own.

One of the most important features of the show, organized by the late Tomas Llorens, the museum's founding director, is the inclusion of examples of González's early jewelry and metalwork. One of these, *Chrysanthemum* (1890–1900), is a beautiful, iron-and-brass flower that is so lifelike it looks as if it were cast from an actual plant. Not only is this phase of González's career interesting in its own right, but it reveals the essential continuity of his art. The qualities of delicacy, precision, and spareness of means apparent in *Chrysanthemum* would both carry through to his mature work and be indispensable to its success.

González's work of the 1910s and 1920s shows him to be respectably modernist but in no way an innovator. The encounter with Picasso would be transformative. Some spark between them would prompt him to invent a sculptural language so radical as to surpass even Picasso's. Nowhere is this more in evidence than in the show's centerpiece and highlight, the life-size *Woman in Front of a Mirror* (1936–37), made of wrought and welded iron.

In Picasso's cubist constructions, most famously the sheet-metal *Guitar* (1914), forms are opened up and dissected, but never beyond the point of recognition. But in *Woman in Front of a Mirror* form isn't just opened up. It is, in a sense, atomized. The human figure is split asunder and reconceived according to new rules that take even greater liberties with nature. The basic body parts are there – head, torso, legs – and we can even identify certain details: curv-

ing linear elements at the top as hair; a circle and projecting line as a hand-held mirror; the adjacent void as an eye or entire face. But beyond that it is impossible to be more specific, and we find ourselves confronted, overall, with an equivocal, almost Janus-faced image.

One moment, she is a coquette: head thrown back, one hip thrust out to the side, coyly surveying herself in the mirror she holds upside down and out from her body. (Continuity again: Here, as in the earlier *Melancholy Standing Nude*, emotion is expressed solely through pose and gesture.)

Yet in the next she is a forbidding, even frightening figure. Her spiky appendages, attenuated proportions and pod-like lower parts suggest a praying mantis, an insect that fascinated the Surrealists owing to the female's practice of devouring her male partner during sex.

But the great importance of *Woman in Front of a Mirror* and similar works of González's maturity lies in its radical approach to form and structure. Until the twentieth century, sculpture had consisted of carved or modeled solids. Picasso's cubist constructions peeled away the skin of things, opening up the sculpture to make the interior coequal with the exterior, solid with void and, because they were assembled, form with structure.

Here again, González goes further than Picasso. *Woman in Front of a Mirror* is composed not of solids or planes but primarily of linear elements, making it open, airy and at one with the space around it, hence the name González gave to his style – "drawing in space." This makes it impossible to speak of "inside" and "outside," "form" and "structure" as distinct entities.

González died less than a decade later, but his language of open, metal construction revolutionized twentieth-century sculpture, inspiring David Smith and later artists.

Despite being made of metal, *Woman in Front of a Mirror* is now too delicate to travel. So for this reason among others, to truly understand González you must go to Valencia.

*Originally published as "Modern Art's Bright Flame"
in* The Wall Street Journal, *June 2, 2016.*

For admirers of the work of Alberto Giacometti (1901–66), the Swiss sculptor best known for his figures of standing women and walking men so slender as to resemble lines drawn in space rather than three-dimensional objects, the last few years have been exciting ones. In 2016 the Kunstmuseum in Basel mounted "Beyond Bronze," an exhibition of Giacometti's work in plaster, which demonstrated in depth for the first time that the material was central to his practice rather than, as it is for most sculptors, an intermediate stage in the casting process. I didn't see the show, but the catalogue quickly took its place as an indispensable part of the literature. Last year Tate Modern mounted a retrospective, which, though grievously flawed (it was poorly installed, portrayed the artist's post–World War II figurative work as so many emblems of existentialist angst, and attempted to position him as a kind of aesthetic godfather of Jeff Koons and Damien Hirst), was notable in one respect: several plasters from the *Women of Venice* series that Giacometti made for the 1956 Venice Biennale, constituting a kind of culmination of his decades-long obsession with the theme of the standing female nude, were on display for the first time since their creation, having for decades been too fragile to move.

This year has been even busier. The spring saw the release of *Final Portrait*, a feature film starring Geoffrey Rush that was based on *A Giacometti Portrait*, James Lord's seminal 1965 memoir of sitting for the artist. The Solomon R. Guggenheim Museum opened "Giacometti," a comprehensive

survey of the artist's work that includes a number of plasters from the Fondation Giacometti in Paris, many never or rarely seen before. A new biography by Catherine Grenier, the foundation's director and a former co-director of the Centre Pompidou, appeared – the first since James Lord's in 1985. Finally, in late June the foundation opened the Giacometti Institute, its headquarters and a public exhibition space in Paris, the highlight of which is a reconstruction of Giacometti's studio, long one of the most storied locales in the history of modern art, and dismantled and put in storage by his widow after his death. All this adds up to a watershed moment in Giacometti studies, a time of fresh insights and experiences, with the promise of more to come.

At the Guggenheim, the artist's work looks resplendent spiraling up the museum's ramp. This is a large show, with nearly two hundred works of painting, drawing, and sculpture, and a triumph of installation. Indeed, if there is a textbook example of how thoughtful display can illuminate an artist, this is it. Frank Lloyd Wright's architecture is famously hostile to the display of art, all but straitjacketing paintings and sculptures in the bays that line the ramp. The co-curator (along with Grenier) Megan Fontanella and the exhibition designer Aviva Rubin had the brilliant idea – why has nobody thought of this before? – to break the tyranny of the bays by extending purpose-built platforms onto the ramp. This permitted a fully three-dimensional experience of the sculptures, something especially critical for a work like *Four Women on a Base* (1950), a roughly two foot-tall bronze of standing female figures on a block-like support, so slender and reduced they seem more like so many smudges in space than representations of humanity. It is a quintessential work from Giacometti's figurative period, deriving from his revelation in the cinema in 1945 that the figures captured "realistically" on the screen in front of him

were nothing more than two dimensional ciphers, whereas what was truly real was his perception of the nearby audience members, connected to him through his vision and their position in a shared space. The remainder of his career would be dedicated to capturing that reality. For this sculpture to work, the viewer must believe, as the artist did, that he is looking at the barely perceptible, evanescent image of four women in the distance just coming into view and seen in the vastness of space. Set in a bay, it might have read as a relief sculpture. Out on its platform about two thirds of the way into the show, its figures generate a palpable awareness of the space around them, and so the sculpture registers hypnotically.

It is only with this exhibition that I have come to understand what an awkward fit were Giacometti and Cubism. He had embraced the style in the 1920s as a route into modernism, but he never seems to have understood what it was really about. He didn't open up and fragment forms but instead combined large, cube-like forms in an effort to suggest personages, as in *Composition* (*Cubist I, Couple*) of 1926–27. His sensibility was too visionary and inward to be comfortable with the analytical, formalistic aesthetics of Cubism, which may be why his most successful effort in this vein is at once his most and least cubist work. Entitled *Cube* and dating from nearly a decade later (1934), it is a broadly faceted vertical monolith that exudes a powerful, quasi-figural presence. It would seem to be an evocation of his childhood experience of a large stone encountered in the countryside and anthropomorphized into "a living being, hostile, threatening," as he later wrote.

From his very beginnings as an artist, there had been a tension in Giacometti's mind between creating and making, the former equated with discovery, the latter simply executing a preconceived idea. So it is paradoxical that one of his

greatest works, *The Palace at 4 a.m.* (1932) (represented here by his painting of it), should have been created precisely in that way, the image of it having come to him (so he said) fully formed in a dream and requiring little time to realize in three dimensions.

Nonetheless, one does notice a split in the works of Giacometti's Surrealist period between the "made" and the "created" – what you might call the pro forma and the inspired. In the former category is *Disagreeable Object* (1931), a long wooden phallus with spikes at its tip. Little more than an illustration of Surrealism's aesthetic of sex and violence, it reads more like a schoolboy prank than a work of art, something anyone could have made. At the other end of the spectrum is an array of masterpieces all produced within the space of just a few years: besides *Palace*, these include *Flower in Danger* (1932), *Point to the Eye* (1931–32), *No More Play* (1931–32), *Hands Holding the Void (Invisible Object)* (1934), *Woman with Her Throat Cut* (1932), and *Suspended Ball* (1930–31). This last consists of a metal cage from whose top is suspended a sphere with a cleft underside that appears about to brush or be penetrated by the sharp edge of a melon-slice form on the platform below. It has been given wonderful *film noir* lighting that dramatically intensifies its aura of mystery and menace.

These works are suffused variously with an atmosphere of looming threat, imminent danger, or wanton sexual violence. At the same time they are charged with a potent ambiguity, their expressive power all the greater because specific meanings are impossible to parse or pin down. Unlike *Disagreeable Object*, their sources are uniquely Giacomettian: childhood memories; private fears and obsessions; daily life in Montparnasse; study of the art of the past. The formal vocabulary is not drawn from any pre-existing style but is original, *sui generis*, and, except for the cage motif that later

150

would be taken up by the Abstract Expressionist sculptor Herbert Ferber, wholly unrepeatable.

In the end, Giacometti resolved this tension between creating and making with his return to figuration and work- ing from the model in the mid-1930s, since it required him to confront reality – the motif – anew each time he sat down to work. Although perhaps "resolved" isn't the right word, since it set him down a road of torturous self-doubt about the outcomes that would dog him to the end of his days.

In an exhibition that has already seen many highlights, this section, featuring work from the mid-1930s to the mid-1950s, is surely the apogee. In its mix of works in plaster and bronze, it gives us a clear picture of how important this former material was to Giacometti and what far greater range of expressive effects he was able to realize in it than in bronze. Indeed, other than Auguste Rodin in his work on the *Gates of Hell*, no modern sculptor has made such creative use of plaster as he.

Take *Tall Figure II* (1948–49), a nearly six-foot-tall painted-plaster female nude. Though larger, it is similar to the bronze *Four Women on a Base* (1950). But the differences are more telling, the former being more physically and perceptually present, thanks to the vigorously fingered material and the use of paint, particularly around the eyes. They seem to fix on you with the intensity of a Byzantine mosaic. *Head on a Rod* (1947) is a shocking work. Its rough, almost violent handling of surface and mass is as critical to its expressive effect as the image itself. And in a vitrine containing some half dozen small painted plaster portrait heads, Giacometti, whose standing figures so often evoke ancient deities and idols, here seems to be going even further back, to geological time. They are like rocks whose indentations, points, and hollows are the product of accident, the objects themselves things the artist happened to pick up on a walk

after espying in them the face of a familiar. In these and the other plaster works there is a greater engagement with the material for its own sake than in the bronzes, and Giacometti seems to be challenging himself to reconcile opposites – the plastic and the perceptual.

This tendency manifests itself in a series of bronze and plaster busts from the mid- to late 1950s, in which Giacometti seems to be overturning – or at least questioning – the very premises of his art. These trace their lineage to the fraught output of World War II, the sculptures of pin-sized figures on equally small bases. "Fraught" because, each time, Giacometti had started out trying to make a large figure in his hotel room in Geneva, only to find his sculpture dwindling in size under his fingers. The effect, though, is powerful – of a figure seen at a great distance. Something like that happens here, but with a twist. In *Bust of a Man* (1956) the head is tiny and seems far away. Yet it is poised atop a torso of such thickly and heavily worked matter that Giacometti undercuts his perceptual illusion by loudly calling attention to that portion of the sculpture as a tangible object. The work of the remaining decade, such as the series of busts of Giacometti's wife and model, Annette, so reminiscent of Matisse's *Jeanette* series, is very much in this vein – richly material and heavily worked. The earlier slender crusts of form are now replaced by lumpier, even more monumental figuration. The artist has taken the first steps on an entirely new path. How one would like to know what would have come after.

Rarely does one have the impression reading a new book that it has been written as a point-by-point rebuttal to an earlier one on the same subject. Yet that is exactly what I felt reading Catherine Grenier's *Alberto Giacometti: A Biography*. My hunch was reinforced when I got to the references to Lord near the end of the book. After calling his *Giacometti Portrait* "remarkable," she goes on to say, "After Giacomet-

ti's death, Lord was to author an exhaustive if less inspired biography, an inextricable mix of attested facts and romanticized interpretations." Ouch.

The truth is, though, that there has long been a need for a new life of Giacometti, for the more one reads the Lord book the more its flaws stand out. Granted, a biographer must like his or her subject, but Lord veers between being witness for the defense at the bar of history and out-and-out hagiography. Annette comes across like one of the shrieking harridans Picasso painted. And despite quoting Giacometti's denial that his art was an expression of existentialist philosophy, Lord takes a distinctly existentialist approach in discussing the life and work ("Giacometti's drawings convey ... the importance of an achievement which is confirmed by the evidence, so to speak, of its failure"). And some of his readings of individual artworks are all but incomprehensible. His strength, as you would expect from the author of *A Giacometti Portrait*, is the creative process. His description of the artist's travails in Geneva is unforgettable, and worth quoting:

> Sack after sack of plaster was hefted up the circular staircase, but neither the size nor the number of acceptable works increased, while the accumulating residue gradually transformed the little room into a bizarre wilderness. Chunks and crumbs and flakes and dust of plaster settled upon every surface, clogged every crevice, filled every crack, seeped through every seam of the room itself and of everything in it, including the man whose efforts had brought into being this weird, ancillary spectacle, by which he himself was transformed. His hair, his face, his hands, his clothes were so penetrated with plaster dust that no amount of washing or brushing could eliminate it, and for five hundred yards around the Hôtel de Rive the streets bore the ghostly imprints of his footsteps.

Grenier's biography is very much the anti-Lord. There is a notable absence of Lord's *sturm und drang*, and the author has taken it upon herself to dispel myths – even those fostered by Giacometti himself – and correct misperceptions. For example, she is careful to note that it is only "according to legend" that Giacometti transported the fruit of his Geneva labors back to Paris in September 1945 in six matchboxes. She is excellent on the work – an entire, illuminating chapter is devoted to *The Palace at 4 a.m.* Perhaps the greatest difference between her book and Lord's is in the portrayal of Annette, who emerges as a flesh-and-blood person, a loyal if long-suffering companion. Grenier and those she quotes use words such as "joyful," "adaptable," "good-natured and always calm and content," and "patient" to describe her.

But Grenier's would not be the valuable life it is were it only a riposte to Lord. She also greatly enriches and adds to our understanding of the artist. Accounts of the influence of his painter father Giovanni have generally been limited to pointing out that he let the young boy paint and draw alongside him in his studio, guided his art education, and insisted he move to Paris in 1922 to widen his horizons. In Grenier's account, Giovanni emerges as a much more important influence than previously known, decisively shaping his aesthetic: "For Alberto's father, the question of representation was central. The organic bond between art and nature was the essential lesson he was to inculcate into his son, though he left him free to take up his own aesthetic position."

In addition, she is excellent on the pivotal episodes in Giacometti's life. Her account of the 1945 epiphany in the movie theater is the best I have read. Just as valuably, she clarifies – hopefully once and for all – the exact relationship between Giacometti's art and Existentialism as well as its place in the historical context of post–World War II Europe, when his fig-

ures tended to be seen as depictions of ravaged humanity. They are about something larger: stillness, timelessness, and presence. Or as Grenier says, quoting Jean-Paul Sartre, "Giacometti was seeking a truth that exists outside of history's grasp."

Besides himself, his brother Diego, Annette, and his mother, the other great "character" in Giacometti's life was his studio. His living and working space for some four decades, it became as legendary as Brancusi's – visited, filmed, and photographed and meticulously recreated for the film *Final Portrait* under the watchful eye of the Fondation Giacometti. It was famously small – only about fifteen feet square – filled with works in progress, completed works, drawings on the walls, and the materials of creation. And it was just as famously Spartan: "[E]xterior communal toilets, no bathroom, a simple portable stove that did not allow for cooking, an old coal stove for heat. The pipes froze in winter and the leaks in the roof grew so large that [Giacometti's dealer] Pierre Matisse had to send them tar paper from New York to seal the gaps," Grenier writes at one point. Oh, and "a plant sprouting through a crack in the wall that he had let grow into a small bush."

And the studio is, now, the first thing you encounter when you visit the Giacometti Institute, literally, for it sits just inside the front door on the right. It is an extraordinary experience to be in the presence of the real thing after seeing so many photos of it and reading of its centrality to Giacometti's art and life. On the far side are two original studio walls, the two near "walls" being edge-to-edge, floor-to-ceiling glass panes. Inside in the nearmost corner is a long table covered with brushes, paints, and other paraphernalia of the painter. Diagonally across in the far corner is a single bed with one of the artist's coats thrown across it as if he had just come in. Between are a sculpture stand on which

rests a version of the portrait he was working on at his death, his easel, and his chair. Next to the chair a low table with his ashtray – filled. The famous sketches drawn directly on the wall's surface are visible, and there is sculpture of all kinds and from all phases of his career everywhere, among them a group of standing figures, some with their armatures exposed in one corner; under the table a plaster version of *No More Play* and other Surrealist works; on the other side of the room a plaster of *Cube*, a tall *Standing Woman*, and shelf upon shelf of smaller sculptures.

Small it is, but it doesn't *feel* small. (In typical Giacomettian fashion, he once told someone that "The longer I stayed, the larger it grew.") Rather, it feels sufficient to the needs of someone whose art is based on close proximity to and scrutiny of the living model and who, whether painting or sculpting, always had his work within his arms' reach.

In that regard, the whole thing powerfully evokes the presence of the artist and, without sensationalism or artifice, makes you something of a witness to the creative process. There is a window seat on the short wall, and if you sit there and position yourself behind Giacometti's chair you find yourself exactly at the height, and with the same sightline to the easel, as he would have had. It's hard to think of another environment that offers such a vivid, direct connection with the artist.

Fifty years after his death, Giacometti today seems as alive and available to us as ever. One wonders what the artist, who famously believed his every effort had ended in failure, would have made of that.

*Originally published as "Giacometti renewed"
in* The New Criterion, *September 2018.*

"IT IS A MISTAKE for a sculptor or painter to speak or write very often about his job," cautioned Henry Moore in 1937, relatively early in his career. "It releases tension needed for his work." Strange, then, that over the next fifty years (he died in 1986 at eighty-eight) Moore was to prove one of the most voluble of artists. When not carving one of his familiar reclining female figures, most of them bearing his signature sculptural idiom, the hole, Moore accepted invitations to set down his reminiscences and his thoughts on art – his own work and that of other artists and periods. And in the decades after World War II, he made himself available for interviews on a scale more in keeping with a politician than a practicing artist.

In 1966, the English curator and critic Philip James published *Henry Moore on Sculpture*, an anthology culled from over sixty published sources. Ten years ago, the Henry Moore Foundation issued a five-volume comprehensive bibliography that listed over six hundred utterances. Even allowing for reprints and foreign language versions, that is an extraordinary amount. Now Alan Wilkinson, author of the definitive study of the artist's drawings, has published *Henry Moore: Writings and Conversations*.

The new book contains most of the material that appeared in the first anthology. This includes such seminal texts as "The Nature of Sculpture" (1930), "Mesopotamian Art" (1935), "The Sculptor Speaks" (1937), "Primitive Art" (1941), "The Hidden Struggle" (1957), and "The Michelangelo Vision" (1964). In addition, drawing on the invaluable resource of

the bibliography, as well as the foundation's archives, Mr. Wilkinson has included two early texts not in James: an important letter from the mid-1920s in which Moore describes his visits to the Musée Guimet and the Louvre, and a 1932 interview with Arnold Haskell. Finally, it adds material that has appeared since, such as important statements on Rodin and Giovanni Pisano as well as a moving tribute to Giacometti.

All in all, Wilkinson has produced an indispensable book. But reader (and scholar) beware: Moore was an articulate, sometimes eloquent, commentator on art. When it came to his own, however, his aim was almost always to point us away from his work rather than to lead us deeper into it. Shakespeare's "Dive, thoughts, down to my soul" would be an apt epigraph for that portion of this book.

How many of today's artists would have the modesty to describe what they do as just a "job"? That same spirit informs Moore's writing. His statements are never hectoring, bombastic, or obscurantist. There is no toying with the interviewer in the manner of Picasso. Nor was Moore given to the kind of visionary, dreamlike narratives or philosophical musings favored by Giacometti. The approach is down-to-earth, the prose workmanlike.

Both the James and Wilkinson books are organized by subject – Moore's biography, his views on other artists and periods of art, and his thoughts on his own work. But read chronologically, the entries give us a clearer sense of Moore's evolution both as an artist and a writer. Thus, the pulse of passion is most evident in the early pieces – two letters from his student years written during a traveling scholarship that took him to Paris and Italy in 1925. Their run-on sentences and categorical judgments about art reflect his youthful intensity. Moore at this stage was already a committed modernist, believing in the supremacy of carving over mod-

eling and the superiority of non-Western art over the Greco-Roman tradition, or what he was to refer to a few years later as "the complete domination of later decadent Greek art as the only standard of excellence." This trip is famous in accounts of the artist's life for the aesthetic and emotional crisis it precipitated when his exposure to the riches of Renaissance art forced him to rethink this doctrinaire rejection of the Western canon.

Those conflicting currents are already evident in these letters. Paris, he writes in the letter discovered by Mr. Wilkinson, is "a dull hole," with the Louvre hardly meriting a mention, although Mantegna does catch his eye. But the Musée Guimet gets a long, excited paragraph in which Moore singles out an Indian figure as "one of the finest pieces of sculpture I've ever seen." Once in Italy, "the work of Giotto, Orcagna, Lorenzetti, Taddeo Gaddi, the paintings leading up to and including Masaccio's are what have so far interested me most." On the other hand, "[o]f great sculpture I've seen very little – Giotto's painting is the finest sculpture I met in Italy – what I know of Indian, Egyptian and Mexican sculpture completely overshadows Renaissance sculpture." About the only exceptions are late Michelangelo and Donatello. But here, too, there is a qualification: "Donatello was a modeler," he writes, "and it seems to me that it is modelling that has sapped the manhood out of Western sculpture."

The tone shifts in the 1930s and 1940s, becoming more coolly analytical. Moore seems to be examining as much as articulating an idea, turning it over in his head as if it were one of the stones or bone fragments he had begun picking up during his outings as potential source material for his sculpture. These are Moore's most productive decades as a writer, both in terms of output and what he has to say. In four of the six key texts of this period – "A View of Sculpture"

(also known as "The Nature of Sculpture" in James's book), "On Carving" (the Haskell interview), "Unit One" and "The Sculptor Speaks" – Moore lays out his artistic credo: the importance of the human figure (It is "what interests me most deeply"); the relationship between representation and abstraction ("[Sculptures should be] creations, new in themselves, not merely feats of copying, nor of memory, having only the second-hand life of realistic waxworks"); truth to materials ("Sculpture in stone should look like stone, hard and concentrated"); the penetration of the sculptural mass ("The hole connects one side to the other, making [the work] immediately more three-dimensional.... A hole can itself have as much shape as a solid mass"); the need for "vitality" in sculpture ("a pent-up energy, an intense life of its own, independent of the object it may represent"); and the importance of natural forms ("from which [the sculptor] learns such principles as balance, rhythm, organic growth of life, attraction and repulsion, harmony and contrast").

These are the decades when Moore came into his own not only as an artist but as a critic of art. Indeed the two were intertwined. As an art student in London in the early 1920s, Moore had read Roger Fry's *Vision and Design*, later crediting Fry's essay "Negro Sculpture" with opening his eyes to the collections of the British Museum. In the 1930 "A View of Sculpture," Moore reflects something of Fry's formalist outlook when he writes of the need to pay attention to "the intrinsic emotional significance of shapes instead of seeing mainly a representational value." By the end of the decade he has moved beyond Fry, declaring in "The Sculptor Speaks" that "It might seem from what I have said of shape and form that I regard them as ends in themselves. Far from it. I am very much aware that associational psychological factors play a large part in sculpture.... Each partic-

ular carving I make takes on in my mind a human, or occasionally animal, character and personality, and this personality controls its design and formal qualities, and makes me satisfied or dissatisfied with the work as it develops." 161

The two other important essays from this period are "Mesopotamian Art," a book review, and "Primitive Art." It's clear from these that Moore's regular visits to the British Museum had turned him into nothing less than a connoisseur of sculpture – steeped in the history of different periods and cultures, familiar with the literature, attuned to nuances of style and iconography, and able to move easily from broad generalizations to a telling insight about a single, closely-observed object. Here is Moore on Sumerian art:

> For me, Sumerian sculpture ranks with Early Greek, Etruscan, Ancient Mexican, Fourth and Twelfth Dynasty Egyptian and Romanesque and early Gothic sculpture, as the great sculpture of the world. It shows a richness of feeling for life and its wonder and mystery, welded to direct plastic statement born of real creative urge.... [I]ts greatest achievement is found in the free-standing pieces ... and these have tremendous power and yet sensitiveness....
>
> See the alabaster figure of a woman which is in the British Museum ... with her tiny hands clasped in front of her. It is as though the head and the hands were the two equal focal points of the figure – one cannot look at the head without being conscious also of the held hands. But in almost all Sumerian works the hands have a sensitiveness and significance; even in the very earliest terracotta figures, where each hand seems no more than four scratches, there is a wealth of meaning there.

Beginning in the 1950s, the tone shifts again. Now it is detached, orotund, Olympian – the official voice of the

world-renowned artist. "The Sculptor in Modern Society," a 1952 address to an international conference of artists sponsored by UNESCO and Moore's longest piece of writing, reads as if it had been written by a committee of bureaucrats. A typical sentence reads, "The specialization, due to psychological factors in the individual artist, may conflict with the particular economic structure of society in which the artist finds himself." This change is most striking when Moore returns to an earlier subject. Writing again on Mesopotamian art in 1974 he begins, "It is my profound conviction that the testimony of the past must not be ignored. A knowledge of our history can be of great use in our life." He sounds like a mayor at a ribbon cutting.

Perhaps we should not entirely blame Moore for these bromides. By the early 1950s, he was Britain's foremost artist and the public face of modern sculpture worldwide. His rise coincided with the invention of the modern media culture, creating an incessant and unprecedented demand for interviews and pronouncements. Moore, who had risen from humble origins by, literally and figuratively, the sweat of his brow, was justifiably proud of his place in English society. And he was a naturally open, accessible personality. The pressure to respond to the barrage of entreaties must have been nearly irresistible.

But when it mattered to him, he could summon up again the private, personal voice of the artist. Moore's visual acuity is evident in later discussions of artists whose work he admired, in particular in his comments on Michelangelo's *Rondanini Pietà*, Rodin's *Walking Man*, and Cézanne's bathers. His admiration for Giovanni Pisano, whose work he saw for the first time on his traveling scholarship in the 1920s, is expressed in a 1974 essay that surely found a whole new audience for this extraordinary but little-known Italian Gothic sculptor. It reverberates with the old passion and

keenness of observation. "The drill technique was a very special mark of the Pisano school, but Giovanni used it as an expressive instrument as well as a practical one," Moore writes. "He used it to give colour and texture to a surface so that if he wanted to make a beard have darkness, he would so drill it that it would take on a colour and texture seen from a distance."

When it came to the art of his own time, though, Moore was on less sure ground. He could be glib, even philistine, about artists or movements he disliked. Van Gogh's painting is dismissed as "panicky," born of "weakness." Nonobjective art lacks humanity, "forbidding the artist to use so much mental & human & visual experience that it can never have the fullness & richness of meaning that art with a human reference with human drama has."

Still, Moore went against the grain in championing Renoir when it wasn't fashionable to do so, lobbying hard in 1961 for the National Gallery to purchase two 1909 paintings of dancing female figures. And he captured the essence of Giacometti in an almost poetic turn of phrase, telling John Russell in 1961 that in Giacometti's figurative work, "the armature has once again become the life-line of the sculpture."

When it came to his own work, however, it is a different story. Moore's work is some of the most elusive and hermetic in all of modern art. Yet he used words to draw a curtain between the outside world and his deepest artistic impulses. The idea was to conceal rather than reveal. Only once do we feel we are privy to the innermost recesses of his artistic thought. This is in "The Hidden Struggle" of 1957, Moore's last major overarching aesthetic statement and in many ways his most important.

There is one quality I find in all the artists I admire most. . . . I mean a disturbing element, a distortion, giv-

ing evidence of a struggle or some sort.... I personally believe that all life is a conflict; that's something to be accepted.... One must try to find a synthesis, to come to terms with opposite qualities. Art and life are made up of conflicts.... I think really that in great art, i.e., in the art I find great, this conflict is hidden, it is unsolved.... All that is bursting with energy is disturbing – not perfect. It is the quality of life. The other is the quality of the ideal. It could never satisfy me.... This disturbing quality of life goes hand in hand with the disturbing quality of our time.... [People] do not understand the basic character of their age. They want to escape. Many of them expect of art perfect craftsmanship, artifacts.... Never once did I want to make what I thought of as a "beautiful" woman. This does not mean that I don't want beauty in what I do. Beauty is a deeper concept than perfection or niceness, or attractiveness or sweetness, prettiness. To me, "beautiful" is much more than that. I find a bull more beautiful than a frisking lamb ... or a big fleshy beech-tree trunk more beautiful than an orchid.

"The Hidden Struggle" is Moore's least fluid piece of writing. The word "struggle," for example, seems to have more than one meaning. But his overall message is clear: the truth of art lies below the surface, not on it. His own work possesses many of these same qualities, a "disturbing element," a synthesis of opposites. There is a recurring note of anxiety, even anguish in it. Within a given sculpture, ease is interchangeable with unease, succor with a sense of acute vulnerability, sleep with death. The only thing is, Moore here isn't talking about his own work, except obliquely. The focus of his discussion is the great masters of the past: Rembrandt, Cézanne, Masaccio, Michelangelo, Piero, and others. Yet one cannot help feeling his real subject is himself. There is

something about the essay's hesitations, its abrupt changes in direction and the simple, even stark, statements of principle that suggest the discomfort of someone accustomed to revealing little of themselves finally opening up.

Because when speaking of his own work, Moore made sure to keep the struggle hidden. Most of what he says is purely anecdotal. He almost never addresses what he is trying to say through his forms. When he speaks of his materials, we learn only about their physical, not their associational properties.

It isn't that Moore's words about his work aren't helpful. The problem is that, contrary to the rule about taking an artist's statements with a grain of salt, Moore's interpreters, from the very beginning, have accepted them at face value and looked no further. There has been a great deal of insightful writing about Moore. But Moore's own writings have had an extraordinary influence in shaping the discussion of his work. There is a kind of "Moore litany" that permeates the literature, a linear narrative that has been the perennial template for Moore criticism. Those topics – Castleford, art school first in Leeds then in London, the British Museum, "truth to materials," the trip to Italy, bones and pebbles, the Shelter Drawings – were accepted as the only keys to understanding his art. Those he ignored or preferred not to go into were set aside. As a result, there is much about his sources and influences and his iconography that remains unexplored.

Take the matter of the First World War. Moore enlisted in the army in 1916 at age eighteen, was sent to the Western Front, and saw action at Cambrai. He was gassed and invalided home. His biographer, Roger Berthoud, wrote that the after-effects of gas poisoning lingered throughout his life, a constant reminder of his war experience. "[Moore's] voice was from then on prone to huskiness. In moments of strong emotion it sometimes failed him altogether."

In succeeding years Moore rarely spoke about the war. One can easily understand why. Less easy to understand is why critics and scholars should have interpreted this reluctance as an indication that it had no bearing on his artistic development and so left its impact unexplored. In his 1966 monograph on Moore, Herbert Read, who should have known better considering how deeply marked he had been by his time at the Western Front, blithely characterized Moore's war service as "a great adventure." Philip James didn't address it at all in his anthology. Mr. Wilkinson does, including six statements. One is the 1968 observation to the photographer John Hedgecoe that "I was not horrified by the war, I wanted to win a medal and be a hero." Two others are excerpts from letters Moore wrote to Alice Gostick, his elementary school art teacher and mentor, from the front. Largely unrevealing, they would seem to confirm the conventional wisdom that the war had no impact on Moore. Instead, they illustrate the risks of relying on Moore as the exclusive guide to his life and work.

In *The Great War and Modern Memory* (1975), Paul Fussell speaks of the danger of looking to letters from the Front for an authoritative account of their writer's experiences. "Few soldiers wrote the truth in letters home," he tells us. "The trick was to fill the page by saying nothing and to offer the maximum number of clichés.... The main motive determining these conventions was a decent solicitude for the feelings of the recipient. What possible good could result from telling the truth?" And he concludes with a warning: "[A]ny historian would err badly who relied on letters for factual testimony about the war."

There is another letter by Moore, written to a friend in 1919 or 1920. By then the war had ended and the reality of its horrors had become so widely known that there was no

longer any need for euphemism. Unlike the other letters, this one is filled with raw, uncensored emotion: "The one great mistake in religion as I have known it, is the belief it creates in one that God is Almighty. He is strong & powerful & Good; but were he Almighty, the things I saw and experienced, the great bloodshed & the pain, the insufferable agony & depravity, the tears & the inhuman devilishness of the war, would, could never have been." This letter is listed and excerpted in the Moore bibliography. Yet by omitting it Mr. Wilkinson suggests that he, too, subscribes to the received view that Moore emerged from his service unmarked.

One wonders if Moore's war experience is the source of the dark strain that runs through his art. In the catalogue to his 1994 exhibition, "A Bitter Truth: Avant-Garde Art and the First World War," the art historian and critic Richard Cork (the first person to explore the possible impact of the war on Moore's art) proposed that the source of the stump leg in the 1952 "Warrior With Shield" was not, as Moore had once said, "a pebble I found on the seashore in the summer of 1952 and which reminded me of the stump of a leg amputated at the hip," but rather the memory "of similar deformations Moore [had] observed at Cambrai. He saw many of his fellow soldiers receive fatal wounds during [the battle]; and ... the patients he found [after arriving at the field hospital] could easily have included soldiers with bodily truncations as grievous as the amputated warrior Moore modeled thirty-five years later." Art historical overreaching? Not in this case. Cork doesn't mention it, but the stump leg had already appeared in a 1934 multi-part Reclining Figure, the one usually interpreted as little more than a gloss on Giacometti's *Woman With Her Throat Cut* (1932). In other words, long before Moore took that walk on the beach,

the stump leg motif was a part of his art. Moreover it is one of three that recur throughout Moore's work which, in evoking the violence of war, suggest sources in things seen on the battlefield rather than imagined. The other two are heads cleft almost in two and heads thrown back with the mouth wide open, as if in a cry or a rictus.

It isn't only in his published discourse but in his titles, too, that Moore wishes to avoid revealing too much. They are mostly simple, descriptive titles such as *Reclining Figure* and *Mother and Child* that make no effort to indicate the often wide variations of feeling in each one. And, as with his other words, it is dangerous to take them at face value. A 1936 sculpture called, simply, *Carving*, is a stone cylinder, its wider upper half angled slightly off axis and capped by a flat plane into which a pattern of geometric forms – circles and rectangles – is carved in a relief design that strongly resembles the abstractions of Ben Nicholson. Although it looks like one of Moore's few forays into complete abstraction, many writers have interpreted it as a stylized head, the abstract relief the "face", with a "nose" formed by a raised L-shaped rectangle and "eyes" and a "mouth" small sunken circles. What seems to have been overlooked, however, is that seen in this way, the sculpture reads as an image of anguish, a head thrown back with mouth agape. Moore here seems to have deliberately chosen the cerebral, rational language of geometric abstraction to mask the most personal and intense kind of expressionism. Some "Carving."

Moore's impulse to use titles to deflect us from his innermost self is vividly illustrated in an anecdote about the *Mother and Child* of 1953. It is Moore's only overtly violent work, in which a mother strains to keep at arm's length the child who is aggressively lunging, open mouthed-toward, her upturned breast. When one viewer pointed out that the

infant appeared to be "gnawing" at the mother, Moore chuckled and promptly turned that observation on its head, nicknaming the piece "Nora" on the spot.

In using words as he did, Moore wasn't being coy or dis- ingenuous. He was protecting himself. Moore's biographer Roger Berthoud hit upon this point in an amusing prefatory anecdote about the frustrations of getting information of substance out of Moore. "[He] had long since worked out an edited version of his life and thoughts, no doubt to reduce the psychic drain of countless interviews," writes Berthoud. "When I asked him questions calculated to guarantee a fresh response, he would – with a skill which one could but admire – steer his way back to one of the trusted old gramophone records with a couple of bridging sentences, only to break off with the words, 'but I've told you that before, haven't I, Roger.'"

In the end Moore was able to have it both ways, to "speak or write very often about his job," yet retain "the tension needed for his work." As an art student in London in the 1920s, Moore had resolved the conflict between the academic training he was receiving at the Royal College of Art and his new-found enthusiasm for the non-Western sculpture in the British Museum by hewing to the former during the school year and waiting until vacations to explore the implications of the latter in his own work. This became the pattern of his life: doing what was expected of him in one corner of it in order to gain the freedom to do what he wanted where it mattered the most – in the studio. So Moore's "gramophone records" allowed him to discharge his obligations as a public figure and still function as an artist. But he paid a price for this success. The statements that gave the public what it wanted sold his work short, too often leaving the impression that what Moore said about his work

is all there was to be said about it. He deserves better. Moore created a body of work whose depths we have yet to fully sound, much less thoroughly plumb. Perhaps it is time to lay his words aside and let his art speak for itself.

Originally published as "The writings of Henry Moore" in The New Criterion, *December 2002.*

THE HENRY MOORE FOUNDATION – the artist's former home and studio complex in Much Hadham, outside London – has mounted "Henry Moore Drawings: The Art of Seeing." Organized by Sebastiano Barassi and Sylvia Cox, curators at the Foundation, it brings together more than 150 works on paper from Moore's seven-decade career. It is the first such exhibition since the late 1970s. But while that was chronological survey, this is organized thematically and is informed, as few Moore exhibitions have been, by the presence of Picasso.

With the exception of the famous "Shelter Drawings" – images of Londoners seeking refuge from the Blitz in the London Tube – Moore's reputation as a sculptor has largely obscured his work as a draftsman. But not only was it extensive – like Matisse and Rodin, he drew continuously throughout his life – his relish for and mastery of the art form was such that it must be considered a parallel career.

In his approach to drawing, Moore was not modernist. Unlike, say, Matisse, he didn't incorporate the whiteness of the sheet or its flatness as elements in the drawing's overall aesthetic conception. On the contrary, as we see from the very outset in the opening section devoted to Moore's student years, and throughout, he is drawing as a sculptor, vigorously "carving into" the flat sheet to make it accommodate massive, weighty forms – mostly female nudes – within their own space.

The Shelter Drawings receive a succinct and well-selected representation of about a dozen sheets, beginning with the first one: *Women and Children in the Tube* (1940), a Stygian subterranean space indicated by a wash that covers the entire sheet, within which a group of mothers cradle children amid other shadowy figures, their small size emphasizing the vast scale of the underground environment. The viewpoint of this and similar drawings reflects Moore's initial concern about invading the shelterers' privacy. But, gradually, driven perhaps equally by a growing confidence and desire to get to the essence of his subject, the figures get bigger and closer. In *Woman Seated in the Underground* (1941), a single figure fills most of the sheet, with a row of sleepers just visible in the distance. *Sleeping Shelterer* and *Study for Shelter Sleepers*, both from that same year, are close-ups, the former of a head only – eyes closed, mouth agape – and the latter of heads with arms raised and crossed above them.

This body of work remains powerful and resonant today – small wonder that the drawings were such an enormous critical and popular success when they were shown during the war. Moore later said that their humanistic subject helped him resolve the artistic crisis precipitated by his 1925 trip to Italy, which had set up a conflict between the Western tradition, which he had heretofore abjured, and his modernist impulses. And, indeed, his scenes and figures can possess some of the gravitas and monumentality of Giotto, Masaccio, and other Renaissance artists. But that tells only part of the story. We cannot fully grasp the meaning or impact of these drawings without taking into account the long shadow cast by Picasso's *Guernica* (1937).

Moore was familiar with the painting, having seen it in Picasso's studio while it was a work in progress. He then almost certainly saw the finished painting when it was

exhibited in London in September 1938 (after which it trav-
eled to Leeds and Manchester). Its traces appear in Moore's
work: the composition of *Three Points* (1939), a sort of organic,
supine E-form whose three bars converge as sharp spines
that almost touch, has long been recognized as deriving in
part from *Guernica*'s screaming horse motif. In addition,
Moore was an intensely self-critical artist, constantly mea-
suring himself against contemporaries and revered figures
from the past. (Among the books inventoried in his library
after he died was an edition of Otto Benesch's six-volume
catalogue of Rembrandt's drawings into which he had inter-
leaved six drawings of his own.) So given the identical subject –
a civilian population under aerial bombardment – it would
not have been lost on Moore that anything he did would
have to hold its own against Picasso's definitive portrayal.
But how to proceed? No modernist artistic language could
hope to compete with Picasso's – and, besides, Moore was an
official War Artist and as such operating as a documentar-
ian. His solution was *reculer pour mieux sauter*, dealing with
a quintessentially modern, twentieth-century subject by
returning to the language of pre-modernist art. And so he
reached into the toolbox of the Western tradition, nowhere
more so than in those close-ups of sleepers. Some writers
have observed that these heads could be those of corpses as
easily as sleepers. I think this is deliberate on Moore's part.
From ancient Greek vase painting to Victorian photography,
the sleeping figure in Western art has often served as a met-
aphor for a deceased one. Moore, who was deeply knowl-
edgeable about the history of art, would certainly have been
aware of this. Here he conflates sleep and death by eliminat-
ing context and descriptive detail, and zeroing in to focus
on pose and gesture. In so doing, he elevates what would
otherwise have been mere reportage into a powerful medi-
tation on the calamity of total war.

173

After two sections on Moore's postwar drawings – most notable for a Picasso-esque freedom as Moore shuttles easily between subjects, stylistic idioms, and media, as well as such Seurat-influenced images as *Stonehenge* (1972), sheets where the forms emerge from darkness and are defined by high contrasts of light and dark – the show ends on a poignant note, with Moore's drawings from the 1980s. There have been exhibitions devoted to an artist's last years, but I can think of no other in which the work speaks so starkly and unequivocally to the artist's awareness of the coming end. We see this in his accelerated output: according to the wall text, of the 3,500 drawings he produced in his last decade, nearly one-third date from his final two years. We see it in the retrospective mood of some of the subjects, such as the copy of a Giovanni Pisano sculpture, the artist he had discovered five decades previously. We see it in the way a signature subject is adapted to reflect the artist's changed sense of self. In *Mother and Child on Seashore II* (1982), the two figures are not posed frontally as they normally were, but with their backs to us, and shown looking out at the horizon as if contemplating an unknown future.

Most of all, however, we see it in the final work in the show, (*Hands*, 1984–86) in which Moore has drawn his own hands. It is a subject he first took up in the 1970s. The earlier drawing is an image of vitality: the lines are swift and vigorous, the image has clarity and definition and the hands clasp each other energetically, evoking the interlocking forms of certain sculptures. This later work is an image of age and infirmity. The lines are hesitant, a blur of small, repeated strokes resulting in a hazy image. The familiar nurturing theme returns in the pose: the right hand seems to have swooped in to massage the stiff or aching joints of the left.

Hands is an almost heartbreaking image. Moore's hands were the locus of his identity as an artist: They gripped the

chisels and swung the hammers to create the early carvings, kneaded and gouged clay and plaster for the later bronzes, and held the implements that generated the thousands of sheets of graphic work. Yet here they struggle to discharge their function. More than a study from nature, this drawing is an act of self-reflection, a final self-portrait in which the artist looks back on his life and confronts his own mortality. It puts one in mind of nothing so much as another unsparing, twilight-years self-confrontation, a certain crayon-on-paper drawing from 1972. Picasso again.

Excerpted from "Moore & Moore"
in The New Criterion, *June 2019.*

Anne Truitt: Minimal form, maximal feeling

"ANNE TRUITT: A LIFE IN ART," which recently opened at the Baltimore Museum of Art, is small but cumulatively powerful. The exhibition surveys the career of an artist who, though well-known within the art world, has failed to receive the wider recognition she deserves.

Truitt's sculptures consist of vertical, rectangular volumes. They are constructed of wood and painted, often in more than one hue. Her work reaches back to the art world of the 1960s, when artists who were committed to abstraction involved themselves with "pure aesthetics" – all references to the natural world were banished in favor of a dialogue with form and color. Sculptors strove toward "literalism," making something that was as real and unartlike as a piece of furniture.

Truitt's work is very much in this tradition. Her geometric forms express the contemporary desire for clarity and absence of any outside association or story. Her sculptures don't rest on pedestals but on the floor, standing freely in open space. The purpose of color in her work isn't description or decoration, but is meant to bring about a fusion of painting and sculpture. The solidity and tangibility of sculpture are conveyed and mediated by the optical, non-tactile medium of color. Rather than a painted column, Truitt aims to create a column of color.

In her work, Truitt manages to achieve perhaps the most complete and articulate synthesis of sculpture and painting of any artist of the period. Each element – color and form – is dependent on the other. The volumes give body to the

color, while the colors occasionally function the way a chisel does on stone. A light-colored band around the top of a tall column "cuts" that much of it off. It's an illusion, but a powerful one. And just when you think her work amounts to nothing more than three-dimensional painting, her sculptor's keen sense of form asserts itself. The rectangular volumes, which a moment before had an off-the-shelf look, take on their own individual, inevitable character. And when it seems she's interested only in Euclidean form, the music of her palette makes itself heard.

Truitt moved quickly into abstraction. The earliest work in the show, titled *First* and dating from 1961, looks like a portion of a picket fence transferred from the garden to the museum. The giveaway that this isn't so is in the subtle variation in the sizes of the three pickets. *First* wittily straddles the line between a work of art and a real-world object. And it does more: It locates the roots of Truitt's abstraction, however fleetingly or tenuously, in nature, the world outside the studio. Thus her abstract language has less in common with the Minimalism of Donald Judd than the "hard-edge" painting of Ellsworth Kelly. Nonetheless, *First* is the only occasion when the real world intrudes. By the following year three "pickets" have become five, but they've been closed up and squared off into a five-part grave slab. We're in the realm of pure form once and for all.

Truitt's sculpture is quintessential high modernism: intensely self-involved, preoccupied with minute variations on a single theme, austere and aloof. It makes no concessions to the viewer unwilling to muster the concentration to ponder it. In this it may seem like Exhibit A in the often-heard indictment of abstract art as little more than decorative design, or a mode of expression that is out of touch with life and what matters in it.

But look again. Look at the form: It's usually a slender

upright. Look at the proportions: Normally the sculptures are no more than five or six feet tall, the height of a person. They stand like sentinels, addressing the viewer and mirroring his configuration in their form. And despite their considerable austerity, these works pulse with a quiet lyricism that transcends purely aesthetic concerns. It all adds up to a profoundly humanistic statement – one that only the best abstract art can make.

Originally published as "Truitt's Creations More Than the Sum of Color, Form" in the Washington Times, *February 23, 1992.*

SAY THE WORD "DRAWING" to someone, and they'll likely think of an image rendered on paper in a medium such as pencil, crayon, or charcoal. Say "sculptor's drawings" and what will come to mind is a preparatory sketch for a soon-to-be-realized, three-dimensional object, or of something more fully worked up that renders as completely as possible, in two dimensions, what could not be executed in three.

At root, Richard Serra's drawings are traditional, in that they consist of marks made by the artist on a two-dimensional surface that is then hung on the wall. But as "Richard Serra Drawings: A Retrospective," the well-selected and illuminating exhibition that has been touring the country and is now at the Met makes clear, any resemblance to drawing as the term is generally understood ends there. Consisting of sheets of paper or canvas many feet wide and tall, uniformly covered with black that Serra applies using home-made bricks of paintstick, his drawings typically function as elements in an installation rather than as discrete works of art. They are conceived not as vehicles of depiction – preparatory sketches or fully wrought images – but as self-sufficient objects.

One wants to say "sculptural objects," for they are designed to function aesthetically exactly as do his sculptures, engendering in the viewer a heightened awareness of the weight, balance, and gravitational pull of their forms, thereby to establish a highly charged, dynamic relationship between the work of art, the viewer, and the space they share. *Blank* (1978) consists of two roughly ten-foot-square black-covered sheets of linen facing each other on opposite

walls of a smallish gallery. With any other artist, one's habit would be to enter, look at one work, turn to look at the other, and move on. Not here. The scale and placement of these elements in relation to the size of the room turns the entire space into a work of art. Once inside, you experience both the dialogue between these two forms and the pressure they exert on the space between and around them. Serra doesn't always need an enclosed room to achieve this effect. *Pacific Judson Murphy* (1978), an L-shaped work with one part longer than the other, does something similar to a corner space in an otherwise open area.

Serra further blurs the line between drawing and sculpture with his technique. Given the size of the surfaces to be covered and the relative obduracy of the material – paintstick is a waxy oil paint – it's a process that involves the action of the artist's whole body, not just his wrist, and as such is more akin to working in three dimensions than two.

Not since David Smith's "Sprays" of the early 1950s – in which he placed pieces of metal on a sheet of paper, spraypainted them, and pulled them away, leaving white space where the shapes had been and pigment on the surrounding surface – has an American sculptor evinced such a radical conception of drawing. In blurring the distinctions between figure and ground, "positive" and "negative" form, Smith's "Sprays" invite us to ponder such questions as: What kind of image are we looking at? Where and within what sort of pictorial space? What is figure and what ground? But those works still kept faith with the traditional idea of a drawing as a picture of something, and were just one aspect of Smith's graphic output. Serra's rejection of an image-based approach to drawing defines his graphic output in its entirety.

Yet there is an intriguing paradox at the center of Serra's work in two dimensions, albeit one Serra rejects and the catalogue's contributors seem at pains to skirt. That is the

role played by illusionism. Serra's art has always pursued the modernist ideal of the "real." His work engages with the viewer's space and experience, and avoids anything that would smack of eye-fooling trickery and thus Renaissance-style representation. The elements in *One Ton Prop (House of Cards)* (1969), an open-topped cube consisting of four 500-pound sheets of metal leaning against each other, are held together by weight and gravity alone. This method of construction had the effect of shifting the ground of sculpture, creating an experiential, rather than an aesthetic object, one that made the viewer acutely aware of and intimately engaged with the physicality of its components and the drama of its precarious existence. And it made all other constructed sculpture, whose disparate parts are welded together, seem artificial, and thus at a certain remove from the viewer.

Serra has had similar ambitions for his drawings. In a 1977 interview with the filmmaker Lizzie Borden, republished in the exhibition catalogue, he replied in the affirmative when asked, "In other words black is not on the drawing, it *is* the drawing?" And in his own "Notes on Drawing" from 1988, also in the catalogue, he declared, "All illusionistic strategies must be avoided. The black shapes, in functioning as weights in relation to a given architectural volume, create spaces and places within this volume and also create a disjunctive experience of the architecture."

The fact is, however, that Serra's success in achieving such effects depends precisely on that very quality he most vociferously rejects: illusionism. As the creator of those works, Serra is free to talk about them any way he pleases. But the reluctance of his interpreters to discuss that aspect of his work obscures an essential aspect of his achievement.

Organized by Bernice Rose and Michelle White of the Menil Collection and Gary Garrels of the San Francisco

Museum of Modern Art, the exhibition consists of some fifty drawings spanning the entire run of Serra's career, from an untitled piece based on an early outdoor work and *Encircle Base Plate Hexagram, Right Angles Inverted* (1970), to his signature large-scale "installation" drawings, like the "Forged Drawings," in which paintstick is applied to blocks of steel about two feet square, and works of the last decade where Serra has passed the paintstick through a meat grinder before applying it to the surface to give a more physical, "fluffier" pigmented surface.

Serra is nothing if not ecumenical in his approach to drawing. He may not make preparatory sketches, but he does just about every other kind of drawing a sculptor can: He draws after a particular sculpture, as with the untitled work mentioned above. He will sketch one of his sculptures once it is installed. He has even made a suite of twelve drawings based on the experience of walking around *Circuit* (1972), a work consisting of four steel plates, each bisecting one corner of a room and leaving a smallish clearing at the center for the viewer, where the forward edges of the plates stop just short of touching. (Standing in it is like facing a four-man firing squad at point-blank range.) On each sheet there are three or four vertical black lines of varying lengths and distances from each other, and reflecting the edges of the four plates seen from different positions.

The exhibition is supplemented, to great effect, with Serra's famous 1967–68 "Verb List," a compilation of some one hundred ways of acting upon a material or site ("to roll," "of time") that constitutes a kind of sculptor's manifesto, continuous-loop showings of some of the films he made at that time such as "Hand Catching Lead," and some sketchbooks. Serra carries these last in his pocket as *aides mémoires*, recording things seen on his travels, in the course of his

work, or while surveying his sculpture. They tell a lot about the workings of the artist's eye and mind. The images contained in them are striking and intense, showing the artist's ability to succinctly conceptualize a motif and render it in short, quick strokes of a thick charcoal occasionally supplemented with a smudge of shading.

Perhaps because the broad, black planes of Serra's drawings so closely resemble the dark, industrial impersonality of the steel and lead sheets of his sculptures, the tendency has been to see it as an outgrowth of them. But what emerges from this show, particularly from the early drawings, is just how deeply rooted his drawing practice is in the pictorial traditions of modernism. The two drawings after *Base Plate*, dating from the early 1970s, consist of concentric circles drawn in clear, unhesitating charcoal lines on a gray-smudged ground against the white of the sheet. They recall drawings by Matisse in which a line drawing sits amid a gray cloud of multiple erasures that reflects the process that led to the final image.

Abstract painting in the Ellsworth Kelly vein would seem to be the source of an untitled drawing from 1973. Here, a solid black trapezoid sits against a white ground, three of its four corners almost touching the edges of the sheet, picture plane uncompromisingly asserted throughout. But then it flips into another dimension, with the black form suggesting a Serra-like steel plate seen in foreshortening, even torqued a bit, as if in anticipation of the artist's sculptures from the 1990s. Josef Albers makes an appearance in *Untitled (14-part roller drawing)* (1973). The series opens with a black rectangle on the left side of a sheet and nothing but white on the right. Gradually, over the fourteen drawings, the tonal relationships change, the black area lightening and the white area darkening, until by the final

image they have reversed, with pure white on the left and jet black on the right. This drawing mirrors almost exactly one of the first exercises that form part of Albers's legendary 184 color interaction course, which Serra actually taught while a graduate student under Albers at Yale in the early 1960s. And of course, the immediate antecedent of Serra's later paintstick technique is to be found in the drawings of the post-Impressionist Georges Seurat, who similarly eschewed line, developing his forms instead through graded strokes of conté crayon on heavily-toothed paper. (Serra, we learn in the catalog, owns a Seurat drawing.)

Then there is Serra's use of black. In interviews, Serra has said he chose it because it is the one color that doesn't suggest anything in nature, thus allowing him to avoid any hint of representation or illusion, and because its light-absorptive properties endow his forms with visual weight and density. No doubt. But Serra didn't come to this latter insight independently. The notion that black has any sort of active role to play in a work of art derives from modernist painting, specifically the work first of Manet and, later, Matisse, who transformed it from a "negative" element – something used mainly to depict shadows – to a "positive" one capable of adding visual weight and emotion to a painting. Later painters, such as the New York School artists Robert Motherwell and Helen Frankenthaler, adapted this insight to their work. The lesson from all of this would seem to be that, though Serra's mature conception of drawing is profoundly sculptural, sculpture and sculpture-related drawing themselves offered no precedents for his evolving aesthetic. He had to find his way primarily by pictorial means.

But Serra's pictorial allegiances do not end there. For all that he might declaim about the need to avoid "illusionistic strategies" in his drawings, such strategies are essential to their success. What are they? The first is applying the black

paintstick with sufficient edge-to-edge uniformity and accumulated thickness to give the shape the optical density it needs to suggest solidity and weight. And the second is determining the final form of a drawing on site, fine-tuning the relationship between shape and spatial environment to get the effects exactly right. In other words, like artists down the centuries, he is manipulating his materials, hand and eye working in tandem to transform the facts of nature into the truth of art.

Not only is illusionism central to Serra's drawing, it is the necessary measure of his success. Without it, his images read as little more than black forms on a white ground. Take, for example, the *Weight and Measure* drawings from the 1990s, a series of framed works in which one large black square is superimposed over another, their relationships changing from drawing to drawing across the series. It grew out of an experience Serra had seeing a sculpture of the same name, consisting of two large blocks of steel, installed at the Tate Gallery. Viewed end on, with one block behind the other, the rear block appeared to him to float above the nearest one, a sensation he sought to recreate in two dimensions. Yet it never quite happens. Though they exert a powerful presence, they nonetheless read as geometric abstractions, sort of stripped-down and more robust Mark Rothkos.

Compare those with *Pittsburgh* (1985). Here Serra has drawn a rectangular black shape. Its bottom edge is coincident with that of the sheet, its left and right edges tilting slightly inward, out of plumb, and its top edge a broken line. It begins at the left corner as a near-horizontal with a slight upward tilt, rises vertically for a few inches at about the halfway mark, then resumes its journey to the right corner as a near-horizontal, but this time tilted slightly downward. The visual effect is of two distinct forms, upright sheets of steel, each one standing slightly off the vertical, whose inner

edges just barely overlap. Serra's careful calibration of the edges is the key to the effect of this piece and suggests the fruit of his close study of Brancusi in the 1960s – he drew from the Romanian artist's sculpture in the reconstructed studio in Paris. For in Brancusi's work, too, the edge or contour of the sculpture is critically important to determining the character of the interior volume.

Yet you will find no mention of illusionism in the catalogue by anyone other than Serra. Though Ms. White mentions his truing and fairing of the drawings on site, she doesn't explore the implications of this practice. Ms. Rose tells us that Serra owns a Seurat drawing, but asserts that the older artist absolutely, positively had no influence on Serra. How is she so sure? The statement is footnoted to a May 2010 interview with him. Serra is exceptionally articulate about his work but even so, artists aren't always the most reliable guides to what they do. A writer needs to balance what their subject tells them with their own perceptions and insights. Yet too much of what's been written about Serra over the years, these essays included, reads as if the authors had simply taken dictation. The Stockholm Syndrome is not a useful starting point for the criticism of art.

Despite what Serra implies in "All illusionistic strategies must be avoided" and similar statements, the presence of illusionism in his work does not make it less respectable or "modern." For one thing, illusionism and representation are not synonymous, and for another, its presence highlights Serra's central achievement as a draftsman. For it has allowed him to bridge two worlds, to put pictorial means to plastic ends and, thereby, to make something altogether new out of the art of drawing. Like any draftsman, Serra makes marks on a sheet, marks which – at least when seen from an angle, in raking light – record the artist's presence

and touch through their accumulation and texture. And yet the results are, in a very real sense, powerful works of sculpture. Had he never touched metal, Serra would still be one of the foremost artists of our time.

187

Originally published as "Richard Serra's illusions"
in The New Criterion, *May 2012.*

Richard Serra II: Sculpture in the active voice

THOUGH ORGANIZED BY a commercial gallery, this museum-quality show is the third in an important series of recent Richard Serra exhibitions that have greatly deepened our understanding of this artist's work and achievement. The first, MOMA's 2007 retrospective, offered a broad overview of his career as a sculptor. Three years later, the Metropolitan Museum of Art's "Richard Serra: A Drawing Retrospective" explored the artist's career as what can only be described as a "graphic sculptor." Hard upon that comes "Richard Serra: Early Work" at the David Zwirner Gallery in New York, which zeroes in on Serra's formative years in the late 1960s, which began with the rough-edged (literally and figuratively) "Process Pieces" and ended with the "Prop Pieces." As such, it recreates the period that saw Serra emerge as a fully mature artist, the moment when he turned "sculpture" from a noun into a verb.

The show consists of twenty-four sculptures, the earliest from 1966 and the latest dated 1969–71; Serra's famous 1967 "Verb List," a kind of artistic manifesto; and five films from the late 1960s and early 1970s, the best known of which is perhaps *Hand Catching Lead* (1968).

The Chelsea space consists of two large galleries. The first one contains the Process Pieces: works consisting of *Slow Roll: For Philip Glass* (1968), a number rolled up sheets of lead; *To Lift* (1967), a sheet of vulcanized rubber positioned on the floor so it looks like an upright cape minus its owner; *Tearing Lead* (1968), a square formed by wiggly lead ribbons with more such strips bunched and billowing from

each corner; and *Cutting Device: Base Plate Measure* (1969), a cluster of materials like wood, stone, and steel on the floor but dispersed in a way that looks as if it has just been bisected by a chain saw.

These early works were a reaction to Minimalism's austerity and emotional detachment, and what's striking is the extent to which they reflect the lingering spirit of Abstract Expressionism, despite being antithetical to it in so many other ways: the gestural quality of the splayed lead ribbons in *Tearing Lead*, the all-over dispersal of *Base Plate Measure*, and, throughout the work of this phase, an eschewing of the closed contour. Yet there remains something tentative and small-bore about them. They have the quality of experiments or demonstrations rather than self-sustaining works of art.

The adjacent gallery contains a selection of the Prop Pieces that grew out of these efforts. These are open form sculptures made by combining sheets of lead – and sometimes pipes – such that they are held together only by their own weight and the force of gravity. Thus, *One Ton Prop (House of Cards)* (1969) consists of four, four-foot-square lead plates, each one positioned on one edge and leaning against each other to form an open cube. *Equal (Corner Prop Piece)* (1969–70) consists of a same-sized lead plate balanced on one edge and held in place by a horizontal lead bar wedged into a corner and poised on a single corner of the lead square. They are especially noteworthy in this context for their embrace of a Minimalist clarity and formal rigor.

Those early Process Pieces were radical in their use of unconventional materials (rubber, neon, lead), their direct, informal relationship to the viewer (leaning against the wall, spread across the floor), and in the conflation of making and meaning. Yet radical as they were, they remain firmly within the tradition of sculpture as it had existed for millennia in that, like any conventionally carved, modeled,

or constructed sculpture, they represent the residue of a process. A series of forming actions was required to create them; at a certain point those actions came to an end; a work of art was the result. A look at the verbs used to describe these works makes this point: The materials in *Cutting Device: Base Plate Measure* have been sliced through; the lead sheet in *Tearing Lead* has been ripped; in other works, the same material has been folded and unfolded, rolled or spiraled, just as one would say that Michelangelo's *David* has been carved or that Picasso's sheet-metal *Guitar* has been assembled.

By contrast, it was the Prop Pieces that broke decisively with sculpture as it had been practiced up to that time by making process – the act of forming – and the resulting form itself both coincident and continuous. Again, verbs tell the story: The four square planes in *One Ton Prop (House of Cards)* are leaning into each other; the pipe and plane in *Equal (Corner Prop Piece)* are balancing; the large steel sheet that is *Strike* (1969–71) is jutting out into the room. Thanks to Serra's innovative use of weight and gravity in place of welding or other traditional methods of adhesion, the act of forming and the form itself – the resulting sculptural configuration – are inseparable in these pieces. As such, they exist in a kind of continuous present. They are continuously coming into being, while at the same time continuously existing as completed works of art – sculpture in the active voice

Two other insights emerged from this show. One was the extent to which the aesthetics of the Prop Pieces scramble traditional sculptural vocabularies. *House of Cards* is a volume with no mass but considerable weight – in the form of the four five-hundred-pound lead sheets that make it up. Hitherto a plane had been thought to be a building block of sculpture but insufficient in itself to be one – lacking the requisite substance or dimensionality. Yet in *Strike*, and in other works not included in this exhibition, Serra upends

that notion by producing powerful works using a single, uninflected sheet of steel.

The other was how important proportions are to Serra's sculptures. He seems to have paid a lot of attention to sizing individual elements and completed Prop Pieces to achieve the ideal one-to-one relationship with the viewer, neither so large as to be overwhelming to him nor so small as to be dwarfed by him. These pieces "look you in the eye," as it were. At the same time, when he does opt for monumental scale, as in the eight-foot-by-twenty-four-foot *Strike*, the single plane is so proportioned that it retains an overall visual tension, like a canvas pulled taut across its stretcher.

The one regret here is the presence of tape on the gallery floor marking off the boundary beyond which one may not approach each Prop Piece. It was obviously required by the insurance company (MOMA did the same thing in its retrospective), but it does grievous harm to the works themselves, which in the precarious balancing of heavy pieces of metal are all about establishing a direct, even fraught, interaction with the viewer. The tape boundaries sequester the sculptures into a safe zone separate from the viewer, turning them into the very "museum pieces" from which Serra sought to move sculpture away, beginning with his earliest efforts. Perhaps one day some institution will find a way to balance liability protection with aesthetic integrity and exhibit the Prop Pieces unmediated by barriers. It seems unconscionable that such exciting, revolutionary works should be doomed to being forever displayed in a way that so diminishes their vital forces.

Originally published as "Exhibition note: 'Richard Serra: Early Work'" in The New Criterion, *June 2013.*

H. C. Westermann: The absurdity of the absurd

The most refreshing art exhibition around right now is at the Hirshhorn Museum, where an array of quirky, anarchic constructions by H.C.Westermann can be seen through May 12. Walking through "H.C.Westermann," the retrospective organized by Lynne Warren and Michael Rooks of the Museum of Contemporary Art, Chicago, where it originated, you feel as if someone opened a window in the art world and let some air in.

Though Westermann's heyday was the 1960s and 1970s (he died at age 59 in 1981), his sculpture strikes a chord today because like much contemporary art, its underlying theme is the artist at odds with society. But the similarities stop there. In place of today's stifling sanctimony, Westermann's critiques of man and his world are larded with humor, albeit of a kind that belies their dark seriousness.

More importantly, unlike the cookie-cutter similarity of much of the "new" art being shown now, he's a complete original. While one gets glimpses of Westermann's aesthetic pedigree throughout his work – Picasso, Duchamp, Joseph Cornell – he was entirely *sui generis*.

Westermann was a modernist magpie who went beyond the assemblage practiced by his contemporaries, who fabricated objects from a multitude of different parts, some scavenged, some handmade. Instead, Westermann merged this ad hoc, intuitive creative puttering with its opposite, the labor-intensive craft of cabinetmaking, and then leavened

his work with a sardonic wit. From a farrago of raw materials he created wry sculptural expostulations about a world maniacally out of joint.

His signature image is the "Death Ship." In many small sculptures made over the course of his career, a freighter floats in the water, circled by sharks. They are potent icons of doom. Westermann's other principal modes were humanoid assemblages (often life-size) that are emblems of an out-of-control, man-made machine world, and what you might call "container constructions" – houses and boxes, such as *Memorial to the Idea of Man if He Was an Idea* (1958), whose interiors enlarge on the implied narrative of their exteriors.

These latter recall the Surrealist boxes Cornell had been making since the 1930s. But where the forms in Cornell's boxes serve as springboard to reverie, those in Westermann's blend the allusive poetry of Surrealism with a kind of funhouse raucousness. And whereas for Cornell the box format provided a stage wherein his sensibility could dilate, for the all-stops-out Westermann it served the opposite purpose: reining it in and focusing it.

Born in Los Angeles in 1922, Westermann enlisted in the Marine Corps in 1943. He served as a gunner aboard the U. S. S. *Enterprise* in the Pacific, defending it against kamikaze attacks and watching as a suicide plane struck the magazine of its sister ship, the U. S. S. *Franklin*, killing more than 1,000 and forcing hundreds of others to hope for rescue in shark-infested waters. Out of such experiences the "Death Ships" were born.

Even before his war experience, though, Westermann had seen ample evidence of a world cruelly awry. At eighteen months, he was badly burned when he fell into a gas heater at home. Soon afterward, his grandfather committed suicide, but with a weird, Gothic twist: He chose the town where his daughter, Westermann's mother, had been born, as the place

to do himself in. Westermann's mother died when he was twenty. He learned about it from his Marine Corps recruiting officer, not his father, and then two months after the fact.

194 Life was to perpetrate one final ghastly trick on the artist: Having spent more than a decade building a house and studio from scratch with his own hands (right down to milling the lumber he needed), Westermann died of heart failure just as he and his wife were getting ready to move in. It was to be an eerie real-life enactment of the conceit represented by *Mysteriously Abandoned New Home*, a 1958 sculpture of an octagonal structure whose ground-floor doors and windows are boarded up. One of the upper windows frames a question mark.

The "Death Ships" excepted, the dominant note in Westermann's work is the absurd, but of a subtler strain than your garden-variety existential angst. You might say this worldview is inflected by an awareness of its own limitations – the absurdity of the absurd. *Suicide Tower* (1965) is a cantilevered jumping platform reached by a stairway of such length as to suggest that anyone on his way up would have ample time to reconsider his rash act. And if he didn't, he would be forced to expend so much effort to be able to kill himself that life's travails would soon seem enough of a welcome relief for him to want to turn back. Westermann may have had a melancholy view of things, but somehow, he always managed to have the last laugh.

Originally published as "The Gallery: The Absurdity of the Absurd – Many Opposites Attract in H. C. Westermann's Dark, Playful Sculptures" in The Wall Street Journal, *April 18, 2002.*

From the beginning of his career twenty-five years ago the figure of Mark di Suvero has loomed large on the artistic landscape. Indeed, he is one of the few sculptors of his generation to have become something of a myth. In 1960 he made a dramatic debut at the Green Gallery with an exhibition of oversized sculptures. In the same year he was in a near-fatal elevator accident which for some time dramatically limited the range of his artistic activity. By the late Sixties, however, he was back in full possession of his powers, making sculptures on an even bolder scale than before. In the early Seventies he caused a sensation by going into self-exile to protest the Vietnam War. And when he returned in 1975 he was greeted by a triumphant retrospective of his work at the Whitney Museum. All of this by now has helped to confer upon di Suvero a legendary status. Even his media image is that of the artist-superman – bare-chested, hard-hatted, working the controls of a crane or battling resistant work-in-progress.

The Whitney Museum's retrospective was really the crest of the wave. It marked the return of the artist-exile at the moment when America was ending its commitments in Southeast Asia. It also presented di Suvero as both the heir of David Smith in the tradition of constructed sculpture and a younger, brasher rival to the Englishman Anthony Caro, whose own retrospective at the Museum of Modern Art had closed only a few months before. As such the Whitney retrospective signaled the end of one phase of di Suvero's career – its long, troubled beginning – and the opening of another in which one anticipated that di Suvero would be able to give

full rein to his formidable creative powers, undistracted by physical disabilities or political interests. Ten years have passed since then, and now another di Suvero retrospective is on view, this one at the Storm King Art Center in Mountainville, New York. How does di Suvero's work look now that all the hoopla is behind us?

"Mark di Suvero: Twenty-five Years of Sculpture and Drawings" is, it must be said, somewhat misleading. Comprising twenty-one sculptures indoors and eighteen outdoors, it omits the large-scale early works, such as *Barrel*, *Hankchampion*, and *Che Farò Senza Eurydice*, that did so much to establish di Suvero's early reputation and announce his sculptural concerns and intentions. From the late Fifties the exhibition presents only the expressionistic, Rodin-inspired Hand sculptures; it then moves on to the post-accident pieces of 1961–67 without acknowledging in any way the important work that came between.

At the outset, then, we are given a distorted view. As it stands, the visitor unfamiliar with di Suvero's sculpture is likely to come away from Storm King with the impression that his early works were part of a protracted "warming up" period during which he experimented with many different modes of sculptural expression before finally finding his true artistic self in the later (post-1967), large-scale outdoor sculptures.

The truth is very different. These small-scale works – at least those from 1961–67 – represent an interim phase of di Suvero's work. It consists of work executed during the long period of convalescence, that is, the period before he felt sufficiently recovered to return to making large-scale, gestural sculpture. Thus if we are to get any accurate sense of the inner logic of di Suvero's work over the years – surely the purpose of a retrospective of this kind – it is vital that we have these early pieces before us.

Di Suvero's early works (happily two are on view at the
Modern and at the Whitney) were striking at the time, and
remain so today, for the manner in which they fused the
language of constructivism and the sensibility of Abstract
Expressionism. They were six or seven feet high and formed
from worn planks and pilings scavenged from the wharves
of lower Manhattan; occasionally they incorporated more
recognizable objects, such as ladders or barrels. These dis-
parate elements were held together – and apart – by steel
rods and chains in a manner which suggested forces held in
permanent tension. While constructivist in their use of dis-
crete, found forms and in their vestigial cubist syntax, they
were without the traditional cubist "core" which would nor-
mally order and lock disparate parts. Instead, all the ele-
ments thrust away from the center, creating voids which di
Suvero worked as eloquently as his solids. The result was
sculpture whose drama resided in both its size and its vigor-
ous, gestural character.

Much was made at the time – and in the years following –
of the similarities between this phase of di Suvero's career
and Abstract Expressionist painting, that of Franz Kline in
particular. The cantilevered lengths of wood were seen as
sculptural analogues to Kline's bold, black paint swaths,
forms which likewise appeared arrested in space.

Yet far more important – and, as far as I know, little
noticed at the time – was the way di Suvero altered the for-
mal vocabulary of constructivism as it had existed from
Picasso down through David Smith and, later, Anthony
Caro. For in using battered pieces of wood and readily rec-
ognizable objects, di Suvero departed from the more tai-
lored, elegant look of orthodox constructivist sculpture.

Artists such as Smith and Caro strove continually to de-
emphasize – within certain limits, to be sure – the industrial
origin of their forms, the better to accommodate them to

the overall aesthetic program. Smith, even when using something as distinct as a wrench or a pair of tongs, achieved this accommodation by articulating the form's purely sculptural qualities – its mass or lack of it, its contours, its spaces. Caro, in turn, eschewed recognizably industrial elements – except for I-beams – preferring more generalized forms. And of course he painted his work. Both men consistently attempted to put a certain amount of distance between their finished sculpture and the scrapyard or the steel mill that was its source. "De-naturing," as this was referred to at the time, was nothing more – and nothing less – than the passage from nature to culture. The world of things was drawn upon and the object transfigured and so made part of the world of art. Such a transfiguration was vital to the success of constructed sculpture as it had existed prior to di Suvero. David Smith acknowledged this fact when he spoke disparagingly of "stopped images" – sculptures in which the borrowed industrial forms violated the integrity of the whole by affirming too explicitly its identity in nature.

Di Suvero, in making no concessions to such refinements, in effect "de-aestheticized" constructed sculpture, bringing it down from the loftier realms of good taste in order to give it a rawer, more direct expressive charge and relation to the viewer. (In this there is a small element of irony, for it reflects the belief that constructivism, originally thought radical in its use of common or debased materials, needed the very sort of *bouleversement* it had administered to the established practice of its time.)

Nowhere was this "de-anesthetization" more evident than in di Suvero's unadulterated use of large, recognizable objects – ladders, barrels, and the like. In their consciously incongruous, "look-at-me" character they had a quality of artistic subversiveness and daring that suggested the artist's willingness to take enormous risks and his desire to

make a brash gesture in the interests of making sculpture more "real."

All of this gave a populist dimension to di Suvero's work. He used whatever materials came to hand, as opposed to restricting himself to certain "ideal" forms, the implication being that anything is admissible in the making of art. The more direct, down-to-earth mode of address to the viewer implied a more democratic outlook, one deliberately opposed to the more rarefied, "fine art" creations of earlier constructed sculpture.

Di Suvero's 1960 accident – he was riding atop an elevator that crushed him when it failed to stop – brought his artistic activity to a halt. When he was well enough to sit in a wheelchair, he could only work by welding pieces of metal in his lap, or by using assistants to move modestly larger forms. These sculptures form an eclectic mix – not surprisingly, really, since they are the work of someone trying to get used to another order, another smaller scale of sculptural operation. They make one realize how much the earlier works were scaled to an upright body. What we have in these works is di Suvero trying to teach himself a new language – new to him, anyway – but without leaving behind the old vocabulary.

Thus among this group there are works which come across as "drawing room" pieces – overly elegant, precious things made of overlapping and intersecting arcs of stainless steel, such as *Moonrise* (1961–62). Or there is *Bach Piece* (1962), a masterpiece of sculptural illusionism – admittedly a curious thing in di Suvero – in which a tilted chunk of beaten-up wood and three or four vertical nails stand at opposite ends of a sloping steel "hill," the tense, charged relation between the disparately scaled groups vividly suggesting four persons confronting a giant monolith. And there is *For Giacometti* (1962), a moderately large-sized floor

piece (four feet high, six feet wide) in which, at opposite ends of a platform, a section of wooden beam wrapped in chain and another with a metal ring projecting from its top tilt away from each other. In its poise, dynamic tension, charged interior space, and gestural character, *For Giacometti* is closest to the earlier large-scale works. It conflates the essential qualities into what is almost a landscape configuration.

Not until di Suvero gets fully mobile again does he truly recover his sculptural momentum. When he does, it is in a manner even more vigorous and expansive than before. In 1967 the artist shifted from wood construction to metal and embarked on a succession of enormous sculptures (thirty to forty feet high) made of extended I-beams and cables, apparently in an effort to recapture the impressive gestural style of his earlier phase. Owing to the attenuation of the I-beams, these later sculptures have reduced, linear silhouettes that make them look somewhat fragile and give them a surprising grace and elegance; in relation to their rougher forebears, they are almost refined. The earliest, *Are Years What? (For Marianne Moore)* (1967), carries over the staccato rhythms of the prior phase and so stands as a perfect point of transition. It is as if the accident had never happened and di Suvero was indeed simply moving on from what he had done before. What differentiates these sculptures, more than their size, is the introduction of an element that will soon become the artist's signature: the suspended or balanced form. Here it is two I-beam sections joined to form a "V," and hung by one end so that the "V" floats and rotates in space midway up the sculpture.

If in these sculptures di Suvero does return to his former gestural manner, it is gesture with a new artistic center. This is understandable, for there can be no doubt of the causal link between this new campaign and di Suvero's full recovery from the accident seven years before. So sudden, and so

extreme, is the shift in size, and so aggressively do these sculptures stake their claim to their environment, that they suggest a sudden release, an exultation at the onset of free, unfettered mobility – exactly what one might expect of an artist recently emerged from a period of prolonged physical debility and confinement, particularly an artist whose earlier work had been so animated and physical in character. All at once, it seems, di Suvero moves from a generalized, aesthetic expressionism to one that is personal, even autobiographical.

In the sculptures following *Are Years What? (For Marianne Moore)*, the balancing element is no longer incidental: it is central to the entire work – in a way similar to Calder's stabiles, where forms are also suspended from firm structural supports. Additionally, these sculptures are not the spreading configurations of old: they are architectonic, structural affairs divided into two parts, "support" and "action."

It goes without saying that at such a scale, such feats as di Suvero performs are highly dramatic. The sight of *Mon Père, Mon Père* (1973–75) – with its enormous "V" form suspended horizontally some twenty feet in the air – is captivating, and not a little terrifying. Yet once one has gotten past the drama, these aspects strike one as gestures undertaken for their own sake. They have a decided attention-attracting character to them, a character one had seen earlier in di Suvero's work but now isolated and made the "subject" or point of the work. Other sculptors, notably George Rickey, have made balancing their "subject," but in Rickey's work it has a symbolic as well as plastic *raison d'être*, expressing continuity, stability, equilibrium. Di Suvero's balancing, by contrast, has no meaning outside itself. Even as an expressive gesture it falls flat, functioning as a diluted, more genteel version of the dynamic tension of the earlier works. What we have here, then, is not the coordinated set of aesthetic

relations we associate with orthodox constructivism but instead a heroic demonstration – a demonstration of freedom from physical considerations and principles.

With this freedom comes another development in di Suvero's form vocabulary, again an outgrowth of tendencies seen in the earlier sculpture. If previously the artist used whole, recognizable objects in his work in order to "de-aestheticize" the constructivist language, to make it more "real" and accessible, in the large, post-1967 outdoor works he uses recognizable objects without giving them even vestigial aesthetic roles. Thus, suspended from the middle of *She* (1977–78) – a low, laterally spreading sculpture – is a steamroller drum. It hangs there inert, with no relation to anything else around it. Similarly, affixed to one end of *Sunflowers for Vincent* (1978–83) – a bright yellow, horizontal sculpture – is a stainless steel ship's propeller.

In these sculptures di Suvero's populist stance becomes more pronounced. The directness and relative ease of access of the early works – always, it should be stressed, existing on an *aesthetic* plane – is transferred to the physical realm as the artist increasingly makes sculptures with parts that can be pushed, rotated, or otherwise maneuvered by the spectator. The ultimate version of this is his increasingly frequent practice of suspending low platforms off his sculptures – there is one suspended from *She* – designed for the viewer to sit or recline on. In di Suvero's exhibition of recent work this summer at the Oil & Steel Gallery in New York there was even a piece whose "sculptural" members were *only* supporting such a platform. Clearly here the imperatives of constructed sculpture have been overturned and put in the service of a kind of "playground sculpture."

The emphasis on demonstration as the principal artistic statement, the increasingly explicit use of recognizable objects, and the more physical, interactive aspects of his

sculpture tell us that di Suvero has moved a long way from the tradition of orthodox, constructivist sculpture. Indeed one might say that at this point di Suvero's sculptures are not so much constructivist as simply *constructed*. He has tried to extend into these monumental works the vernacular expressionism of his early pieces, but he has succeeded only in emptying them of any but the most transitory satisfactions. By renouncing his earlier aesthetic logic and formal rigor he has left us with the casual, the utilitarian, the entertaining.

As such di Suvero's sculptures represent not the vital extension of a tradition but the playing out of one. They anticipate, even clear the ground for, a figure like R. M. Fischer, who combines discarded industrial forms to make not abstract sculpture but "abstract" lamps, domesticating the constructivist impulse and taking the anti-aestheticism announced in di Suvero's work to its ultimate conclusion. Di Suvero's work thus stands as an important benchmark in the journey from late modernism to the formulation of the so-called postmodern canons of irony and the commonplace.

What a difference a decade makes. Ten years ago it would have been unthinkable to suggest that di Suvero stood in anything but the mainstream of modernist sculpture. That we can no longer hold this view is a consequence of the passage of time and the displacement effected by new art. No doubt di Suvero's artistic persona is robust enough to withstand these changes. Still, it is unlikely that we will ever again look upon his sculpture with the same innocent enthusiasm as we did before.

Originally published as "Di Suvero and constructivism"
in The New Criterion, *September 1985.*

William Tucker: Speaking the "language of sculpture"

THE STORM KING ART CENTER in Mountainville, New York, is something of an annual pilgrimage point for aficionados of modern and contemporary sculpture, not to mention ordinary art lovers wanting a day in the country. Located in the Hudson Valley about two hours northwest of Manhattan, Storm King is a former private residence turned outdoor sculpture museum. A Norman-style building sits amid four hundred acres of gently undulating terrain. It's a sort of Brobdingnagian version of MOMA's sculpture garden, but with the Modern's catholic taste exchanged for a concentration on constructed sculpture. Noguchi, Moore, and Hepworth may be in evidence, but they only highlight the preponderance of Smith, di Suvero, and, lately, Calder.

It is a splendid anomaly: a major museum positioned off the beaten track and devoted to exhibiting outdoors a form of art not known for its affinity with nature. Yet there's a rightness about the place. Each piece of sculpture is so magnificently situated that it makes you overlook weaknesses you'd trip over anywhere else, and there's no museum in the world that can make a visitor feel more at home. But there's also an edge. Because of the size and drama of the setting, and the character of the sculpture on view, there's a feeling of art and nature jockeying for position, each worried the other will get the upper hand. It requires a certain robustness for a sculpture to make itself felt at Storm King, and not every work on display there has what it takes.

On the face of it, the English-born sculptor William Tucker might seem an unlikely – even risky – choice for Storm King's annual special exhibition. For one thing, Tucker's work has of late consisted of the modeled monolith, a form that was favored by such early modern sculptors as Rodin, Degas, and Matisse and thus one that might seem out of place amid the hard-headed modernism of Storm King's permanent collection. Then its scale, which is consciously human, makes it vulnerable to being swamped by the Art Center's physical setting and the size of much of its collection. But most of all, it is the tone of Tucker's work that sets it apart from the work around it. It is a deeply introverted, private sculpture that lacks the confident expansiveness of its many neighbors.

Nevertheless, as "William Tucker's American Decade, 1978–1988" shows, the artist's work more than holds its own at Storm King. Indeed, it confirms the impression left by successive encounters in art galleries recently that Tucker is one of the most gifted sculptors working today. In its modest physical scale and introspective mood Tucker's work offers the viewer an experience at once more measured and more substantial than that provided by some of the more inflated or parochial fare at Storm King. And Tucker makes sense there for other reasons as well. He's an artist absorbed by – to borrow the title of his 1974 book on Rodin, Brancusi, and other early modernists – the language of sculpture, and by its history. Going through the exhibition, we feel Tucker's work now playing off of, now aligning itself with, the ideas and idioms on view at Storm King. At the same time, it addresses itself to issues of the moment. If other annual exhibitions at Storm King have joined the aesthetic flow of the place, or offered alternative channels, Tucker's work tacks back and forth across the mainstream. He reveals as much about the present and past of sculpture as he does about his own work.

The show has a welcome completeness for those who know Tucker's sculpture only from biennial gallery exhibitions and who have wanted a broader view. Thirty-five sculptures and drawings are on display, all drawn from the last decade. It was during this period – beginning, that is, in the mid-Seventies – that Tucker came to live in the United States, emigrating from his native England. (He became an American citizen in 1986.)

We emerge from the show at Storm King with an awareness of what the move did for him. It signaled the point at which he became his own man. That is, he stepped out from the brightly colored, Minimalist-derived object-sculptures he had made as a member of the "New Generation" of British sculptors who studied under Anthony Caro at the St. Martin's School of Art in London. And he abandoned the less derivative, but almost as formalist, pieces of the early Seventies.

As his emigration would suggest, Tucker's is one of those careers characterized by sharp breaks and changes in direction rather than by the steady pursuit of a single idea. His American work divides clearly into two phases. Until 1984, it consisted of open structures composed of recovered timbers or beams, or of plaster laid over a steel armature with subordinate flanges or struts extending outward at regular intervals. Since 1984, Tucker has moved in a different direction, manipulating large mounds of clay and plaster in an effort to imbue them with the feeling of the human body in motion and at rest. Although both groups of work are resolutely abstract, they seem to have little in common.

The sculptures from Tucker's first phase seem almost transparent, so greatly is mass subordinated to space. They either enclose space, evacuating the center and moving the focus to the perimeter, or open up to it, radiating parts from a central armature or core. *The Prisoner* (1981) exemplifies

the former type. It is a shallow, four-sided volume with struts on its inner surfaces that looks as though it has been kicked high on one side – one vertical is dented inward, pressing its struts toward the rest like cogwheels that are about to interlock. *The Contract* (1978), on the other hand, resembles a version of *The Prisoner* turned inside out. It's an "L"-shaped composite of two-by-fours braced by an inner diagonal with uniformly short struts projecting outward like so many spines. Both works reveal Tucker's interest in probing the ground of sculpture – its orientation to the environment and viewer. By enclosing the "action" of his sculptures, as he does in *The Prisoner*, Tucker sets them off from us. Unenclosed (*The Contract* is an example), the barrier falls, and they assume a place in the space we inhabit.

Tucker's pre-1984 work seems linked to the Constructivist impulse in its assembled character and in its reduction of mass to line and structure. But it actually has more to do with something iconic and monumental. Mass may be reduced to line, but it's a heavy line. Tucker adds timbers or builds up the plaster to add as much weight as possible. By affirming the pull of gravity, these sculptures tell you they're part of the same world you are. (In the catalogue essay for a show he organized in 1974, Tucker wrote, "The condition of sculpture is gravity.")

Tucker's affirmation of gravity is what really sets him off from Constructivism, which habitually denies it. Tucker's sculpture – though nominally open-form, like Smith's and Caro's – isn't about laying claim to space through physical spread or distension. Instead, his pieces hew to an actual or implied center. They almost seem worried about making too much of themselves. *The Contract* may be as bare and open as any Constructivist sculpture around, but with its small struts and modest elevation, its reach into space is tentative and discreet – so much so that, far from possessing

space or grappling with it (as does so much of the sculpture at Storm King), the piece seems only to want to get under its skin a little.

208 Tucker's greatest departure from the Constructivist aesthetic lies in the realm of content. While much Constructivist sculpture can often seem to be about little more than formal relations, Tucker goes beyond that, suggesting a physical or psychological state of being, though one at odds with modernism's recurrent mood of *joie de vivre*. The titles of his work – *The House of the Hanged Man*, *The Hostage*, *The Prisoner* – give, off a dark cast, a feeling reinforced by certain elisions between a sculpture's form and the ideas suggested by his titles. *The House of the Hanged Man* (1981) (named after a Cézanne painting) is a large "A"-shaped structure made of bolted, creosoted beams with half a dozen smaller wooden pieces descending from them vertically. It's a brooding work, swathed in an aura of recent (or imminent) tragedy. *The Prisoner*, with its pressed-in side and converging struts or "teeth," conveys a powerful feeling of constraint and pressure. There's no specific illustration in these sculptures, though. Tucker is treading the line between abstract sculptural object and quasi-narrative reference, asking whether abstract sculpture cannot aspire to more than formalist (Caro) or polemical (Judd) expression, and proposing his own answer that it can.

What's remarkable in this phase of Tucker's work is the scope of what is at root a very simple formal language: struts coming off a spine. That language expresses everything from *The Prisoner*'s enforced enclosure to the freedom and litheness of *The Law* (1983), a drawing of five verticals projecting from an upward-arching plane. It's as if he's putting his formal language through its paces, testing its range and suppleness. These first sculptures have the quality of a dice throw, not because they appear careless but because totally

new and unpredictable results are arrived at through a regular recombination of identical elements.

To step outside Storm King's main building and see Tucker's work since 1984 is to pass into a different world. The spare, skeletal, assembled forms give way to tooled monoliths. These works are apparently influenced by a new appreciation of Rodin and a desire to place the figure once again at the center of sculptural discourse. But Tucker's "figures" are unlike any we have seen before. They seem more like mounds of material awaiting the artist's touch. In *The Horses* (1987), we may discern the generalized heads of horses caught in the act of rearing, but we can't be confident that we're right. The animal image keeps slipping in and out of focus, trading places and competing with visions of inert, untransfigured matter.

As it happens, Tucker isn't interested in the figure as it is known to the eye. He's after something more immediate, even more intimate. It's what the body feels like from the inside that seems to concern him, the body as something both "occupied" and "carried around" – as the subject and object of physical exertion. Accordingly, Tucker conveys the idea of the figure by means of an opposition between built-up mass and inner animation. *The Gymnasts*, for example – a series of sculptures from 1984 – is made up of two curving, L-shaped slabs which defy their own weight by "flexing." *Okeanos* (1987–88), a magnificent, circumflex-shaped, larger-than-life-sized piece, seems to be heaving itself toward the vertical before our eyes.

As with the earlier skeletal sculptures, Tucker is careful in these pieces to avoid a reference that is too specific. This is the point of generalizing his form. He wants as wide a range of reference as possible. Indeed, in these monoliths he's doing what he did earlier: giving us a sculptural form that appears so minimally worked as to be little more than

raw material, yet a form possessed of the most forceful emotive power. Tucker isn't alone among sculptors these days in pursuing a broad associativeness in his work, but he goes about it differently. There's an idea among younger sculptors that the more things a work suggests the better it is, an idea that someone like Joel Fischer has made a career out of. But when a work of art means many things, it usually winds up meaning nothing, and this is the problem with Fischer's work and with that of some of his fellows.

Tucker's work, by contrast, has a center. You may be able to see a rearing horse's head in one of the sculptures, or (alternatively) an arm, part of a leg, or perhaps a torso. But what's more important is the general idea, which remains constant: the body under stress. Tucker thus manages to address the question of how to expand sculpture's range of meaning in the wake of Minimalism without falling into the trap of making "consensus sculpture" – work that has a little something for everyone but no real character of its own.

As Tucker sets out to communicate a sensation of the lived-in body, he is far from dispassionate. These sculptures are filled with pathos. Their surfaces seem scarred rather than hand-worked, and they convey the grinding effort that is exerted in levering physical bulk against itself and gravity. For Tucker, the body is a tragic thing, doomed to wage a battle it can never completely win.

Pathos, indeed, is the real subject of all Tucker's work, the one common denominator in an otherwise highly diverse œuvre. For it is present also throughout the skeletal, pre-1984 pieces. The pressure and containment of *The Prisoner* express this pathos, but most of all it is evident in the way Tucker's work is oriented to the world. Its isolation in and minimal displacement of space, and the simple, unembellished materials he uses (wood is left unsanded, blemishes remain undisguised), endow his work with a prosaic naked-

ness. In one sense, of course, this is nothing more than literalism of the kind seen in Donald Judd's work, a deliberate blurring of the distinction between the worlds of art and everyday things. But in Tucker's hands it adds up to something larger. I find it hard to think about any one of his pieces of this period without also thinking of a seemingly unrelated one – Houdon's *La Frileuse* in the Metropolitan Museum, a bronze of a nude young woman huddling with a shawl around her shoulders and over her head shielding herself from the cold. For me, works like *The Prisoner* and *The Contract* partake of the same feeling of internalized bodily exposure as does Houdon's shivering figure.

In *Okeanos* and the other monoliths, Tucker's view of the figure is unlike any other in modern sculpture. You have to go back to Degas to encounter sculpture as expressive of the inner stresses and strains of the human body in motion. Indeed, Tucker has taken Degas' sculpture to its logical conclusion, stripping it of all that "clothed" his idea – the naturalistic figure, the dance subject – to arrive at an essence. Other sculptors have attempted something similar, Caro in his early bronze work and Joel Shapiro in his Minimalist-derived, figural abstractions. But by retaining the integral human form, they were only able to go so far. The force of Tucker's sculptures comes from his jettisoning the human form. No "subject" interferes with pure sensation.

The affinity of Tucker's work with Degas' points up an important aspect of Tucker's latest phase, one felt especially in the environment of Storm King: its dialogue with sculpture's past. For many contemporary sculptors, time begins no earlier than Picasso. It is as though there's a point beyond which one cannot go as a sculptor and still hope to fit into the mainstream; and Picasso, or perhaps Brancusi, represents that terminal point. Storm King's collection traces its roots back to Picasso and González, while much of what's

visible in the galleries now has antecedents only in Minimalism. One can't help feeling that this circumscribed historical outlook has led to a comparable aesthetic constriction.

In reaching past Brancusi and Picasso and returning to the modeled monolith, Tucker has re-admitted to artistic discourse the relevance of a tradition before modernism. Indeed, he asks us to think about sculpture as an expressive language not limited to any one period style but unbound by historical divisions. In so doing, he makes available a body of material – largely closed off until now – with which to renew sculpture. Michelangelo and the *Belvedere Torso* are as present in Tucker's sculpture as Degas and Rodin. But they are invoked to address issues about sculpture's meaning and its direction at the present moment rather than out of some misplaced feeling of nostalgia. It is one of the paradoxes and triumphs of Tucker's art that by reaching into the past it should have so much to say to us in the present.

Originally published as "William Tucker's American decade"
in The New Criterion, *September 1988.*

BACK IN THE 1970S, the Museum of Modern Art followed an exhibition of late paintings by Paul Cézanne with a retrospective of Sol LeWitt's career. The contrast between the two – the pioneering modernist's intensely wrought views of Montagne Sainte-Victoire versus the cool, impersonal sculptures and drawings of a pioneer of 1960s Minimal art – was extreme, and deliberate.

This year, MOMA is at it again. During the summer it showed Richard Serra's sculptures – enormous, canted sheets of industrially produced steel that took visitors on a roller-coaster ride of emotions ranging from fear to exhilaration. Beginning last month, the museum followed that by showing sculpture of a very different stripe: Martin Puryear's meticulously hand-made and magically allusive wood constructions.

Organized by John Elderfield, the museum's chief curator of painting and sculpture, "Martin Puryear" brings together nearly fifty sculptures running the gamut of the artist's career, from the mid-1970s to this year.

Aside from their sheer beauty, the one common denominator of this work is its mood of poetic whimsy. Mr. Puryear's works combine insouciance, mystery and wonder in a way that recalls Alexander Calder's earliest assemblages – mobiles and other works – of the 1930s.

Take the three enormous sculptures occupying MOMA's cavernous atrium gallery: *Desire* (1981) features a large

wheel attached to a long axle whose other end anchors to a tower; *Ladder for Booker T. Washington* (1996) is a long wiggly ladder that gradually narrows, creating a perspectival illusion that suggests it's disappearing into the sky; *Ad Astra* (2007) consists of a boulder-like form loaded into a barrow whose handle is, well, sixty-feet long. Wandering among them, you feel like a Lilliputian visitor to a storage area for farm implements designed by Lewis Carroll. Yet far from being disquieting, the experience is one of pure delight.

Then there's *Sanctuary* (1982), an open box atop two long, vertical tree branches with a single wheel at the bottom. It might have been titled "The Timid Unicyclist," since it leans against a wall in one of the galleries, a personage unwilling to roll the dice with gravity. Or *In Sheep's Clothing* (1996–98), an enclosed rectangular volume with an opening on top that has you curious about what might be inside. Except that the opening's too small for you to really learn anything.

Yet there can be a darker side to Mr. Puryear's sensibility as well. In the catalog, Mr. Elderfield quotes Mr. Puryear's explanation that *Desire* (1981) expresses unfulfilled longing, the wheel doomed to perpetually circle, but never meet, the tower. And there's *Self* (1978), a tautly enclosed volume the artist has stained a deep black that sits there, hunched and brooding.

Born in 1941, Mr. Puryear is (like Richard Serra) of the generation that came of age artistically in the heyday of Minimalism. Yet while he shares something of that outlook in his preference for simplified forms, his sensibility is too rich and his inventiveness too restless for him to have been contained by its straitjacket of impersonality, strictly geometric form and industrial manufacture.

In fact, Mr. Puryear is a hard artist to categorize, because his work confounds and overturns many of the things we'd

come to take for granted about twentieth-century sculpture. Where wood was most often a carver's medium, Mr. Puryear uses it additively. Sometimes his work will remind you of Brancusi. But the Romanian modernist was after a kind of formal and spiritual purity in his work, whereas Mr. Puryear is interested in a wide range of metaphor and allusion. And while his sculpture frequently engages with the space around it like Calder and other earlier sculptors, just as often he does something they never did – seals the space in so you're aware of it as an element but can't see it. Time after time Mr. Puryear has reshuffled the aesthetic deck and dealt the cards to suit himself. He is a complete original.

Nowhere is this go-it-alone attitude more in evidence than in Mr. Puryear's dedication to handcrafting his sculptures. While in college in the early 1960s, he made acoustic guitars. (Essayist Michael Auping perceptively sees a connection between this experience and Mr. Puryear's mature sculpture, writing that "the description of a guitar – a body, a hollow space, a neck – could refer to any number of his sculptures from the past three decades." He adds: "Throughout his career the artist has turned again and again to the idea of an enclosed, hidden space with a carefully assembled outer shell."

In the late 1960s while in the Peace Corps in Sierra Leone, Mr. Puryear learned wood carving from local craftsmen. Later he spent time observing a custom furniture maker in Stockholm.

Out of those three experiences grew an approach to craft that combines the modernist practice of assemblage with joinery and boat building. But Mr. Puryear's craft technique – the way he chooses to assemble his pieces – is more than a means for realizing an idea in three dimensions. It's integral to his works' impact as art. The frantic crisscrossing of the lengths of wood that make up *Thicket* (1990), for example,

has an expressionistic flavor suggesting a sculptural equivalent of one of Jackson Pollock's drip paintings.

216 Beauty, lightness of spirit, a premium on craft skills – Mr. Puryear's art combines all these things. At any time that would be a significant achievement. But in today's art world – crassly commercial, cynical, and tendentious – it's a public service.

Originally published as "The Meticulous and the Magical" in The Wall Street Journal, *December 20, 2007.*

ONE OF THE MORE intriguing features of the history of sculpture since Rodin is the recurring presence of posthumously discovered bodies of work which ultimately prove to be seminal, even revolutionary. Edgar Degas' *Little Dancer of Fourteen Years* (*ca.* 1880) was the only three dimensional work he showed during his lifetime, the ballerinas and horses being otherwise unknown. Honoré Daumier's sculptures were personal creations, made mainly to help him with his drawn and painted caricatures and exhibited only the year before he died in 1879. Even Pablo Picasso's activity as a sculptor only became fully understood in the years after his death. To this list we must now add Jack Whitten, currently the subject of a retrospective at the Met Breuer. Of the nearly sixty works in the show, two-thirds are sculpture. And all will be new to visitors of the exhibition. That's because, as the Met curator Kelly Baum writes in the catalog, "Even though he created sculptures for four decades, Whitten rarely shared them with the critics and curators who visited his studio. He similarly refused to sell or exhibit them, effectively cloaking them in a veil of secrecy – or rather, privacy." Yet as with those earlier sculptors, this show places before us a singular and highly original talent whose work enlarged the possibilities of the art form in new and unexpected ways.

Whitten was born in 1939 in Bessemer, Alabama. (Sadly, he died in January of this year, just a few months before this retrospective was to open at the Baltimore Museum of Art.) In 1960 he fled the Jim Crow South for New York City, enrolling in The Cooper Union. He began studying the col-

lections of African art – a type of work he was seeing for the first time – in the Metropolitan and Brooklyn Museums out of a desire both to explore and to lay claim to his ethnic and cultural heritage. After a while he felt that to truly understand African art he had to begin wood carving, which he did in 1962, thus entering into a career as a sculptor. Prompted by his Greek-American wife's interest in exploring her own heritage, in 1969 the couple visited Crete for the first time, and for the remainder of his life they spent summers on the island, with Whitten making sculpture there exclusively, producing paintings in New York the rest of the year. In this way Whitten could be said to have enacted the journey undertaken by so many modern artists, only in reverse, and with an opposite intent. Artists like Brancusi and Picasso traveled from the periphery – their home towns – to the creative crucible, Paris, to experience and participate in the most advanced art ideas of the moment. By contrast, Whitten the sculptor regularly left the creative center of his time – New York City – for the periphery, Crete, not to engage with a vigorous present but, instead, a deep past: the art and civilizations of Africa and ancient Greece.

Whitten's close scrutiny of African art might have led to a career as a sculptural pasticheur, with the artist producing a steady stream of glosses on and imitations of the forms and styles of African art. Yet nothing could be further from the truth. One of Whitten's unique features as an artist is the way he absorbed and assimilated not just the influence of African art but that of multiple sources and stimuli and even managed to transcend them to produce something completely his own.

To judge from the show, Whitten's evolution was startlingly swift. The earliest works are *Lovers* (1963–64), consisting of one sculpted head hovering above the other at the end of a twisting, serpentine form, and *Jug Head I* and *Jug*

Head II (both 1965), consisting of stylized heads in which the nose extends up, over, and back to form a handle. They aren't especially memorable as sculptural images, but they already show a well-developed feeling for, respectively, form *in* space (one form snaking upward from another) and form *and* space (the opening between the nose/handle and the mass of the head).

Nothing prepares us for his next sculpture, done soon after. *Homage to Malcolm* (1965) is a work of full mastery and mature vision. A six-foot-long, horizontal sculpture, it consists of multiple distinct parts or elements: At one end a smooth, slender horn shape and a shallow dish-like receptacle, both on a roughly carved support. At the other end an oval form whose surface is covered in a thick nest of nails and screws driven into its surface in the manner of the Kongo *nkisi* figures (a major influence on Whitten). Separating these two is a light, smooth, rolling-pin-like form whose even lighter top part suggests the repeated actions of the hand, touching or rubbing. It is a striking, arresting object whose meanings are powerful yet elusive. It suggests a supine body (it's a memorial to the assassinated Civil Rights leader), a club, a totem, even a landscape. And it is wholly original – I can think of nothing like it in modern or contemporary sculpture anywhere.

Thereafter Whitten goes from strength to strength: the three human-scaled, totemic sculptures in the 1972–74 *Anthropos* series; *Reliquary for Orfos* (1978), a work in which Whitten commemorated his love of fishing and an endangered species, the orfos fish, with, among other things, windowed containers revealing clusters of fish bones; and *The Afro American Thunderbolt* (1983–84), the likes of which surely exists nowhere else in the history of modern sculpture. Perched atop two metal rods functioning as a "base" are two smooth, broadly angular horizontal forms, a large

portion of whose surfaces are covered with the dense thicket of nails and screws familiar from *Malcolm*. Their elevation and the space under them are all as much a part of the sculptural experience as the forms themselves, whose meaning is ambiguous but which the graphic energy of the bent and twisted metalwork imbues the whole with a powerful sense of presence.

A brief word on Whitten's paintings, which, being fewer in number and less dramatic in presence, are likely to be overshadowed in this show, though they shouldn't be. They demonstrate that Whitten brought to the art of painting an outlook as original and independent as that which he brought to his sculpture. They tend to be large – seven feet or more to a side – with a prominent central form composed of a multitude of tiny, tessera-like parts (the legacy of his study of Greek mosaics) situated amid a neutral ground. What distinguishes them is an approach to pictorial space, one you might call topographical, unlike any to be seen in the art of his time. One will suggest variously a city or densely populated island viewed from tens of thousands of feet up, another a planet floating in outer space, still another an ice-covered peninsula jutting out into a body of water. Whereas Whitten's sculpture invites us in close to scrutinize its forms and workmanship, his paintings do the opposite: ask us to step back to take in, literally and figuratively, the big picture.

Both the catalogue's essays and the individual entries and exhibition displays superbly explicate Whitten's sources and influences in African and ancient Greek art that were among his major creative wellsprings. The Met has played to its strength as an encyclopedic museum by placing objects from its collections such as a Kongo Power Figure, a Cycladic idol, and an octopus-decorated Mycenaean krater alongside Whitten's works. Indeed, going through the show I felt that here at last the Met had realized the full potential

of the stated aim of its move into contemporary art, that of using the past to illuminate the present. The selections are spot-on, the juxtapositions apposite and illuminating.

At the same time, though, there is a curious lacuna. Whitten began living in New York in a period (the early 1960s) of intense creative ferment. Yet, beyond one or two passing references in the catalogue, we learn nothing of how modern and contemporary art might have shaped his aesthetic. It's probably facile to see in the piled-up forms of the *Anthropos* series the influence of Constantin Brancusi's *Endless Column* or of Joseph Cornell in Whitten's encasing mementos and other objects and ephemera in windowed containers. But then there is *Kritiko Spiti* (1974–75), a midsized vertical carving that is placed directly on the floor and leans against the wall. In the way it "bridges the space between the floor and the wall," as the contributor Karli Wurzelbacher writes in the catalogue, it has notable affinities with the work that artists like Richard Serra, Robert Morris, and Lynda Benglis had been making and exhibiting around that time and earlier. Might Whitten, in this work, have been responding to that? If so, it would not diminish his achievement to make the connection. On the contrary, it would only enhance it, offering further proof of his ability to transcend multiple sources in the expression of his singular vision.

Two things set these and Whitten's other works off – and set off Whitten himself – as wholly original voices in contemporary sculpture. The first is that beyond their status as pure abstract art is their role as works freighted with symbolism to carry larger, multi-layered meanings. Sometimes these are personal and autobiographical. *Lichnos* (2008), a large work dominated by an upthrusting horn shape and the first thing you see on entering the show, is his homage to spearfishing in the Mediterranean. The title is the name of a fish native to the waters off Crete; the main body of the

sculpture carobwood, native to the Eastern Mediterranean; the horn a symbol of power and potency in African culture; the metal mending plate a reference to the artist's childhood in Alabama; and the whitewashed cinder block on which the work rests a reference to the color of Greek and Cretan buildings.

222

More often, though, Whitten has something larger in mind. It wasn't just the forms of African sculpture that he was drawn to, but their ritualistic function as well. And so, as much as making "art," his aim became the creation of objects which, like those he saw in the museums, embodied apotropaic powers, or in other ways functioned as intermediaries between humanity and invisible forces. Hence the repeated horn imagery, the nail motif borrowed from Kongo Basin figures, believed to unleash their powers when nails were driven into them. Hence, too, a work like *The Guardian II, For Mirsini* (1984), a wall-bound abstraction in which one can discern a stylized face. Whitten made it to hang in his young daughter's room to watch over her. This may be why Whitten never exhibited his sculpture; its purpose was fundamentally private.

The second thing that sets off Whitten as a unique voice is that he has introduced new ways of making, looking at, and thinking about sculpture. His works are, in fact, very much "made": at every stage we are aware of the hammering, turning, carving, drilling, dowelling, and adhering that went into the creation of each work. (Though Whitten will occasionally wittily undercut this perception as he does in *Malcolm*, which looks as if it is assembled from multiple parts when in reality it was carved from a single piece of elm.) And "made" in another way: in place of modernist simplification, Whitten's sensibility is additive, even accumulative. He is not afraid of embellishing his works with profusions of matter and material.

Whitten often requires us to experience one of his works in ways different from most modern and contemporary sculpture. The horizontality and disposition of forms in *Malcolm* require that we "read" it – that is, take it in part-by-part and sequentially, from left to right, rather than as a unity. He lofts the main mass of *Thunderbolt* to around eye level. And *Memory Container* (1972–73), a figure-like sculpture with containers on its front and back holding ephemera and mementos, in fact has neither "front" nor "back"; both faces are equally necessary and significant.

Finally, Whitten asks us to ponder such questions as: Can abstract sculpture be more than pure form? Is there a place for spirituality in contemporary art? Martin Puryear, Melvin Edwards, David Hammons, and now Jack Whitten: a line of African-American sculptors drawing on their ethnic and racial heritage to fashion a wholly original, boundary-extending modern art. There are obviously others. Time, surely, to move beyond the single artist, monographic exhibition to a broad-gauged, scholarly survey show.

Originally published as "Jack Whitten's ritual objects,"
in The New Criterion, *November 2018.*

"GREATEST LIVING BRITISH ARTIST" is among the most abused accolades in art criticism. The one person who deserves it is sculptor Rachel Whiteread, now the subject of a retrospective at the National Gallery of Art.

"Rachel Whiteread," which travels to the Saint Louis Art Museum after Washington, was jointly organized by the Gallery's Molly Donovan and Ann Gallagher of Tate Britain, where it began its international tour last fall. It features some 100 sculptures and drawings. The list includes *Closet* (1988), a plaster cast of the interior space of a wardrobe wrapped in black felt to evoke the artist's childhood habit of hiding in closets, and the 1995 model for her acclaimed *Holocaust Memorial* (2000) in Vienna's Judenplatz.

Generationally, Ms. Whiteread (b. 1963) is one of the Young British Artists, seen here in the notorious "Sensation" exhibition in 1999. Temperamentally, however, she couldn't be more different from that group, lacking for example the drive-by irony of a Damien Hirst. Ms. Whiteread is old school: Her art expresses something personal and deeply felt.

Ms. Whiteread came to three dimensions via two, after learning the casting process while a painting student at Brighton Polytechnic in the 1980s. She then studied sculpture at the Slade School of Art in London. The painter's eye endures, however, in her fondness for color in some of her sculptures.

Another formative experience surely came earlier. As a child she helped her father lay the concrete floor when he converted the basement of the family home into a studio for

Ms. Whiteread's artist mother. This likely would have opened her eyes to interior spaces and the way surfaces define them. That, at any rate, became her direction – articulating a vision of the world as so many containers rather than, as sculptors generally have, space-displacing solids. (She has spoken of wanting to "mummify the air in the room.")

Ms. Whiteread's breakout work, included here, was *Ghost* (1990), a plaster cast of the living room in a North London house of the kind she grew up in. A roughly eight-by-eleven-by-ten-foot monolith, its most distinctive feature is a floor-level protrusion on one side – the hollow of the fireplace. Her next major work was *House* (1993), a concrete cast of the inside of an entire London house, subsequently torn down, that she exhibited at the original site. It, too, was later demolished. (A video in the exhibition documents its creation and destruction.)

Perhaps because, like *Closet*, *Ghost*, and *House*, so much of her private work is rooted in memory, Ms. Whiteread is about the only contemporary artist I can think of who is up to the challenge of creating meaningful public monuments and memorials.

Much has been made – too much, in my view – of Ms. Whiteread's allegiances to the Minimalist and Post-Minimalist movements of the 1960s and 1970s: primarily in the abstract, geometric nature of her vocabulary. Overlooked in all this is the way she uses her materials – the white of the plaster and translucence of the resin – to impart a ghostly, otherworldly character to her sculptures, a mood that traces its roots to the dream world of the Surrealists.

In front of a work of Ms. Whiteread's the initial impulse is to reverse-engineer it in one's mind, to trace its shapes back to the original space from which the sculpture was cast. But it's impossible; you quickly hit a dead end. Mirror writing is one thing, three-dimensional form quite another.

That's good though, since it allows the sculpture to move beyond the status of mere replica as other meanings and associations emerge.

226

Take *Untitled (Domestic)* (2002). This enormous work, some twenty-two feet tall and resembling an asymmetrical V on a base, is a cast of the negative space of a fire escape staircase. (Kudos to Ms. Donovan, who has wittily installed it near an actual flight of steps.) But little is parsable beyond that, so other aspects come into view. It quickly asserts itself as a stunning abstract sculpture, its authoritative presence and audacious forms, one of them boldly cantilevered out and up, ensuring that it commands every cubic inch of the surrounding space. At the same time its monumentality, truncated appearance, and pattern of notchings and surface striations combine to suggest an ancient architectural fragment recovered from some desert ruin.

Ms. Whiteread's work would seem to require a certain minimum scale to be effective; some of her smaller efforts here fail to carry. An exception is her series of doors, placed on the floor leaning against the wall. Some take their titles from the dates of their source dwellings, making the sculptures the record of specific places. Yet through her choice of material, resin, she elevates them into metaphors of passage. They become at once barriers and portals: the former because of their manifest physicality; the latter because the resin's translucence makes them penetrable by our vision. Of such modest processes and premises is poetry made.

Originally published as "Where Memories Dwell"
in The Wall Street Journal, *October 3, 2018.*

THE WHITNEY MUSEUM of American Art has mounted "Jeff Koons: A Retrospective" as the swan song in its uptown Breuer building before reopening in its new, Renzo Piano-designed space in Chelsea next spring. Besides his stratospheric auction prices, Koons is famous for industrially produced pop imagery such as sculptures of inflatable hearts and balloon dogs, all turned out on a large, sometimes gigantic scale in cheerful, candy-box colors and polished to a high, reflective sheen. According to the Whitney, it is his biggest exhibition ever, and they've certainly done him proud. Organized by the Whitney curator Scott Rothkopf, it displays some 150 works dating from the late 1970s to just last year, taking up more than three floors of gallery space.

If the scenario sounds familiar, it is. In 1980, prior to shutting down for a four-year renovation and expansion, the Museum of Modern Art gave over its entire building to a Picasso retrospective. The point was to go out with a bang – to affirm Picasso's position as the most important artist of his time. The Whitney wants to go out with a bang in the same way, and has nominated Koons as its Picasso.

Why not? Koons burst on the scene in the 1980s, quickly taking his place alongside the other young art stars of the time. Yet among them, he alone has survived and thrived in the decades since. David Salle and Robert Longo have pretty much flamed out. Julian Schnabel has moved into filmmaking. Eric Fischl hasn't been part of the conversation since the controversy surrounding his *Tumbling Woman* sculpture when it was displayed at Rockefeller Center on the first

anniversary of the 9/11 terrorist attacks. Cindy Sherman might have fit the bill, but MOMA got to her first with a retrospective in 2012. Besides, though her work has continued to evolve, it is still fundamentally rooted in the "Pictures" aesthetic of the 1980s, in which photographic imagery is used to critique the same thing in the mass media and popular culture. By contrast, Koons left the 1980s behind before they were over.

But Koons was not chosen by default. Distasteful as it may be to bestow such an accolade on someone who traffics so brazenly in the shallow, the banal, the meretricious, and the cheap, he really is the most important artist of our time. Koons is the avatar of a new kind of art and a new kind of art world, both of which he helped to create.

After the unremitting barrage of hype and market talk, the Whitney show makes it possible to take a dispassionate measure of Koons's achievement. The result is sobering. The work looks oddly out of place at the Whitney, as if it had somehow washed up there accidentally. And right out of the gate it becomes clear that Koons doesn't have enough ideas to sustain a retrospective on this scale. On the second floor, where the show begins, the elevator deposits you into a gallery filled with eight of the works from his "The New" series (each body of work comes with its own title) that put him on the map in the early 1980s. These are pairs of vacuum cleaners stacked in Lucite cases and illuminated with fluorescent lights – commercially manufactured household appliances displayed as if they were holy relics. In keeping with the avant-garde ethos of the time, Koons here is critiquing society's habit of turning anything and everything into a salable commodity, the sparkling display a comment on society's tendency to "fetishize" such merchandise. Showing two would have made the point; six is padding. This sets the pattern for the entire exhibition.

Koons has parlayed a paradox to fame and fortune. He is the quintessential anti-art postmodernist who has nonetheless become the darling of the art establishment. The wellsprings of Koons's aesthetic are Pop Art (glosses on Andy Warhol, Claes Oldenburg, and James Rosenquist abound here) and Marcel Duchamp. Tellingly, no older art appears to have touched him at all. When it does appear, late in the exhibition in the work of the last few years, it does so as something to be debased in the manner of Duchamp's *L.H.O.O.Q.* Mona Lisa. Thus Gian Lorenzo Bernini's *Pluto and Proserpina* (1622), a monument of Baroque art and one of the greatest works in the history of sculpture, is tricked up like a whore, cast in stainless steel, tinted an acid yellow, and festooned with bouquets of flowers.

The one thing in all of art history that seems to have impressed Koons is the Duchamp Readymade, the storebought utilitarian object (urinal, shovel, bottle rack) consecrated as art by being displayed in a gallery or museum. This concept dominates the early work, such as the vacuum cleaner pieces, the stainless steel ten-foot-long Jim Beam decanter in the form of a train, and much else. Its presence can be felt, too, in most of Koons's subsequent work.

But around the mid-1980s, Koons seems to have sensed that, with the Pop artists having cornered the market on popular culture, and his contemporaries having done the same with consumer culture, he would need different source material if he was to truly make a splash. So he turned to the last remaining items in the anti-art store cupboard: kitsch and pornography. In the late 1980s he produced his "Banality" series, sculptures of such subjects as Michael Jackson, Buster Keaton, a Leonardo-derived Christ figure, and a Playboy bunny– all executed in large scale in polychromed wood or porcelain, not by himself but by professional artisans.

A little after that came the "Made in Heaven" series,

nothing-left-to-the-imagination paintings and sculptures of Koons and his then-inamorata, the porn star Cicciolina, *in flagrante*. Except that it isn't pornography – the wall label reassures us – but rather "an extremely risky and vulnerable form of self-portraiture." (Just to be on the safe side, however, the Whitney has shrewdly confined the most explicit examples of this "vulnerable form of self-portraiture" to the exhibition catalogue.) Then it was off to Playland as, in five successive series beginning in the mid-1990s and extending to the present – "Celebration," "Easyfun," "Easyfun-Ethereal," "Popeye," and "Hulk Elvis" – Koons turned to the world of children's playthings, beach toys, and comic book figures, casting them in metal, often on an enormous scale. *Play-Doh* (1994–2014), an aluminum replica of a multi-colored mound of the modelling compound, is ten feet tall.

In the end, "Jeff Koons: A Retrospective" is profoundly depressing, the first time I have experienced such a feeling in a lifetime of visiting museums. The show is suffused with the atmosphere of cold calculation, of a career advancing as the result of a series of carefully thought-out moves and strategizing rather than proceeding naturally, without premeditation, as artists normally do. The work feels the same way. For all the warmth of the bright colors and ingratiating subject matter – puppy dogs, hearts, balloons – the manner of their execution, the works' razor-sharp contours and impersonal, textureless, polished surfaces, makes them feel icily remote and distant. Next to a Koons, your average marble by the Neoclassical sculptor Antonio Canova (1757–1822) is a roiling cauldron of passion.

Then there is Koons's relentless drive to the bottom, his unremitting effort to delegitimize the high in order to elevate the low to an equivalent stature. In service of this goal, he adopts some of the techniques of high art (metal casting) as well as some of its attributes (large scale), clothing it all

in an overlay of facile "interpretation." Thus *Aqualung* (1985), a bronze casting of a diver's breathing apparatus, isn't the repurposed Readymade it appears to be but "an image of certain death," a reminder that "despite one's best attempts to achieve a state of equilibrium in life, mortality is inevitable." Finally, the show is depressing because of what it tells us about Koons's rudimentary notions of worth: Overblown scale + Garishness = Timeless value. Sadly, in today's art world, he seems to be on to something.

231

In my view, too little attention has been paid to Koons's five-year career selling mutual funds and commodities on Wall Street in the 1980s. In fact, it is the key to understanding his art. So much of what Koons has done and the way he has done it bears the stamp of an astute entrepreneur rather than an artist. The rollout of each neatly packaged and titled series resembles the test marketing of the latest product line more than the unveiling of "new work" – an artist's latest *démarche*. This is particularly noticeable in Koons's early pieces, produced from the late 1970s to the early 1980s. They are too tidy, missing the mix of unevenness, eclecticism, and general messiness that is commonly the hallmark of a conventional apprenticeship phase. Then there is Koons's persona. He's no brooding Romantic loner. Rather, Koons is the affable pitchman, nattily dressed in a suit and tie, ready with a smile and some soothing patter with which to reassure or elucidate the confused spectator, journalist, critic, curator or collector. He's even willing to abase himself just a little in the interests of self-promotion, as he did this summer in a *Vanity Fair* photo shoot showing him pumping iron in the buff.

Indeed, there's a sense in which Koons isn't really at home in the role of artist. He possesses no real imaginative gifts and doesn't seem to understand what artists do. Real artists take raw material and transform it. Even a Duchamp

Readymade is transformed, through its altered context rather than changes to its physical form. By contrast, Koons's "transformations" are mostly sideways moves – increases of scale, replication in another material, the addition of little embellishments like flowers or gaze balls – colored, mirrored spheres used in garden décor. The original object remains largely as it was.

This point was brought home to me one afternoon in the exhibition when I saw a school group gathered around the enormous *Balloon Dog (Yellow)* (1994–2000), earnestly trying to capture it with pencils and sketchpads. On one level, they were the latest link in the chain of artists down the centuries learning by copying the great masters in the museums. Yet it made for a rather comical sight because in this case the link had been severed. What aesthetic insight was to be gathered from this exercise? The students would have learned just as much about three-dimensional form, proportion, texture, and the rest from drawing an actual balloon dog.

But just because *Balloon Dog* and the rest offer no aesthetic rewards doesn't mean they're devoid of content. It's simply that meaning in a Koons – his patter notwithstanding – resides solely in its technique, its mode of production and realization. The labels made this clear. In a notable departure from standard practice they included, in addition to the objects' title and date, lengthy descriptions of what had been required to bring them into existence: the processes and procedures, the number of individuals employed, and above all the technical challenges faced and overcome. With most artworks this information is only part of their message; in Koons's, technique *is* the message. There is no other.

Koons's Wall Street background is most in evidence in the way he has turned himself into a brand. The connection between art and money is nothing new – it was pioneered by

Andy Warhol. Casting about for a new income stream in the 1970s, Warhol settled on the idea of celebrity portraiture, silkscreened snapshots overlaid with smears of color. These works didn't tell you anything about the sitters, nor advance the form in any other way – they weren't meant to. Their purpose was strictly pecuniary. A few quick operations in the Factory and presto, thousands of dollars changed hands.

Koons has taken this idea to a whole new level. The exhibition press kit contained the announcement of an alliance between Koons and the fashion retailer H&M, surely a first for a museum. The company described the collaboration as one that would create "a platform through which fans have a unique opportunity to access his artwork through fashion." Ads around New York this summer announcing H&M's new flagship store on Fifth Avenue featured not a building façade but Koons's *Balloon Dog*. "FASHION LOVES ART – JEFF KOONS," screams the tagline. It is but his latest such joint venture.

This is why it is makes no sense to talk about Koons's art in conventional art-historical terms. Discussions of sources and influences, materials and techniques, iconography, good versus bad taste have no place in his art. Nor does it matter in the end whether, as is often debated, Koons is being sincere, ironic, or pulling everyone's leg. In a world where a bronze aqualung can be passed off as a *memento mori*, and pornography explained away as a "vulnerable form of self-portraiture," the boundaries of language have been stretched beyond the breaking point and words have ceased to have any meaning.

"That's right!" I hear Koons's patrons cry, *"We don't need no stinkin' art criticism!"* And they don't. The barker at his auction podium with hammer in hand, the buyers seated below fluttering their paddles, the dealer in the back room working cellphone and laptop in an effort to close a sale –

these are the true art critics of our time, at least as far as Koons is concerned. For it is Koons's signal achievement to have created a wholly new kind of art, one immune to all forms of judgment save that of the marketplace. Trashy? Sure. Vacuous? Utterly. But it sells for millions – sometimes tens of millions – and there's no reason to suppose it won't continue to do so. That's all that counts. Koons has succeeded by emptying his images of everything except the cheesy, the easy, the sweetly appealing, and the familiar. His works are big, they're cute, they're shiny, and they make no demands. What do they mean? What do you want them to mean? Something for everyone. They aren't there to be pondered or engaged with in any significant way. They exist solely as emblems of value.

This, in the end, is why Koons's work looks so out of place at the Whitney; it doesn't belong in an art museum. Its proper venue is the sale room, the commercial gallery, a corporate headquarters, or even the Museum of American Finance on Wall Street in Lower Manhattan, places where, with all aesthetic pretense cast aside, it can stand forth fully and unequivocally in its true nature as an instrument of exchange, a high-priced, tradable commodity.

"Commodity" – where have we heard that word before? Ah yes, back at the very beginning of Koons's career, in the vacuum cleaner pieces and other works that critiqued the values of contemporary consumer culture. Nowadays, Koons embraces those values with a manic zeal – indeed he personifies them. What a long way he has come. Andy Warhol, wherever he is, must be green with envy.

Originally published as "What Jeff Koons has wrought"
in The New Criterion, *September 2014.*

A Note on the Type

The Necessity of Sculpture has been set in Kingfisher, *a family of types designed by Jeremy Tankard. Frustrated by the paucity of truly well-drawn fonts for book work, Tankard set out to create a series of types that would be suitable for a wide range of text settings. Informed by a number of elegant historical precedents – the highly regarded Doves type, Monotype Barbou, and Ehrhardt among them – yet beholden to no one type in particular, Kingfisher attains a balance of formality, detail, and color that is sometimes lacking in types derived or hybridized from historical forms. The italic, designed intentionally as a complement to the roman, has much in common with earlier explorations in sloped romans like the Perpetua and Joanna italics, yet moderates the awkward elements that mar types like Van Krimpen's Romulus italic. The resulting types, modern, crisp, and handsome, are ideal for the composition of text matter at a variety of sizes, and comfortable for extended reading.*

SERIES DESIGN BY CARL W. SCARBROUGH